WHAT PEOPLE ARE
CHARITY BOWMAN WEBB AND CREATIVE FUSION...

It has been a delight to see the journey described in this book unfold. Conversations, God moments, and opportunities to hear revelation pour forth have peppered the last decade, and I can say that I know no one who carries this message—the release of God's creativity for societal transformation—like Charity does. There is a maturity and depth to what she shares, mixed with a childlike wonder at God's secrets, that leads to very practical steps to enter into this creative revolution that is no longer coming, but now arising, in the church. It is time! This book is the right message at the right time, apples of gold in settings of silver, for the season we are in. The fact that it springs from the blood, sweat, and tears of one who has been willing to pay the price and clear the path for others to follow just increases the impact it can have on your life. May you hear His voice calling you in. The tabernacle awaits!

—*John E. Thomas*
President, Streams Ministries International, USA

In these last few years, we are hearing more and more clearly the call for a restoration of the fullness of the embodied message of the gospel and the kingdom. *Creative Fusion* is offered as a catalyst that will release this message to a weary church and a hungry world. Blending strong prophetic insights with deeply insightful biblical teaching, Charity is able to bring to life the amazing kingdom adventure of *all* things being reconciled through Jesus. She offers each Christian huge encouragement to trust God for the missional task before us, knowing that all that is required for the task is already available. This book is an invitation to step into the most dynamic, creative era the church has ever known.

—*Alan McWilliam*
CEO/team lead, Cairn Movement, Scotland & Ireland, UK

For the past ten years, I have journeyed with my friend Charity Bowman Webb, and I am amazed at the way she has masterfully woven together creativity and the tabernacle pattern. Her prismatic words illuminate the reader's imagination, empowering and inviting us into a personal discovery of our destined place in these adventurous times.

—*Susan Card*
Visual artist, South Carolina, USA

Dear reader, let me commend this book to you, written by my dear friend and sometime partner in ministry. Charity is probably the first person I know who uttered the word *creativity* in the context of God's desire to restore this quality back into His church and people so they would function more fully in His callings and giftings in their lives. Over the years, Charity has been diligent to unpack God's Word on this topic and seek Him out for greater understanding and revelation so she could help train His people. It has been my immense pleasure to see her grow into a great leader in this area, taking up what God has mandated her to do and train and release creativity in people and churches in several countries with great and joyful impact. Prepare for the same as you read *Creative Fusion*!

—*Cindy Hayes*
Streams Ministries International
Training manager, North Atlantic Dreams, Scotland, UK

The Bible is full of types, patterns, and shadows. Recognizing these builds understanding, but unpacking them builds wonder and draws us closer to God. *Creative Fusion* undertakes the momentous task of unpacking the biblical pattern of the tabernacle, creating a pioneering study. The journey for the reader is full of discovery and meaning that are both confirmatory and inspirational for the body of Christ.

—*Hilary McNutt*
CEO, Mustard Seed Thinking Ministry, Scotland, UK

CHARITY BOWMAN WEBB

Creative FUSION

MERGING KINGDOM STRATEGIES TO IMPACT OUR WORLD

WHITAKER
HOUSE

Cover artwork by Susan Card.
www.susancardfineart.com

CREATIVE FUSION:
Merging Kingdom Strategies to Impact Our World

Charity Bowman Webb
www.streamscreativehouse.com
www.streamsministries.com
fusion.connect1@gmail.com

ISBN: 978-1-64123-745-1
eBook ISBN: 978-1-64123-746-8
Printed in the United States of America
© 2021 by Charity Bowman Webb

Whitaker House
1030 Hunt Valley Circle
New Kensington, PA 15068
www.whitakerhouse.com

Library of Congress Control Number: 2021944797

1 2 3 4 5 6 7 8 9 10 11 ⨂ 28 27 26 25 24 23 22 21

CONTENTS

FOREWORD

*But we all, with unveiled face, beholding as in a mirror the glory of
the Lord, are being transformed into the same image from glory to
glory, just as by the Spirit of the Lord.*
—2 Corinthians 3:18

The invisible world is constantly intertwining with what we know and
see. The artistic soul revels in the beauty of awe and loves space to con-
sider the wonder of the otherworldly. *Creative Fusion* bids every person
connected to God and longing for connection with Him to discover the
artist within…and let them out! An anointed vault of wisdom, inspi-
ration, and impartation brimming with treasure, this book invites us
to respond to the hour of God upon us, to receive skills we have not
previously possessed or recognized, and to explore new frontiers, mean-
while awakening, multiplying, and energizing existing skills with divine
power and new levels of Spirit-equipping as we to move beyond theory
into reality.

This book has been sculpted through years of preparation, stripped
bare in raw submission to the Word and to rigor of spiritual service
and discipline, cleansed in fasted seeking and response to Christ's call
to honor Him with such talents as He has gifted the author. Charity

Bowman Webb understands that it is fitting to present those gifts to Him where they belong—at the heart of the church as well as bursting out center stage on the open square of the marketplace.

The divine is manifest everywhere and in everything, yet we have largely been trained to overlook Him or to shut our eyes and ears and call for the familiar, the rote, the mundane. It's so much safer—but it isn't any fun. The human spirit, created in His likeness, longs for its home in loving liaison with Him whose destination it is. There is a purpose in taking this journey—a profoundly personal and intimate one where ancient wisdom speaks to modern confusion and longing.

Bidding us to sit at Christ's feet, Charity invites us to discover the dynamics of our divine home, embrace heart transformation, and rise to follow the Holy Spirit in adventures of heaven on earth as co-creators with God. *Creative Fusion* beckons us beyond our "outer courts" expression into spiritual formation and holy encounter with God, into a beauty not just of aesthetics but of presence, glory, and person. This book draws us toward beauty unrestrained and points to true north at the beginning, following the contours of Charity's observations, devotion, and revelation concerning our time.

Through her expertise and experience, inquiry, study, and training in her craft, she directs us forward to where the future church looks different—where, in her words, "He awaits us in the Holy of Holies, its entrance framed with the fabric shards of a torn veil hanging scarlet with sacrifice. It is here we will find a face-to-face friendship that will reveal the mysteries of our future" …and, perhaps for the first time, see our own faces.

—*Bonnie Chavda*
All Nations Church
The Watch of the Lord
Charlotte/Ft. Mill, the Carolinas, USA

INTRODUCTION: ECHOES OF EDEN

When I consider Your heavens, the work of Your fingers, the moon and the stars, which You have ordained, what is man that You are mindful of him, and the son of man that You visit him?
—Psalm 8:3–4

Far out over the depths of an ocean, hovering above the waters, I watched the hand of God curling waves with a fingertip. Vast volumes of water rose through the air in effortless play—waves that had never been created before. Not yesterday's waves, not waves from a prede-signed template that would pattern a million waves. This was a unique swirl of liquid, made new for today by the Creator's hand. Wave upon wave raised from the depths of heavy sea with the movement of a finger as if as light as breath, in the joy of divine creativity unfolding before me. Then my arm was inside of His, caught up in its movements, feeling the exhilaration of designing with walls of water ascending in circular beauty, each like composing the strokes of a painting.

Then I understood: He has not finished His creation. Some people see the heavens and the earth as works of art; others, as scientific mas-terpieces; and still others as habitats. Whatever our viewpoint, many of us have come to believe that God is finished, and we are simply to

live within the reproductive structure: each tree will seed another tree; two humans together produce another. As His children, we may have lost sight of what it means to be "made in God's image." (See Genesis 1:26–27.) Or perhaps we never grasped the meaning of this concept in the first place, still struggling to understand the fullness of who God is.

This oceanic vision swept me into the euphoria of a God playing with water, not disconnected from His waves and stars as if they were mere parts of a formula that would play out with no additional input from their Creator. The whole of creation is God's initial introduction to us. Creation is not simply a textbook for us to learn from but a connection between heaven and earth, a meeting place that reveals to us a profusion of details about His character. And He is still actively involved in His creation. Scientists discover new galaxies and stars, only to conclude that these celestial bodies have probably been there all along. Yet no one can know that with certainty. Even if the ancient age of a heavenly entity is said to be established and true, a thousand years to us are as one day to God. (See Psalm 90:4.) I believe God is still making stars and other celestial masterpieces like those discovered by the Hubble telescope.

> CREATION IS A CONNECTION BETWEEN HEAVEN AND EARTH, A MEETING PLACE THAT REVEALS TO US A PROFUSION OF DETAILS ABOUT GOD'S CHARACTER.

As I curled fresh ocean waves with the Father, I became aware of a great sense of wonder, and I could feel His delight, not only in the production of something unique but also in the joy of sharing this creative process with me. I knew that His invitation has always been for us to come and create together with Him, but this encounter brought me to a far deeper understanding of the process of co-creation. God loves to work with His children to generate business plans, design websites, or prepare for and host major events, especially when such enterprises serve to impact people and nations in a way that advances His

redemptive kingdom plans on the earth. This encounter gave me a sense of endless possibilities.

I wrote this book as an exploration of creativity. One of the most vital gifts God has given His church, creativity holds a priceless value that is often distorted or discounted, so that it is left to gather dust in the corners of our lives. It's time to free this driving force from the constraints of misunderstanding and allow it to flourish to its full potential. Creativity was originally intended to be a hallmark of all believers, regardless of calling and commission. Through the Scriptures—from Genesis to Revelation, from inception to completion—runs a powerful, divine pattern represented by the tabernacle that reveals seven layers, built in succession, of the creative power God intended for His church to employ. *Creative Fusion* travels this path, seeking answers for modern times and unearthing the spiritual weaponry and creative innovation we believers require in order to fulfill the Great Commission and gather a bountiful harvest of souls.

In this technological age, the rate of change is prolific, winding the world in a tightly coiled tension that craves breakthrough answers. God planned for His people to carry the most creatively ingenious and most powerfully innovative solutions to every area of society, modeling the multifaceted character of the Creator who crafted them and bringing answers that will turn the heads of millions to see and accept the Savior they have been seeking. There was once a time when the church displayed its creativity in a powerful way, shaping society with uniquely thrilling innovations. In this book, we will plumb the annals of history to identify the timing and causes of our disconnection from the source of this powerful creativity and the ensuing fallout; while also reaching forward into future, envisioning the potential of a church that picks up the creative weapons stocked in our divine armories. Full of biblical answers and practical activation steps, this book seeks to equip believers to explore and find a greater fulfillment of their original design and calling.

In my first book, *Limitless*, I shared some of my journey, which involved a passion and education in art and multiple areas of design. I

came to salvation in my late twenties and spent the ensuing years working in design, cultivating a love of the local church, and developing a passion for the prophetic—three pursuits that remained separate for many years. Then God woke me up and switched on the blender, combining these ingredients for a powerful result. *Creative Fusion* picks up where the journey outlined in *Limitless* left off, with the main ingredients of my faith no longer separate but cohesive, yielding broader diversity and greater possibilities in my life.

Prior to my wake-up call, I had inadvertently come to accept the normality of the disconnectedness of my artistic creativity, my love for the church, and my passion for the prophetic. It seemed that the arts were reserved for the world outside the church, and I found myself wondering why God would wire some of us to be so passionate about artistry and innovation when such concerns were viewed as having little use in the advancement of His kingdom.

Without answers and faced with widescale acceptance of an entrenched pattern, we sometimes side with the "trench" until someone extends us a hand and pulls us out. One day, God extended His hand to me, and just as if I had come from the cramped confinement of a mud-walled trench into the panorama of the landscape above, my spiritual eyes exploded with new understanding. I doubt it is ever possible to reach the end of the revelation of His creativity, because it is part of His essence. Our Creator embodies creativity. Yet the journey is the game changer, and so we must pursue it. In the new landscape, I saw that creativity is far from being confined to artistry alone, and its relevance to the church is without limit. Today, take my hand, climb out of the trench of stagnant tradition, and let's begin our exploration of the power of creativity as God designed it.

PART I

THE CRADLE OF CREATIVITY

1

OUR GENESIS DESIGN

Creativity is the evidence of the life inside you.
—Emily P. Freeman, bestselling author and podcast host[1]

The creation is a meeting place between humanity and God. Another such meeting place is God's Word. In the first chapter of Genesis, God introduces Himself to us, selecting one name from the 365 names in the Bible that depict parts of His character.

Genesis 1:1 says, *"In the beginning God created the heavens and the earth."* What part of His divine character did God choose to reveal first? You might guess that He revealed His love or His healing power, but it was actually His creativity that He first proclaimed. Yes, the opening line of the Bible unveils God as a creative Creator. Later on in the same chapter, we read:

> *Then God said, "Let Us make man in Our image, according to Our likeness…." So God created man in His own image; in the image of God He created him; male and female He created them.*
>
> (Genesis 1:26–27)

1. Freeman, Emily. "A Creative Liturgy of Everyday Life." Podcast. Makers and Mystics, January 25, 2018. http://www.makersandmystics.com/makersandmystics/2018/1/25/s3-e8-a-creative-liturgy-for-the-everyday-with-emily-freeman.

Up to this point in Genesis 1, God reveals little else about Himself besides His capacity for powerful, world-changing creativity—and his decision to make us *just like Him*. The act of creativity is not narrowed to that of a professional artist's expression. On the contrary, *all* people would be made in His image—and, therefore, *all* people would be called to create, just as He did. Yet countless Christians seem to embrace the rest of the Bible and its wisdom on what is needed for a life well lived in Christ, meanwhile missing or dismissing the importance of Genesis 1, as if creativity is an optional endeavor, an extra bonus reserved for "artistic individuals." How could this misunderstanding have happened, when it is clear that the first revelation given about our nature as humans is our creativity?

The enemy has a plan. Well aware of God's intentions for co-creation with humankind and the battle-winning potential of such collaboration, he will stop at nothing to make sure we remain unaware of the creative possibilities we are capable of. We live in a world jam-packed with creativity and the arts; it seeps into most areas of daily life through the media, music, design, television, sports, and many other arenas, with the regularly using it to megaphone his message and influence millions of minds. When it dawned on me that, according to Genesis 1, every one of God's children is meant to be creative, I began to recognize just how distorted our definition of "creativity" has become.

ACCORDING TO GENESIS 1, EVERY ONE OF GOD'S CHILDREN IS MEANT TO BE CREATIVE.

RIGHTING WRONG PERSPECTIVES ON CREATIVITY

I have asked many Christians what comes to mind when I say the word "creativity." The most common response was that creativity involved being "artistic." Right there is the clincher, the place where

people count themselves out of the potential powerhouse of creativity that is their birthright. The majority of Christian artists are not exempt from believing creativity to be a unique and rare trait reserved for a few. This stance is one that our adversary wants us to adopt, so that we remain ignorant, having limited potential. He has tried to disguise the door to the arsenal of our creative weaponry as something irrelevant or pretty, at best.

The dictionary definitions for *creativity* and *creative* are especially illuminating:

> *Creativity*: "the ability to transcend traditional ideas, rules, patterns, relationships, or the like, and to create meaningful new ideas, forms, methods, interpretations, etc.; originality, progressiveness, or imagination."

> *Create*: "to cause to come into being, as something unique that would not naturally evolve or that is not made by ordinary processes."

Words associated with *creativity* include "original," "ingenious," "innovative," "inventive," "productive," "clever," "inspired," and "leading-edge."[2] Antonyms expressing the opposite include "fruitless," "inept," "unproductive," and "uninspired."

If, like many Christians, we don't consider ourselves to be creative, then do we classify ourselves according to those antithetical terms? Who of us wants to be unimaginative or untalented?! Just the same, many believers feel lacking and inadequate when facing the breadth of problems before them, both in their immediate circle and in the wider world.

Let's believe for a moment we are all "made in God's likeness" and creative, by definition. Now we Christians become gifted, innovative, leading-edge, and visionary! In our current culture, would you say that these terms correspond with the way the world sees the church right now? When a need arises that demands a groundbreaking solution, are

2. "Creative," Dictionary.com, accessed August 5, 2021, https://www.dictionary.com/browse/creative.

people pounding on the church doors for answers because they know God's people are mighty problem solvers equipped with otherworldly wisdom?

Perhaps you would agree that a little change in perspective is yet needed. Step one in this change is to find the door to the dynamo, ignore the sign marked *Irrelevant* that the enemy has set in place, and open it up. What's in there? It does belong to you, after all. It's the first truth God wanted you to understand about your nature as a co-creator with Him.

CALLED TO CREATE

All God's people possess divine creativity in their spiritual DNA. When we connect our built-in potential for creativity to the source of divinity, we remove the limits from our ability to fulfill that which He calls us to accomplish. This creativity is not intended just for "the arts"; it is for every call, profession, community, and believer. This is a decisive key in connecting the activity of heaven to the earthly realm.

There are new ideas, strategies, solutions, and innovations yet to come that will bring leaps in science and medicine, life-giving policies in government, and artistic creations of all kinds that will release the imprint of heaven with their beauty and message. The list of possibilities is endless; it reaches into where you are and where God has asked you to stand. If we begin the shift now, I believe future generations of Christians will access the "dynamo door" early, when life is brimming with opportunities and possibilities in vocation and in life. The result will be profoundly changed individuals and a transformed church.

ALL GOD'S PEOPLE CARRY HIS CREATIVE DNA.

MODELING OUR CREATOR

O Lord *my God, You are very great: You are clothed with honor and majesty, who cover Yourself with light as with a garment, who stretch out the heavens like a curtain. He lays the beams of His upper chambers in the waters, who makes the clouds His chariot, who walks on the wings of the wind, who makes His angels spirits, His ministers a flame of fire. You who laid the foundations of the earth, so that it should not be moved forever, You covered it with the deep as with a garment; the waters stood above the mountains. At Your rebuke they fled; at the voice of Your thunder they hastened away. They went up over the mountains; they went down into the valleys, to the place which You founded for them.* (Psalm 104:1–8)

God's act of creating is the first thing He illustrates to us in the Bible, building a foundation for all His subsequent actions. He formed the world—the whole of creation—and then He shaped us, His children. As we have said, it is significant that God would disclose, before any other details, that creativity is part of the nucleus of His very nature, and that we share the same desire and ability to bring into being things that did not exist before.

Creation is an astonishing system that not only nurtures life in millions of complex ways but also displays spectacular beauty, from the jewellike colors of a dragonfly's fragile wings to the bewildering expanse of light and form in a single landscape. The complexities of the world around us continually lead scientists to discover a never-ending stream of marvels. Yet we live in an age where many scientists are battling to undo the damage people have wrought on this planet. Perhaps, had we consulted the Maker of our planet more diligently on how to live, our world would not be such a mess. The good news is that there is still time for change. When heaven connects with earth, anything can be transformed and healed. It's time to ask the Maker for solutions.

Through creation, by means of general revelation, God has consistently endeavored to communicate to us His nature and to help us understand just what we possess as His heirs. But understanding and revelation come only through relationship. (See, for example, John

15:15.) As the most supremely creative being, God often speaks to us in innovative ways; His messages are not limited to sequences of words. For us as humans, to learn from Him is to grow; to close ourselves off from His communications is to wither in a life of limitation. We are the branches of the all-powerful Vine—live limbs that are meant to keep growing and bear creative fruit. (See John 15:1–17; 2 Timothy 2:15.)

THE COMMUNICATION OF CO-CREATION

Co-creation with God enables us to become personally involved in the process of stretching spiritual capacity as the Holy Spirit multiplies our skill and magnifies our understanding. Our willingness to learn from God can open a kaleidoscope of communication. The more we open ourselves to the limitless methods by which God converses with His children, the more we will come to realize that God is rarely silent! Why live as if fumbling around in the dark, searching for a door, when you can turn on the light switch because you know where it is?

> He who forms the mountains, who creates the wind, and who reveals his thoughts to mankind…the LORD God Almighty is his name.
>
> (Amos 4:13 NIV)

A panorama of communication lies before us. God's voice, in whatever way it speaks to us, brings comfort, healing, and direction in the continual flow of communication that transforms us *"from glory to glory"* (2 Corinthians 3:18). The Father may speak to us through any number of ways: His astonishing creation, our fellow humans, the arts, works of literature, mathematical theorems, astronomical discoveries, or our very circumstances. He may use visions and dreams like mini-movies, with layers of meaning, giving us guidance for the present and the future, for personal or corporate application. He may send us snapshot pictures capable of expressing a thousand words. This marvelous diversity of communication methods can draw us into areas of the divine that we would otherwise struggle to reach for tripping over human logic.

God also speaks to us through the Bible, but we need the Holy Spirit to illuminate our understanding of His Word, or we will be subject to

the passion killer of human-fueled religion. Treasures await us, buried in the symbols and mystery of God's divine language, if we will only develop the spiritual maturity required to handle this costly cache.

GOD'S CHOSEN FORM OF COMMUNICATION IS OFTEN METAPHORICAL; THE QUEST IS FOR US TO LEARN HIS LANGUAGE.

He often speaks through metaphors and other literary devices— not designed to confuse us but to be cleverly devised invitations to enter into a relationship by which we uncover a wealth of wisdom. Our quest is to learn His language. When we desire a relationship with this God of creative communication, our prayers come alive, and become conversations far removed from the dry, distant repetitions of meaningless words. We begin a deepening journey of incomprehensible friendship with the Creator of the universe.

THE NATURE AND AIM OF CO-CREATION

We were never meant to create alone. All the education in the world could never be enough to equip anyone to form anything of eternal value. Many people have strived with excessive effort to produce something of unique worth. Yet when such endeavors are pursued by people disconnected from God, their efforts can be their undoing. A revival of even the most beautiful of materialism cannot transform darkness into light. But when we learn to co-create in collaboration with the Creator, the journey becomes excitingly personal. Being "[seated] *together in the heavenly places in Christ Jesus*" (Ephesians 2:6), we were designed to create from heaven to earth, not the other way around. When we create from an earthly foundation, the product's value is merely temporal. Yet when we create from the basis of our divine identity, with heaven as our starting point, something completely different happens. Whether we have advanced gifting or simply the courage of a novice, God can use us

to create magnificent products of eternal value because He looks at the heart, not at natural aptitudes or talent. (See, for example, 1 Samuel 16:7.) The nature of our character and our cultivation of the fruit of the Spirit (see Galatians 5:22–23) are the stabilizing forces of excellence.

As God seeks to reclaim territory on earth, He calls us to use our spiritual gifts and ministries—not only in the church environment but in the world at large, a spiritually polluted landscape in desperate need of healing and redemption. When we yield to His guidance and respond to His Spirit, He will position us strategically, according to our individualized mix of traits. Any job in any arena can be a sacred work of creativity when yielded to the Lord. If we mistakenly believe that we can fulfill a sacred duty only by training to be a pastor or traveling to foreign lands as a missionary, then we may miss our calling if God intends us to advance His kingdom in a different way. That is one reason why it is crucial to keep a keen ear to His communications, whatever form they may take.

The combinations of a person's callings, gifts, and skills can result in many unexpected outcomes that God uses for His glory. As we correct the misperception of what constitutes secular versus sacred pursuits, we will rediscover our God-given gifting and unleash our potential. A little further still, and we will recognize and access the powerful weapons already present in our arsenal against the enemy.

Creativity can make us uncomfortable when it brings up questions and issues we would rather not think about. Creativity requires taking risks and is rarely satisfied with the status quo, ever probing new possibilities and unprecedented outcomes. It is seldom an explosion of instantaneous genius. More often than not, it is the result of methodical process and unflagging effort. It's time to ask God for a more extensive perspective. What has He given you in terms of gifts, skills, and experiences? How might God want you to combine these personalized elements in a powerful, productive pursuit of something you may never have thought possible? If all your options are open, how might He wish to partner with you in a life well lived in His kingdom?

2

MASTER CRAFTSMAN

Wisdom is the power to put our time and
our knowledge to the proper use.
—Thomas J. Watson, American businessman[3]

Who are considered to be the pillars of wisdom in today's society? Are they artistic individuals—those stereotypically considered creative—such as painters, dancers, and designers? Or are they the men and women whose professions require years of intensive study and practice, such as doctors, biophysicists, chemists, nuclear engineers, lawyers, judges, university professors, and the like? Many people conflate wisdom with intellectualism—and probably would not seek sage counsel from a recording artist or a sculptor.

Society has largely separated the traits of creativity and wisdom, reserving the latter to careers driven by logic and reason rather than by artistic expression and creative production. But here is the bombshell: that's not at all what the Bible says about wisdom!

3. Watson, Thomas J. "Wisdom is the power to put our time and our knowledge to proper use," accessed August 5, 2021, https://www.brainyquote.com/quotes/thomas_j_watson_147145.

WISDOM AND CREATIVITY INTERTWINED

Both wisdom and creativity have been present at every critical historical intersection between God and His children. In the beginning, God took a formless void; then, like the maestro of a paradisaical orchestra, He landscaped it with genius and wisdom: *"The LORD by wisdom founded the earth; by understanding He established the heavens; by His knowledge the depths were broken up, and clouds drop down the dew"* (Proverbs 3:19–20).

The stage was is set for a convergence of the mortal and the immortal—a place to talk, learn, and love; humanity discovering the creation magnum opus and getting to know its Maker. Then came the invitation to be a part of the creative process when Adam was tasked with naming the animals. (See Genesis 2:19–20.) Can you imagine the adventure of being introduced to thousands of creatures—each one different, with weird and wonderful details, mannerisms, and sounds—and getting to dream up the names that would form part of their identities?

Let's pick up the story of creation in Genesis 1 from a different perspective, looking again at the book of Proverbs. In chapter 8, we see that wisdom was right there with God, fashioning creation. Personified wisdom speaks, saying:

The LORD possessed me at the beginning of His way, before His works of old. I have been established from everlasting, from the beginning, before there was ever an earth. When there were no depths I was brought forth, when there were no fountains abounding with water. Before the mountains were settled, before the hills, I was brought forth; while as yet He had not made the earth or the fields, or the primal dust of the world. When He prepared the heavens, I was there, when He drew a circle on the face of the deep, when He established the clouds above, when He strengthened the fountains of the deep, when He assigned to the sea its limit, so that the waters would not transgress His command, when He marked out the foundations of the earth, then I was beside Him as a master craftsman; and I was daily His delight, rejoicing always before Him, rejoicing

in His inhabited world, and my delight was with the sons of men.
(Proverbs 8:22–31)

WISDOM AS MASTER CRAFTSMAN

Today, the word "craftsman" may evoke thoughts of handicrafts or woodworking. Most people probably would not picture the Creator of the universe as a craftsman, according to our picture of the profession today. Let's journey back in time, before the days of mass production and power tools. To be a craftsman in the days of old was to hold a noble profession, to be someone highly skilled in such abilities as designing, drawing up plans, leading team projects, and taking on commissions.[4] In Proverbs 8, the wisdom of Jehovah is described as fulfilling this role in the creation narrative. Scripture indicates that wisdom is not strictly related to intelligence and logic but extends to the hands-on functions of crafting and forming.

Wisdom was right there at the earth's inception, not just as a character dispensing good advice and sound information but as the artist of lush landscapes, dehydrated deserts, majestic mountains, and foam-tipped waves. The earth we inhabit is an astounding masterpiece crammed with the character of its Maker and brimming with evidence of His creativity and wisdom, not only supporting complex life but also preserving sophisticated beauty. God's wisdom tangibly releases the creativity of the Spirit, bringing together a fusion of factors that continue to form our world. Some of the most innovative discoveries throughout history have brought unexpected elements together to produce results of great benefit to humankind.

WISDOM UNLOCKS THE LANGUAGE OF GOD

Wisdom is highly prized throughout the Scriptures. Especially in the book of Proverbs, this quality is praised for its incomparable value. Just consider the following examples:

4. Elwell, W. A., and Beitzel, B. J., *Baker Encyclopedia of the Bible, Vol. 2*, "Trades and Occupations" (Grand Rapids, MI: Baker Book House, 1988), 2085.

[Wisdom says,] *"Receive my instruction, and not silver, and knowledge rather than choice gold; for wisdom is better than rubies, and all the things one may desire cannot be compared with her....Counsel is mine, and sound wisdom; I am understanding, I have strength. By me kings reign, and rulers decree justice. By me princes rule, and nobles, all the judges of the earth. I love those who love me, and those who seek me diligently will find me. Riches and honor are with me, enduring riches and righteousness. My fruit is better than gold, yes, than fine gold, and my revenue than choice silver. I traverse the way of righteousness, in the midst of the paths of justice, that I may cause those who love me to inherit wealth, that I may fill their treasuries."*

<div align="right">(Proverbs 8:10–11, 14–21)</div>

Get wisdom. Though it cost all you have, get understanding.

<div align="right">(Proverbs 4:7 NIV)</div>

Wisdom helps us decipher God's language as we encounter messages and mysteries in conversation with His Spirit. It's a cyclical action of coming nearer and finding increased enlightenment, which, in turn, draws us closer still. Threads of divine wisdom must be woven through our efforts and abilities to impact our world if our endeavors to advance the kingdom are to succeed.

> **WISDOM HELPS US DECIPHER GOD'S LANGUAGE AS WE ENCOUNTER MESSAGES AND MYSTERIES IN CONVERSATION WITH HIS SPIRIT.**

In world culture, we can see where creativity has been divided from holy input in artistic expressions, business ventures, and other endeavors subject to the limitations of earthly thought. Solutions and ideas that spring strictly from the human soul, without any divine input, rarely bring lasting answers and are often tainted by confusion and disappointment. Detached from God and His discernment, they lie

wide-open to the nefarious influences of the enemy, who prowls around preying on the proud, ambitious, and humanistic. Where a fresh idea has broken ground and inspired many, it is frequently repeated in mundane permutations for many years to come. We see this cycle in all areas of culture where the spark of genius is believed to lie with a select few.

OLD TESTAMENT PROTOTYPES OF GOD'S CO-CREATIVE PLAN

In the book of Genesis, accounts of humans being granted heavenly wisdom are few and far between. However, in Exodus, they abound in the story of the tabernacle's construction. Following many years of a veritable famine of sending supernatural wisdom, God poured out His mind upon a team of people—a fleet of artistic, creative men and women who were commissioned to form an imprint of heaven on the earth in the form of a tabernacle, or a dwelling place for God. (See Exodus 31, 35.)

The first tabernacle the Israelites constructed in the wilderness is one of the earliest instances of God and humankind combining efforts to generate something physical on earth. Within what I call the tabernacle pattern, we find a multitude of prototypes—characters who modeled some aspect of God's intention for us as co-creators with Him. Jesus was, of course, the ultimate standard for every part of our lives; but, before we reach that stage of the pattern, we must explore the preceding archetypes who lit the path leading toward His era on the earth, providing a range of examples for us to follow. These individuals were fully human, yet they demonstrated the divine outcomes that are possible through union with the Lord.

BEZALEL, A BLEND OF UNIQUE TALENTS AND DIVINE ENDUEMENT

In the tabernacle whose construction Moses oversaw, we find one such prototype. After enacting a dramatic display of God's power, Moses led the children of Israel out of slavery in Egypt into the desolation of the Sinai wilderness. Longing to draw close to His people, the Lord commissioned the construction of a tabernacle—the place where His presence would remain among His children at the heart of their

community. Moses received very specific details for the building process, including minute directions and dimensions.

The task probably seemed insurmountable in that moment—after all, Moses had enough trouble on his hands trying to lead millions of recently emancipated slaves across the desert. But God had a plan! He reassured Moses that He not only had a team in mind for the project but also a leader handpicked to tackle the task.

> *Then the* LORD *spoke to Moses, saying, "See, I have called by name Bezalel the son of Uri, the son of Hur, of the tribe of Judah. And I have filled him with the Spirit of God, in wisdom, in understanding, in knowledge, and in all manner of workmanship, to design artistic works, to work in gold, in silver, in bronze, in cutting jewels for setting, in carving wood, and to work in all manner of workmanship. And I, indeed I, have appointed with him Aholiab the son of Ahisamach, of the tribe of Dan; and I have put wisdom in the hearts of all the gifted artisans, that they may make all that I have commanded you: the tabernacle of meeting, the ark of the Testimony and the mercy seat that is on it, and all the furniture of the tabernacle…."*
>
> (Exodus 31:1–7)

Were Bezalel alive today, we would give him a lot of credit for having the skills to tackle such a complex undertaking. But Bezalel was also equipped with some additional qualities seemingly unrelated to construction that, together with his building expertise, form an important historical prototype. Popular teachings point to Bezalel as a model for Christian artists, but I think his worthiness of emulation runs a lot deeper than that. I believe he serves as a prototype for all God's people. Why? I will give you three reasons.

BEZALEL WAS FILLED WITH THE HOLY SPIRIT

In the days of Moses, the continual indwelling of the Holy Spirit was not yet available to human beings because Jesus had not yet sent Him. However, in Old Testament times, the Spirit of God would occasionally come upon a person to fulfill a specific purpose. For example, He came upon Othniel, that he might judge the people and lead them to

war. (See Judges 3:10.) He also filled Samson with the strength to slay a thousand Philistines with the jawbone of a donkey.

It says here that Bezalel was *"filled…with the Spirit of God"* (Exodus 31:3). Bezalel was brimming with the Spirit of God, who empowered him to fulfill his commission. God could have chosen anyone to exhibit this phenomenon of Holy-Spirit indwelling—He could have picked Moses or Aaron the high priest. And He chose an artisan! Based on the scriptural record, it seems that an exceptional indwelling was not repeated until the Messiah. Later on came the day of Pentecost, the event that made it possible for every believer to be a tabernacle of God's Spirit.

BEZALEL COMBINED PRACTICAL SKILLS WITH DIVINE INSPIRATION

As the team leader of the tabernacle project, Bezalel would have been identified as a professional master craftsman. In spite of his expertise, it says that he was given the spirit of *"wisdom, in understanding, in knowledge"* (Exodus 31:3). Thus, we see that general intelligence and trained artistry alone were not sufficient for what he was trying to achieve. To pull off this project, Bezalel needed celestial input—to pair his natural skills with the Spirit's wisdom in a collaborative process of co-creating. This combination of wisdom and artistry is not often employed today, even in the church.

BEZALEL UPHELD A STANDARD OF EXCELLENCE

The record indicates that Bezalel had skills for a considerable range of workmanship, including metal, wood, precious stones, and a host of other techniques. Such a range of abilities would have been rare in a single person at that level of distinction. In ancient times, artisans or craftsmen executed much of their trade in temples and ancient palaces by hand, painstakingly forming unique works of art and detailed designs. For Bezalel to be the master craftsman of the team was no small accolade. His skill set reached beyond maker and designer into project manager and head architect, displaying a broad diversification of ability that should inspire us to aim high and work hard to fine-tune our talents.

TO BE LIKE BEZALEL

Bezalel, as a prototype for creativity among all God's people, was filled with the Spirit as we are today. We all have the Creator's DNA. What happened when he was supercharged with the Spirit? He got extremely creative! He was handed a host of specifications designed by God, and in order to carry them through to completion, he required the supernatural help of the seven spirits of God. He brought his earthly education and natural skills as an offering to God, who proceeded to breathe His life force upon them in a fusion of spiritual wisdom. The results catapulted Bezalel beyond natural range into the arena of supernatural ability and outcome. Working on an earthly expression of a celestial pattern, Bezalel became part of the tabernacle pattern itself. He modeled for us what it looks like to be filled with the Spirit, displaying innovation, artistry, and skill mixed with holy power in the masterful coalition of co-creation.

ORIGINS OF HOLY WISDOM AT WORK IN HUMANITY

It's intriguing to see where the concept of individuals being granted holy wisdom first appears in the Bible in relation to creativity because it helps us understand the value God has placed on this divinely ordained alliance. At the outset of creation, the garden of Eden was formed, and humanity entered the scene, dwelling harmoniously with God in a setting of visual perfection and daily discovery. But it was not long before the first man and woman rocked the boat.

A TALE OF TWO TREES

Eden was filled with a profusion of trees not only pleasing to the eye but providing sustenance. (See Genesis 2:9.) Adam and Eve had been informed about two essential trees—the Tree of Life and the Tree of Knowledge of Good and Evil—being forewarned about the dangerous outcome of eating the latter. (See Genesis 2:16–17.) But the devil, in the form of a serpent, soon urged Eve to eat the forbidden fruit, deceitfully promising her, *"Your eyes will be opened, and you will be like God, knowing good and evil"* (Genesis 3:4). The first couple partook, believing they

would thereby gain access to a divine database. This mutinous act constituted the first instance of humankind seeking to gain higher wisdom through an alternative route than the one prescribed by their Maker. The bond of trust was broken, driving a cavernous disconnect into the process of co-creation.

One day in prayer, I had an experience. I was with the Father in a heavenly library. Reaching into a shelf of books dusted with gold, He pulled down a thick volume and stooped to show me something from its open pages. He revealed that throughout history, mankind has reached into the eternal realm and grasped a measure of divine wisdom, sometimes realizing its source as God, at other times alighting upon it by the grace that sees a heart hungry to help humanity. Then comes the tipping point of choice. Humans can either proceed in connection with the eternal kingdom, unearthing more wisdom with the correct application; or, they can pull their discovery back into the earthly sphere of human understanding, and dine on fruit from the Tree of Knowledge of Good and Evil. In the first option, God cannot be left out of the equation. Enlightenment grows through friendship with the Father. Conversely, when we grab a glimpse of divine revelation and try to play it out in the sphere of humanism, we will eventually meet limitation and frustration.

There has to be a restriction when mortals try to pull the mystical wisdom they have encountered into the sphere of human understanding, or we will try building the Tower of Babel all over again. However, I also saw that there will be an increase of people positioned in multiple spheres of culture who have finally learned to live with hands open to God—people who will connect with the Master Craftsman and maintain that connection. Dependency on God will cause continued exploration, which, in turn, will produce extraordinary advances for good upon the earth. Translating anything from the kingdom of heaven to the realm of earth will always require some grapple, skill, and research. These efforts become part of a healthy process of maturing and building strength within ourselves. At the highest levels of genius, such people are and will be few and far between—people who are not easily swayed by the popular agenda and peer pressure, people who stay connected to

the Tree of Life, recognizing that its originator has the ultimate secret to sensational discoveries.

A RAGS-TO-RICHES RISE

Another example from Genesis of a person being endowed with supernatural wisdom from God is found in the story of Joseph. He started out as a Hebrew slave in the employ of Pharaoh, king of Egypt, a place where the worship of multiple gods was commonplace and Pharaoh's cabinet of counselors recognized as the supreme wise men of their age. These men would have been among the best educated and most highly esteemed in the land to obtain such positions, and Pharaoh sought their advice in all matters, including that of the meaning of his mysterious dreams. (See Genesis 41:8.) When Joseph correctly interpreted the dreams and developed a strategy to preserve Egypt's superpower status during the impending drought and famine, Pharaoh realized that Joseph was tapping a higher source.

> Pharaoh said to his servants, "Can we find a man like this, in whom is the Spirit of God?" Then Pharaoh said to Joseph, "Inasmuch as God has shown you all this, there is none so discerning and wise as you."
> (Genesis 41:38–39)

Pharaoh went on to appoint Joseph to the most distinguished position of governance in the land, second only to himself, granting instant promotion from the lowest rank of servants to a place of unsurpassed cultural impact in a single move.

The story of Joseph illuminates the contrasting results of consulting the two Edenic trees we discussed. Seeking a solution for Pharaoh, the wise men drew on their education, understanding, and even nefarious spiritual sources. Still, they could neither interpret the dreams nor provide a strategy to survive the disasters they foretold. Joseph, on the other hand, had learned firsthand that there is no higher source than God's creative wisdom, and he was granted the answer. He made sure to give credit where it was due, too, telling Pharaoh, "It [the ability to interpret

a dream] *is not in me; God will give Pharaoh an answer of peace"* (Genesis 41:16).

Favor followed Joseph from that point forward, granting him a key role in Egypt's strategy to combat coming famine and win extraordinary cultural influence. Joseph is another Old Testament prototype, revealing what can become available to us when we pursue divine flow. He resided in a position of rulership and authority for the remainder of his life.

THE TABERNACLE PATTERN

From the time of Eden, we see God's desire to co-create with His people. The Exodus record spells this out in technicolor. It is paramount that we recognize these were the first two stages of the tabernacle pattern, which is packed with information and instruction to help us thrive as the tabernacle of today.

The Bible bursts with evidence of creativity's significance. Within its pages lies a pattern to teach us the dynamics of our divine home, for we are in this world but not of it. (See John 17:14–16.) It is a divine model of a pattern in heaven—given in symbolic, earthly form—to help us understand more of the kingdom of God. Spanning from the beginning of creation into eternity, it is crucial for today's world, as well as to the journey every believer must take, traveling through a heart transformation that leads us into adventures of heaven on earth.

The pattern runs through seven stages:

Stage One: Eden;

Stage Two: The Tabernacle of Moses;

Stage Three: The Tabernacle of David;

Stage Four: Solomon's Temple;

Stage Five: The Messiah;

Stage Six: Humanity; and

Stage Seven: The Restoration of All Things.

This ancient tabernacle pattern unpacks the route to co-creating with God, bursting with an armory of elements at our disposal. And it is still alive and kicking; it simply needs unearthing.

THE SIGNIFICANCE OF THE PATTERN STAGES

Why is an understanding of the tabernacle pattern so critical for current times and those that lie ahead? How do such elements of the ancient tabernacle as a dusty tent, some goats, and a candlestick relate to life in this modern age? Each stage of the tabernacle pattern serves to connect God and humanity in a way that deepens relationship. At later stages, the tabernacle would be called the *temple*. Both terms signify habituation, a sanctuary, or a house of prayer. We are living in stage six of the tabernacle pattern, and we can and should access this cache of creative power stored up and waiting for us to dip into. We each have a commission for the time in history that we inhabit.

> **EACH OF US HAS A COMMISSION FOR THE TIME IN HISTORY THAT WE INHABIT.**

If we don't understand the pattern or its relationship to modern times, we are bound to live out only part of our design. But when the pattern is illuminated for us, its breadth of possibilities makes perfect sense, answering countless questions and pointing us down the narrow path of godly character development leading into an expanse of opportunities. (See, for example, Matthew 7:14; Psalm 18:19.)

The pattern brings together Word and Spirit, wisdom and wonder. It unfolds God's eternal personality so that we can engage with Him on a more profound level. The winding path of history and opposition has led many people to perceive only a slim slice of God's full nature. Although He is the Maker of all things, we often reduce Him to a particular range of expressions. When we limit God, as His people, we also bind ourselves in potential-killing restraints.

THE INVITATION

Christ's incalculable life offering was made not only that we might gain eternal salvation but also that we might enjoy a dynamic friendship with the Trinity in a life of increasing holiness. Every part of the tabernacle pattern represents a distinct stage of that process, intended to lead us from initial contact to mind-blowing coexistence with the Alpha and Omega. Holiness and divine intimacy are potent weapons against the enemy, yet we often resign holiness to a checklist of rules and rituals rather than a powerful presence and transformative process. Jesus opened up a journey for us to take, but we must choose how far we are willing to travel. The door stands open; He stretches out His hand with the invitation that cost Him everything.

PART II

PROBING THE TABERNACLE PATTERN

3

STAGE ONE: EDEN

In Genesis 1, the Lord explodes with creative force, originating the heavens and the earth, His extraordinary creation. On the earth, He produces Eden, and within Eden, the famous garden. He makes all kinds of vegetation, with flowers like a crowning beauty; carves out great valleys and majestic mountains; and fills Earth with voluminous seas and life-giving waters. He sets the planets and stars in the sky; He establishes weather patterns that nurture the land and atmosphere. Then He creates human life.

WHAT WENT DOWN IN THE GARDEN

In his teaching "Recapturing Your Spiritual Authority," John Paul Jackson looks at the events of Eden.[5] Human beings were given divine authority in Eden to rule and steward all that is on Earth. (See Genesis 1:26–30.) This authority was relinquished by Adam and Eve when Satan deceived them. Although he was ultimately defeated by Jesus's sacrifice on the cross and subsequent resurrection, the enemy is still

5. Jackson, John Paul, "Recapturing Your Spiritual Authority." *Tabernacle of Moses*, Streams Ministries International, 2007.

trying to outwit God's children by convincing them that he has authority over them. Our objective is to see the kingdom of this world become the kingdom of the Lord Jesus, who will, in turn, deliver it to the Father for His glory to extend across the earth. (See 1 Corinthians 15:20–28.) When this happens, our eyes will open wide to the magnificence of the spiritual realm.

GOD'S ORIGINAL INTENT

Before the fall, God gave to humankind authority for what they were appointed to do, and He walked with them in kinship. The entirety of the earth did not look like Eden, for God had placed Adam and Eve within a piece of paradise. Their assignment was to speak to the rest of the planet so that it should come into submission to God. In this way, Eden's life and beauty would extend across the earth as a pattern of heaven. It was the foundation of the journey of co-creation between God and humanity.

MANKIND'S MESS-UP

When all was going according to plan, says John Paul Jackson, Adam and Eve had jurisdiction in the garden. They could stand at its edge and speak to the earth, and the resonance of their voices would produce a response, extending the parameters of Eden. Their rule reached across all creation, with the exception of one tree—the Tree of Knowledge of Good and Evil.

Expelled from heaven (see Isaiah 14:12–14; Ezekiel 28:12–18), Satan, in the form of a serpent, slithered into the garden and convinced the first couple that a taste from the forbidden fruit would endow them with superhuman intelligence. The moment they partook was the moment they ceded their authority to Satan. Oppression ruled the world, and instead of the luminosity of heaven's pattern advancing through the planet, creeping darkness took its hold.

JESUS'S RESCUE MISSION—AND OUR COMMISSION

Enter Jesus as Savior of the world to redeem the situation. His followers were convinced He would overthrow the darkness with an

outside force, thereby overturning the Roman Empire. Instead, He taught them of an everlasting kingdom that reached from the internal heart to change the external world—a concept diametrically opposed to Satan's tactics, and the only strategy that would secure lasting metamorphosis. His agenda was a transformational process of holiness toward the end game, where both the earth and humanity would be fully restored.

After His crucifixion and resurrection, Jesus seized the keys of hell and death from Satan. In an unprecedented act of trust, He restored mankind's authority to subdue the earth and expand the kingdom of God within it. He charged us again with this extraordinary commission. (See, for example, Matthew 28:16–20.) We are to participate in the revolutionary strategy of internal change working outward, declaring healing for the planet, people, circumstances, and cultures as we release Eden's life and beauty in the earth once again.

JESUS TEACHES OF AN EVERLASTING KINGDOM THAT REACHES FROM THE INTERNAL HEART TO CHANGE THE EXTERNAL WORLD.

Satan is still looking to deceive us with the erroneous belief that we do not have this authority. But he could not be more wrong! By the power of the cross of Christ, we can issue creative life that regenerates the earth, invading darkness with light. When Adam and Eve violated God's command, they were sent out from the garden toward the East. Cherubim with flaming swords then guarded the eastern entrance to the garden, to prevent further indulgence in temptation and sin therein. (See Genesis 3:23–24.) The tabernacle pattern given to Moses, which we will explore in the next chapter, symbolized the retracing of steps back through the cherubim, from the fallen world into a holy life lived in the presence of God.

ALLUSIONS TO AN EARLIER FALL

Before we move on to Stage Two of the tabernacle pattern, I want you to notice the connection between an earlier fall—that of Satan, also called Lucifer—from heaven with his angels—and the fall of man.

Satan started out as perhaps the most beautiful of all the angels, gifted with incredible creativity that included musical ability. (See Isaiah 14:11.) Consider this account of his fall from favor:

> *You were the seal of perfection, full of wisdom and perfect in beauty. You were in Eden, the garden of God; every precious stone was your covering: the sardius, topaz, and diamond, Beryl, onyx, and jasper, sapphire, turquoise, and emerald with gold. The workmanship of your timbrels and pipes was prepared for you on the day you were created. You were the anointed cherub who covers; I established you; you were on the holy mountain of God; you walked back and forth in the midst of fiery stones. You were perfect in your ways from the day you were created, till iniquity was found in you.... Your heart was lifted up because of your beauty; you corrupted your wisdom for the sake of your splendor; I cast you to the ground.*
>
> (Ezekiel 28:11–15, 17)

It is no coincidence that Satan is here described as formerly being *"full of wisdom and perfect in beauty"* (verse 11). We now understand that true wisdom is the Master Craftsman of God's creative power and beauty. It's clear from this passage that Satan started out with an unprecedented portion of these virtues. This Scripture shines much light on multiple elements of the tabernacle pattern that we will soon uncover.

A FORMER ARTIST ROBBED OF ORIGINALITY

Satan was there at the beginning in Eden's perfection, full of wisdom and visually dazzling. He was covered in an array of gemstones, linking to the foundations of the New Jerusalem and also the breastplate of the High Priest. He was ordained to release music into the earth through *"timbrels and pipes"* (Ezekiel 28:13). Satan is the only angel specifically

highlighted as carrying such instruments. I am sure that musicianship exists among God's heavenly host in some aspect, but it seems that Satan had an exceptional dose of ability in this regard.

When he fell, rebelling through pride and greed, he lost access to the source of divine originality that carries transformative power. From that point on, Satan's works were robbed of the power of regeneration; all his efforts are darkness, carrying only the ability to counterfeit God's works in poor reflection. When Adam and Eve disobeyed the Lord, seeking power from the wrong source, the true purpose of beauty and creativity was greatly affected, and humanity's authority to release it was removed. But through the cross of Christ, this authority has been restored to us.

The enemy knows the highly effective powers of creativity only too well. Despite having no access to its divine origins, he uses it with vigor to effectively communicate his message across the world, albeit counterfeit and on repeat. If this is the area where he shone most before his fall, this will be the area of human ability and connection to God that he envies most.

CRAFTSMEN TO THE RESCUE

Zechariah the prophet, a contemporary of Daniel's who lived in Babylon, recorded the following vision that is very illuminating:

> *Then I raised my eyes and looked, and there were four horns. And I said to the angel who talked with me, "What are these?" So he answered me, "These are the horns that have scattered Judah, Israel, and Jerusalem." Then the LORD showed me, four craftsmen. And I said, "What are these coming to do?" So he said, "These are the horns that scattered Judah, so that no one could lift up his head; but the craftsmen are coming to terrify them, to cast out the horns of the nations that lifted up their horn against the land of Judah to scatter it."* (Zechariah 1:18–21)

The horns represented demonic strongholds crushing nations into despair. God's people had become scattered in both heart and geography. Who does God send to save the day? Craftsmen! Going by today's

stereotypical perception of crafts, we might envisage four quilters charging to the rescue, ready to tear down scary demonic beings with their fabric squares. But with our broader understanding of the abilities of a master craftsman, we can see this vocation with fresh eyes.

GOD'S REDEMPTIVE PLAN FOR THE NATIONS CANNOT BE PULLED OFF WITHOUT THE ARTS.

There are many nations today feeling oppressed, struggling to find solutions. The number four can be seen to represent God's creative works, since there are four corners of the earth and four seasons of the year. In this prophetic vision, we are shown God's redemptive plan for the nations—a plan that cannot be pulled off without the arts.

The Master Craftsman of wisdom will co-create with believers, crafting strategies and anointed innovations that are empowered to break sinister spiritual citadels over governing forces, terrifying and tearing down nefarious entities. Daniel and Joseph were brilliant examples of such activity. As captives in oppressive nations, they were given the wisdom of such craftsmen. They used tactics that elevated them to primary governmental voices, second only to the kings they served and thereby gaining power to save many lives and change the course of human history. The sphere of art has an important role to play because of its ability to bridge mankind to God's powerhouse through metaphorical communication.

4

STAGE TWO:
THE TABERNACLE OF MOSES

We pick up the story in Egypt, where millions of Israelites are finally released after some stunning supernatural action. Signs and wonders, plagues and warnings, and at last Pharaoh and four hundred years of Hebrew slavery are crushed. The Israelites leave Egypt with Moses at the helm, heading toward a new life in the promised land. God meets Moses on Mount Sinai for forty days amid a mysterious cloud. During this exchange, He reveals to Moses His design for a central worship hub to be constructed in the Israelites' camp—an astounding compendium of details specifying everything from dimensions and materials to furnishings and upkeep. (See Exodus 24:12–18; 25–31.) The tabernacle design is two-fold—it would serve as a physical place of communion with the Father and also would represent a divine pattern to help humanity understand God's ways.

Armed with the exciting new blueprints, Moses gets the project rolling and commissions a team. Before hammer hits bronze, God first requests an offering from willing hearts, a contribution of

quality materials—precious metals, jewels, and fabrics from the recently plundered bounty of Egypt. (See Exodus 25:1–9.)

GOD'S PRESENCE—THE PLACE FOR DIVINE DOWNLOADS

Moses entered God's glory through relationship and a willingness to evolve. It was there that he received divine blueprints for the tabernacle and its function in everyday life. If we desire heaven's answers and ideas, we must seek them in the mystery of God's presence, with humble hearts that kneel before Him.

Moses waited *forty days* for answers from God. He did not get his marching orders in an instant, and we should not expect to, either. The need for patience flies in the face of our quick-fix solution society. But the waiting yielded plans of eternal value, not just earthly usefulness.

In terms of the building materials for the tabernacle, God demanded the very best. What are we prepared to give—of our time, skills, finances, and so forth—to experience an increase of God's presence in our lives? The tabernacle journey will eventually ask for our all. What will be our answer? If we give from the edges, we will live on the edges.

> MOSES ENTERED GOD'S GLORY THROUGH RELATIONSHIP AND A WILLINGNESS TO EVOLVE.

THE JOURNEY BEGINS

It is no coincidence that our journey into the pattern begins with the scorched Sinai desert, like the barrenness of a life devoid of living water. A slave mentality becomes the norm when the spirit of the world is a rod to our back, harsh and driving, like the world of Egypt was for the children of Israel. Freedom can be as much of an illusion as the oasis mirages people sometimes experience in the desert. Its distant promise

seems so real, and yet, on arrival, there is no relief, only more parched earth.

The tabernacle of Moses was defined by three areas that can be seen to symbolize our tripartite human design of body, soul, and spirit: an outdoor enclosure called the outer courts (body or flesh) and two enclosed rooms called the Holy Place (soul) and the Holy of Holies (spirit). These spaces were accessed in this exact sequence; no shortcuts were available.

In the same way, a holy life harmonizes the three parts of body, soul, and spirit in their proper places, allowing the spirit to rise and causing the carnal nature to bow. And just as the tabernacle of Moses journeyed through the wilderness toward the land of promise and plenty—a physical enacting of the transformative process toward a lifestyle of holiness—our journey to discover our identity and part in the unfolding of God's kingdom upon the earth is designed to draw us ever closer to the God of grace.

BREAKING THE BARRIERS

In Moses's day, only the Levite priests were permitted to access the Holy Place in the tabernacle. Entrance to the Holy of Holies was even more specialized. Once a year, on the Day of Atonement, the high priest could enter and seek forgiveness for Israel's sins. (See, for example, Leviticus 16:2–3; Hebrews 9:6–7.) Back then, God required sacrifices and offerings, such as animals, oil, and grain, in the ongoing process of people paying the price of redemption for sin.

The life force of flesh is the blood, and so these sacrifices were meant to remind the people that seeking holiness was literally a matter of life and death. They also brought to remembrance the Passover rescue from brutal captivity in Egypt.

Yet this continual offering of sacrifice was not enough for humanity's unbroken succession of sin and stumbling. In His great mercy, instead of pushing us further away, God's heart was to draw His creation closer

so we could have communion with the greatest deity in the universe, without incineration or sin as the constant elephant in the room.

Jesus became the forever price—His perfect life in exchange for our sin-scarred existence—obliterating the separation between God and His people, so that blood sacrifices were required no longer. (See Hebrews 8:1–2; 9:11–15.) Now, because of Jesus's sacrifice, we can stride fearlessly into the throne room and address God as Father. (See Hebrews 4:14–16.)

The literal veil of the temple tore in two when Jesus departed the earth, His human form left clinging to the cross. (See, for example, Matthew 27:51.) At that moment, there ceased to be a need for a tabernacle building, for we were granted access to a divine temple with Christ as the definitive High Priest. He is the only doorway in, and He holds our pass marked "Unrestricted Access." Yet the choice we make by our free will decides our destiny. Will we enter the unknown and make the trip? Through the journey of trust and transformation, courage, and communion, we come closer. It is not a day trip; it's a life trip.

THE TABERNACLE DESIGN

Positioned in the fiery expanse of the Sinai Desert, the tabernacle appeared as a large rectangular enclosure. Our first stop takes us to the outer courts and their features.

THE OUTER COURTS (EXODUS 27:9–19)

Sixty pillars of brass stand like soldiers of a small yet proud army with silver helmets guarding the perimeter. Between these pillars stretch panels of white linen forming a courtyard over 7 feet in height, 150 feet in length, and 75 feet in width. A riot of color breaks the crisp white frontier with a curtained gateway on the eastern side. Opulent shades of blue, purple, and scarlet woven through the white linen represent the residence of a royal priesthood.

White purity symbolizes Jesus as the door, entirely human yet without sin. (See Hebrews 4:15.) In biblical times, blue, scarlet, and purple

dyes were exceptionally costly to produce due to the rarity of their sources and the difficulty of extracting them. Scarlet spoke of sacrifice; blue, the reality of heaven; and purple signed our invitation to a monarchical court—an invite extended to all, regardless of earthly position or power. The resplendent doorway beckons us into a metamorphosis from our earthly rags to the riches of heaven, calling us to leave behind the world's relentless rejection in exchange for acceptance and belonging in the family of God.

THE BRAZEN ALTAR (EXODUS 27:1–8)

The outer courts compose the largest area of the tabernacle compound, representing the breadth of God's grace that embraces us entirely, just as we are. A huge altar of shittim wood overlaid with the resilience of brass stands full of fire, with the acrid smell of burning meat, fat, and blood pervading the air. Four horns mark the corners of this imposing 7.5-foot-square trough rising 4.5 feet in height.

Here Israel brought their sacrifices, seeking restoration for wrongs; yet they were still unable to progress into the inner chambers for themselves. Today, thanks to the price our Messiah paid, we have unrestricted access. Jesus Christ traveled through the charring fire of sacrifice and death. Yet He did not stop there but journeyed onward into the miraculous resurrection, rising with the keys of hell and death triumphantly in hand, that they would no longer have power over us. (See Revelation 1:18.) We can choose to relinquish all that destines us for damage within the systems of sin, availing ourselves of the great exchange of repentance for forgiveness, spiritual blindness for the beginning of wisdom.

THE BRAZEN LAVER (EXODUS 30:17–21)

Past the altar stands a generously sized basin of polished bronze brimming with water, offering relief from the smoke of sacrifice. This is the place of cleansing, where we plunge our lives in the baptismal waters and the Word of God, and find new life. Blood speaks of a life taken; water, of life restored.

To proceed, we must desire wisdom and growth. Spiritual babes require the gentle sustenance of spiritual milk in a time of lavish grace. But we must graduate from the milk bar to the steakhouse with some determination. (See Hebrews 5:13–14.) There are many reasons people get stuck in the outer courts and struggle to progress further inward. It may be that we struggle to believe we have been made worthy. We must allow God to heal our fears, or they will barricade the entrance to the inner chambers and rob us of the remarkable life inside. Or, it may be that we are unwilling to sacrifice the sacred cows in our lives; we don't want to deal with the toxic attitudes or habits we've adopted. Or perhaps we don't want to relinquish control and trade it, trusting, for the unknown.

Life lived too long in the outer courts dulls the spiritual senses, causing us to accept weak faith, milky food, and distant fathering. At every stage of the journey, we have a choice: whether to trust and advance, or doubt and remain in place. When we remain hovering by the Brazen Altar, the offering of our all makes little sense. With scarce experience of the inner rooms in this life, we presume their wonder is accessible primarily in the life to come. This great deception prevents many believers from tasting the life eternal on Earth.

Leave your offering in the flames, wash in the healing waters of the Spirit, gather your courage and the priestly garments of your destiny, and enter the mysterious inner rooms of the tabernacle pattern. A journey awaits that you can scarcely imagine.

THE HOLY PLACE (EXODUS 26:7–14)

Are you ready to enter the Holy Place? Five gilded pillars support another curtained doorway enrobed with royal colors. Its cloth forms part of an internal covering arching the whole structure of the two inner rooms. Contrasting layers are built upon this: coarse goat hides, red-dyed ram skins, and an outer screen of badger pelts, sealing these spaces from the elements. Each layer plays a part in the symbolism of sin and redemption.

In distinction to the wide outer courts, this smaller enclosure measures 30 feet in length and 15 feet in width and height. The walls stand enrobed with poured gold, dancing with the flickering light of several flames as a fragrance whispers around the room. Three golden sculpted pieces of furniture occupy this space, their form going beyond mere function and revealing the excellence of artistry.

A symphony of colored fabric patterned with cherubim envelops the inner sanctum of this room, yet it is revealed only across the ceiling before draping behind the walls. In direct contrast to the surrounding splendor, the floor lies carpeted with dusty, primal earth, reminding us that we must stay connected to our earthly commission while we navigate the mysteries of the divine. Raising our eyes to heaven, we will find angelic comrade forces in the fight for kingdom advancement. We cannot premeditate our experience of this sacred space; we must leave our preconceived notions and agendas at the door.

THE TABLE OF SHEWBREAD, OR THE PRESENCE (EXODUS 25:23–30)

The first piece of furniture inside the Holy Place is a small table of acacia wood overlaid with gold. A decorative rim surrounds twelve cakes of bread laid in two stacks (see Leviticus 24:5–9), representing the twelve Israelite tribes, and Jesus as the bread of life. (See John 6:51.)

In the sacrament of Communion, we consume the bread and consider His cost, then receive the promise of healing. (See Isaiah 53:5.) Frankincense was sprinkled upon the bread, its earthy, cleansing aroma and healing properties reinforcing this theme.

THE GOLDEN LAMPSTAND (EXODUS 25:31)

A large lampstand resplendent in hammered gold stands over 5 feet tall, the primary source of light. This is the menorah, with seven symmetrical branches burning the oil of pressed olives in an unbroken cycle of light. Each branch represents one of the seven spirits, each a part of the Holy Spirit: the Spirit of the Lord; the spirits of wisdom, understanding, counsel, strength, and knowledge; and the fear of the

Lord. These give us perfect direction for every aspect of life. (See Isaiah 11:1–4.)

Things are not as we first imagine when the menorah light breathes a different wisdom on the layers of our lives. It's a two-way trade: spiritual enlightenment for the acceptance of our need for change. This is not the walk of shame but the exchange of love, a crown of beauty for ashes. (See Isaiah 61:3.) This is the power of God searching and purifying our hearts, as it says in Proverbs 20:27: "*The spirit of a man is the lamp of the* LORD, *searching all the inner depths of his heart.*"

On the day of Pentecost, when God poured out His oil and fire upon us in the form of His Holy Spirit, a spark ignited, and we became living tabernacles for the Holy Spirit—billions of people across the ages instead of as many as could fit in one tent. (See Acts 2:1–4.) The more we allow His light to transform us and radiate outward, the more we empower the people and culture around us. We can maintain a small flame or build a vivid fire. The brighter the flame, the greater the impact.

> **THE MORE WE ALLOW GOD'S LIGHT TO TRANSFORM US AND RADIATE OUTWARD, THE MORE WE EMPOWER THE PEOPLE AND CULTURE AROUND US.**

THE GOLDEN ALTAR OF INCENSE (EXODUS 30:1–4, 34–38)

At the end of this room sits a box of acacia wood covered in gold, 3 feet high, and half that in breadth and width. A decorative crown ornaments the top edge with a connecting horn at each corner. A heady mix of rich and rare spices blended with frankincense and salt burns upon hot coals, firing day and night as a continual aroma of prayer and worship. These substances were known to have healing properties for mind, body, and spirit.

The burning coals represent for us the cleansing of our sin that grants us the crown of life. (See Isaiah 6:5–6; James 1:12.) From this place, billions of prayers have ascended across the ages toward the heavens, filling the bowls and the heart of God. (See Revelation 5:8.)

Prayer is a lifeline to heaven, an intentional process of developing connection. However, it is often divided by what is perceived as the secular versus the sacred. The problem with that theory is that most people live much of their day in the down-to-earth, seemingly secular sphere, failing to realize that because God invented the mechanisms that sustain life, such as family and work, they are all sacred in the life of a believer. When we have been sanctified by the blood of Jesus, we are holy whether we are doing a load of laundry, cooking a meal, working in an office, or kneeling on the floor at a prayer meeting

Limiting our understanding of this area restricts our proximity to the heart of God. The breath of prayer should weave through our daily moments as we learn to bring our lives to our heavenly Father as devoted offerings, in all their practical and spiritual glory. Each of us is wired uniquely, and when we open ourselves to creativity in the area of prayer, we uncover a world of language that cultivates continual conversation with God.

I have painted prayers; I have witnessed warfare waged through dance. I have seen people healed by engaging with art, and I have been in the presence of poetry that led many souls to a depth of divinity. How about interceding and worshipping through mathematics or metalwork, cooking or cloth, science or sport? Whatever God has given you to express a response to His Spirit, use that to pray!

THE VEIL AND THE GOLDEN PILLARS (EXODUS 30:5–6)

Behind the Altar of Incense hangs a vast, heavy veil, filling the entire height and width of the room. Several inches deep and supported by four golden pillars, its woven form discharges the same imperial colors of the other doorways. This is the entrance to the holiest place of all, yet

the fabric stretches solid and opaque, void of any break to allow access. Divine intervention allowed for the high priest to enter annually.

For us, this immense barricade lies torn apart; we enter wearing robes of righteousness, wrapped in cloaks of humility. Such are the only garments that will survive what lies on the other side.

THE HOLY OF HOLIES (EXODUS 26:31–34)

A blinding light permeates this space, but it is not the brilliance of a dazzling sun or a thousand flickering lamps; it is the shekinah glory of God. The parched earthen floor and walls of glowing gold continue through this room. Sumptuous jewellike colors flow through the veil and continue across the ceiling. This room forms a cube 15 feet in each dimension, a pattern of the New Jerusalem with its breathtaking beauty.

In this place, we are seen and loved, Spirit to spirit. There is no room to wrestle our own agenda above God's; the weight of His glory would crush us. Here we finally see no need to try. We must travel through the other areas, grappling with challenge and change to find the abandon of trust. Before the throne of God, the air is dense with purity. As our limited vision aligns with the expansion of heaven, we find the sweetness of a love we cannot imagine for ourselves.

THE ARK OF THE COVENANT (EXODUS 25:21)

A rectangular golden box stands in the center of the room, one of the most potent symbols of God's manifest presence on the earth in Old Testament times. Inside are sacred items: stone tablets carved with the Ten Commandments, a plumb line of the faith; the golden pot of manna, representing the promise of provision; and the budding rod of Moses's brother Aaron, a warning against rebellion. (See Numbers 16.)

THE MERCY SEAT (EXODUS 25:17–21)

The top of the ark forms another piece called the Mercy Seat. Two cherubim of hammered gold face each other, stretching their wings to touch tips across the hallowed contents, as the protectors of God's throne.

This object represented the throne of grace. Jesus, our merciful High Priest, passed through the heavens to save us. He died on a cross, shaking the earth until the immense veil that shielded the Holy of Holies was slashed in two. No more restrictions; we have been invited all the way into the shekinah light of the everlasting Father, where we enjoy full immersion in unconditional love. (See Hebrews 4:14–16.)

Despite all this being available to us, it is still our choice to enter. The door to touch the eternal is always open and waiting.

THE CLOUD (EXODUS 40:34–38)

When the construction of the tabernacle was complete, having been done precisely as instructed, something incredible happened: a cloud of God's presence rushed in to fill the earthly space, visible evidence that He was with His people. *"Then the cloud covered the tabernacle of meeting, and the glory of the LORD filled the tabernacle"* (Exodus 40:34).

This sign served both to reassure them and to deter their surrounding enemies. The cloud remained hovering above the tabernacle, and by night, a fire burned at its core. When it was time for the Israelites to up stakes and move camp, the cloud went before them, and they were expected to follow faithfully. (See Numbers 9:15–23.)

As God's people today, we are still required to be flexible, observing the times. The world is constantly changing, and God is an expert at reaching into the shifting culture to help His people. We were never meant to lose sight of the cloud that navigates His church through change; it is inhabited with the fire of His glory. As Christians, do we recognize when the cloud has moved, and are we flexible, willing, to shift direction?

GOD'S TABERNACLE TODAY

One of the great grapples of our era is the church's ability to connect with modern society. If we present a culture that seems to belong to another era, people will struggle to believe we have relevant answers for today. We must be on guard, lest we get lodged in the ideas of yesteryear,

and be cautious not to set up camp with no intention of moving forward when the cloud of God's presence summons us.

The tabernacle pattern is not yet complete; it changes from era to era. The requisite laws and rituals in the days of Moses were replaced when Jesus became a human temple. However, the elements of temple worship and sacrifice were still evident in His life, albeit in different forms. Now that we are the tabernacle, we need to figure out what this pattern looks like for us, personally—in us and through us. One thing is certain: the pattern is not devoid of fresh creativity for every era.

Throughout the tabernacle of Moses existed important elements that endure today and still invite God's presence. Therefore, these elements are crucial for us to understand, since we are now God's tabernacle. Interestingly, some of these components have been neglected, suppressed, and even eliminated in today's church. We need to consider that the enemy has gone after something he recognizes as a daunting weapon in our hands.

The tabernacle was not a bare tent focused on practicality and function alone. The supernatural presence of God was paramount. It was not aimed to be a dazzling show-stopper; it was His natural essence. The Bible regularly erupts with accounts of His supernatural power in action. Mystery and symbolism hung in the air, inviting discovery; and for thousands of years, people have studied the tabernacle, trying to excavate its endless layers of meaning. We need to grasp the creative language of God. Through dreams, visions, mysteries, enigmas, and parables, He initiates discussion with His people. The tabernacle was also a place of artistic and creative excellence, a riot of color, a feast of beauty. Traveling through the pattern into the innermost two chambers, we find that the volume of these things increases exponentially.

In the next chapter, we will visit a more recent tabernacle—that of David.

5

STAGE THREE:
THE TABERNACLE OF DAVID

From their conception under Moses's leadership, the tabernacle and the ark of the covenant embark on a journey. The Israelites claim the promised land, and the tabernacle rests at Shiloh for 369 years. Through a series of events, the ark becomes captured by Israel's archenemies, the Philistines. But the box of holy dynamite wreaks havoc wherever it lands, resulting in its eventual return to Israel. David succeeds Saul as king of Israel. Victor of many battles to defend the nation, he has proven himself a great military leader. He recaptures the almost impenetrable city of Jerusalem from the Jebusites and aims to establish it as a political capital that will bring stability to Israel. He also desires to set up a center of worship there, envisioning a resplendent temple to replace the aging tabernacle tent that will restore the ark with the full tabernacle pattern once again.

What takes place is remarkable. The initial separation of the ark from the rest of the pattern was due to disobedience and enemy activity. Yet, rather than reuniting these parts of the model, David decides to

bring the ark to Jerusalem to rest on Mount Zion within a transient tent. At the inception of this new worship center, David and the priests alone are granted access to the sacred ark. This temporary abode possessed profound prophetic significance, foreshadowing a future church of believers who would enjoy free access to God's presence. This transitional structure, known as the tabernacle of David, existed for forty years, until the completion of the magnificent temple.

PROPHECY AND FULFILLMENT

Fast-forward more than two hundred years to Amos the prophet, who lived at a time when Israel was falling into grave sin and idolatry. Amos prophesies a future restoration of the epic glory experienced during the time of David's tabernacle. (See Amos 9:11.) Later, this prophecy would be paraphrased by the apostle James as he addressed the Jerusalem Council. A new age of the church was beginning, with humankind becoming the tabernacle of the Spirit. The apostles were debating the dilemma of gentile inclusion when James reminded them of the prophecy, saying:

> *After this I will return and will rebuild the tabernacle of David, which has fallen down; I will rebuild its ruins, and I will set it up; so that the rest of mankind may seek the Lord, even all the Gentiles who are called by My name, says the Lord who does all these things.*　　　　　　　　　　　　　　　　　(Acts 15:16–17)

These prophecies pointed toward a restoration when Jesus would become the saving hope of humanity, Jews and gentiles alike. A direct descendant of King David, He would preside over the new church as its forever High Priest and King. The order of the tabernacle of David must be restored so that *all* humankind can be drawn to seek the Lord. The prophetic meaning of Amos's word goes beyond a description of today's church to indicate the great end-of-days revival that King Jesus will accomplish across the earth. Today, we mainly associate the tabernacle of David with prayer and worship, but many examples of God's

creative force took place during David's reign that will inspire people to seek God. If it's in the pattern, it's ours for the taking!

THE ORDER OF THE TABERNACLE OF DAVID MUST BE RESTORED SO THAT ALL HUMANKIND CAN BE DRAWN TO SEEK THE LORD.

KEY ELEMENTS OF THE TABERNACLE OF DAVID

David presented God with the idea of building a magnificent temple to permanently house the tabernacle pattern. Interestingly, God backed this up; looking into David's motive, He found a pure heart. Yet David was a man of war, and the Lord wanted the temple to be built in the future time of peace, during the eventual reign of David's son Solomon. Far from being excluded from the process, David was given breathtaking architectural and interior blueprints. (See 1 Chronicles 28:19.) He amassed a staggering cache of materials and a fleet of craftsmen. Fine metals, woods, precious stones, and more were gathered in abundance. David presented his son Solomon with a well-stocked treasury and commissioned him with the task of overseeing the temple's construction. David also substantially upgraded Jerusalem, with projects such as having a royal palace constructed. An alliance with Hiram, King of Tyre, provided a boost of experts and materials. (See 2 Samuel 5:11–12.)

PURITY OF HEART AND PASSION FOR GOD'S PRESENCE

Spilling from David's pursuit of presence came victory for Israel over their enemies. Through a series of resounding successes and total mess-ups, David maintained remarkable favor with God, who was captivated by his quest for connection, calling David a man after His own heart. (See 1 Samuel 13:14.)

David's desire for authentic worship surpassed ritual and formula. He craved experiential presence, to be engulfed by a beauty where fear and failure melt away. The psalms record expressions of this desire—for example, Psalm 27:4: *"One thing I have desired of the LORD, that will I seek: that I may dwell in the house of the LORD all the days of my life, to behold the beauty of the LORD, and to inquire in His temple."*

With a passion that was both private and public, David sought God often, with no hidden motive such as earning the admiration of others. He understood that the pursuit of wisdom with creative expression would be hampered by the fear of man. It is no different for us today.

NEW FORMS OF WORSHIP

Even though David's tent was temporary, some revolutionary things were activated during its existence, including a new generation of worship forms.

DANCE AND CREATIVE MOVEMENT

In a pivotal moment of Israel's history, David danced to celebrate the ark's arrival in Jerusalem, igniting fresh hope for a new era. (See 2 Samuel 6:14–15.) *"David danced before the LORD with all his might"* (verse 14). This was no mere foot shuffle but a vigorous dance, a display of utter abandon before his King.

This story has become a cherished cameo in biblical history. David stepped away from the comfortable and expected, such as the customary use of his musical talents or his typical kingly speeches, and the moment has been highlighted for all time. Dance is an important part of the historical culture of nations, sculpting air with mortal form.

INNOVATIONS IN SOUND AND MUSIC

David introduced perpetual exploratory worship and prophecy around the ark with cutting-edge music and songwriting. *"David spoke to the leaders of the Levites to appoint their brethren to be the singers accompanied by instruments of music, stringed instruments, harps, and cymbals, by raising the voice with resounding joy"* (1 Chronicles 15:16; see also

Psalm 149:2–3; 150:3–6). From the 38,000 Levite priests, 4,000 were chosen for the task, with a core team of 280 leading the way. Skill and heart posture were equally paramount. Asaph, Heman, and Jeduthun headed up this formidable team using vocals, wind instruments, and stringed instruments. David even designed and made new instruments, as his astonishing breadth of ability extended to invention, achieving new sounds and directions. (See 1 Chronicles 15:17–24; 16: 37–42; 23:4–5.) Because he embraced a full spectrum of possibilities in God, his skill set continued to expand.

This same principle is available to us today. The church has moved through many musical eras. Are we still following the example of David's tabernacle—a worship center that embraced continual exploration? Or have we become a little stuck at the end of an overstretched wine-skin with a restricted range of acceptable worship songs and sounds? Without wishing to merely criticize, I keep running into the outcome: Christians who struggle to be creative and original, even though they carry the heavy imprint of a DNA that yearns to develop originality deep within them.

DIVERSITY

The body-soul-spirit Davidic worship spilled from the Old Testament into the New, providing permission for such liberating explorations in God's presence as…

- Spirit-filled worship (see Ephesians 5:18–20);
- speaking (see Psalm 34:1, Hebrews 13:15);
- shouting (see Revelation 19:1, 6; Psalm 47:1);
- singing new songs and singing in the spirit (see 1 Chronicles 15:16–27; Ephesians 5:19; Psalm 33:3; 98:1; Revelation 5:9; 1 Corinthians 14:15);
- musicians (see 1 Chronicles 23:5; Psalm 33:2–3);
- playing and prophesying with instruments (see Psalm 33:2; 1 Chronicles 25:1–5);
- dancing (see Exodus 15:20; Psalm 149:3; 150:4);

- lifting and clapping hands (see Psalm 47:1; 63:4; Isaiah 55:12; 1 Timothy 2:8);

- standing (see Psalm 134:1);

- bowing down (see Psalm 95:6; Revelation 4:10);

- seeking the Lord (see 1 Chronicles 16:10–11; 2 Chronicles 7:14);

- thanksgiving (see 1 Chronicles 16:4, 41);

- sacrifices of praise (see Hebrews 13:15); and

- rejoicing (see 1 Chronicles 16:10; Psalm 27:6).

Israel followed a rhythm of feasts at God's instruction, important pauses for prayer and remembrance. But these were also times of party-packed pageantry, artistry, feasting, rest, and relationship, all of which expressed God's character. In a beautiful paradox, God not only requested but commanded that the members of this post-slave nation lay down their tools and participate.

ECHOES OF DAVID'S TABERNACLE IN TODAY'S CHURCH

The tabernacle of David models for us a powerful, creative church, one that is not content with rote rituals and premeditated outcomes. Jesus challenged the traditional religious practices of His day when their original significance lay forgotten, replaced by safe, dulled rituals of habit rather than heart. We are a people who have been granted admission to the ark of God's presence, the place of mystery explained, and enigma expounded, where we can reach into the heavenly realm and engage its energies.

WHEN WE LEARN TO CREATE FROM WITHIN THE TABERNACLE PATTERN, THE POWER OF GOD IS IGNITED.

The restoration of David's tabernacle is about revealing the Creator's character and the repertoire He has made available to His church to reach all people and draw them into a search for Him. Why wouldn't the enemy try to diminish our understanding of creativity when it has the potential to yield a prolific harvest? Tabernacle conversation is conducted through sculpture, textiles, architecture, interior design, music, song, poetry, story, dance, words, mystery, and metaphor, all enveloped in the presence of God. It's a vocabulary that can only be translated through close proximity to its Author—and that's the whole point!

WORSHIP INNOVATIONS AS WARFARE AND SOUL-WINNING

The seemingly cryptic information contained within metaphorical language is a bit like codes the enemy can't crack. During wartime, opposing sides send coded messages to their networks, sneaking intel through enemy lines undetected. Learning the coded symbolic and pictorial language of God is like deciphering hidden intelligence, and it is a strategy with many benefits. For one, it enables us to have a better understanding of the Word because it is full of this type of communication hidden amidst the obvious. As we bore deeper, we gain increased accuracy and discern the voice of the Spirit with greater precision. Messages written in an invisible ink, of sorts, emerge, and the path is illuminated before us.

Picture a piano keyboard. How many pieces could you compose using only five notes? Not many at all. But when the entire keyboard is essential and available, you can experiment with new arrangements. As you tap a fresh resonance, stunning sounds begin to form, creating music you barely imagined possible. What sorts of pieces do you suppose the world would rather hear—those composed of merely five notes, or those generated from the entire keyboard? When we express God through only five keys and offer the resulting song to an eclectic world of people, why are surprised by the lack of enthusiasm in the response? If they are already familiar with God's fame, it will be obvious that the five keys portray far too little of the Hero they need. Such a restriction portrays Him as limited and lacking—and causes many people to turn away from Him. But when we reclaim the other keys and reveal the

expanse of God's character to the world, countless more people will be drawn to seek Him, as the prophecy says.

STRATEGIC LEADERSHIP

King David was a full-spectrum leader and an outstanding military strategist who constantly advanced Israel's territory. He understood that creative language was a doorway to practical strategy for real challenges and that limited keys would reduce his ability to understand and utilize heavenly guidance. As a result, he caused Israel's culture to flourish, established a strong epicenter for the empire, and subdued some super-scary enemies. He became one of the most famous and widely discussed characters of the Bible—not bad for someone who started as a shepherd and a poet-musician. Today, most people would probably prize David's political leadership and military aptitude above his ability to write music, assigning his artistry to the hobby box of light relief after a hard day in the kingly throne room. Yet the Bible never takes this tack. Among the stories of his numerous victories is an entire book dedicated to his songs and creative writing. The Psalms remain one of the most well-read and beloved books of the Bible.

Music and the arts may be far more valuable than we ever thought. Let us unleash the full spectrum, using artistry to unlock clues for the economy, dreams to ignite invention, prize prose to plumb political insights. Let the musical, metaphorical language of God unearth unprecedented wisdom for this age.

6

STAGE FOUR: SOLOMON'S TEMPLE

Solomon grasps the baton smoothly from his father, his era flowing seamlessly from David's. He advances Israel through the next epoch of the pattern, which defines more facets of God's creative energy. Solomon was the unconventional son of King David and Bathsheba, a story that began with a shocking stumble of morality from David and ended with a costly outcome. Even so, it bears the beauty of sincere repentance and redemption and leads to the birth of Solomon. Crowned as a young man, he begins well, leading Israel with divine guidance, and reigns for thirty-nine years.

When Solomon steps into his rather daunting new leadership position and temple commission, he asks for help from heaven, and God meets him in a dream with an unexpected question: *"Ask! What shall I give you?"* (2 Chronicles 1:7; 1 Kings 3:5). Smart enough to realize he needs to be smarter, Solomon asks for divine wisdom and understanding to lead, and he receives the largest dose of wisdom ever granted to a person. (See 2 Chronicles 1:12; 1 Kings 3:12.)

You can almost hear the sharp intake of breath as Solomon wonders what that might look like. His father, David, had taught him well,

prioritizing tabernacle time with God above human efforts to find solutions of eternal substance. This was and still is a contrary route to many human leaders who make decisions based on experience, education, and advice. While none of these sources is wrong, per se, they lead merely to human wisdom unless God is sought as the highest source of input. Divine presence yields divine answers. Solomon lived before Pentecost and the infilling of the Holy Spirit. He was a prototype for the potential of divine wisdom in a human being.

SOLOMON'S LEGACY OF LEADERSHIP

King Solomon possessed a catalytic combination of God's authority and favor and consequently made a stunning impact on the world around him. Foreign royals and people of great influence and prestige traveled dangerous deserts to experience the results. (See 1 Kings 4:34; 10:23–24.) These rulers had powerful decision-making authority that could enhance the lives of multitudes. They were attracted to the radical advances they saw under Solomon's jurisdiction. Not only this, but Israel lived in abundance with wealth to spare. Like bees to honey, these individuals flocked closer to find the secret of Solomon's success. What they discovered, in a polytheistic world, was the true God at the center. A visit from the Queen of Sheba left this formidable woman feeling overwhelmed, yet she recognized with accuracy the source of Solomon's riches.

When the queen of Sheba had seen all the wisdom of Solomon, the house that he had built, the food on his table, the seating of his servants, the service of his waiters and their apparel, his cupbearers, and his entryway by which he went up to the house of the LORD, there was no more spirit in her. Then she said to the king: "It was a true report which I heard in my own land about your words and your wisdom. However I did not believe the words until I came and saw with my own eyes; and indeed the half was not told me. Your wisdom and prosperity exceed the fame of which I heard. Happy are your men and happy are these your servants, who stand continually before you and hear your wisdom! Blessed be the LORD your God,

who delighted in you, setting you on the throne of Israel! Because the LORD has loved Israel forever, therefore He made you king, to do justice and righteousness." (1 Kings 10:4–9)

The role of influencers today involves a great deal of problem-solving and pioneering, not just maintaining the status quo. Inventiveness and cutting-edge creativity speak their language. As Christians, we long to effect society for good, yet we often remain stumped for strategy. When Solomon wrote that nothing could compare to the value of God's wisdom (see, for example, Proverbs 8:10–11), he had tapped a truth that caught the attention of droves of people.

Thus Solomon's wisdom excelled the wisdom of all the men of the East and all the wisdom of Egypt. For he was wiser than all men… and his fame was in all the surrounding nations.

(1 Kings 4:30–31)

Today, those known for exceptional wisdom are often assumed to possess vast knowledge and powers of logic and reasoning. However, the divinely endued wisdom of Solomon manifested far beyond the realms of head knowledge into an explosion of creativity throughout Israel's culture. Like David, Solomon did not limit the extent of God's creative expression or ascribe lesser value to areas of artistry and design. The evidence was visible through the pioneering innovations that were made during his reign in such areas as science, architecture, design, the arts, engineering, trade and commerce, justice, leadership, and government.

AN AMBITIOUS UNDERTAKING

The magnitude of a creative project such as Solomon's temple had never been attempted in Israel. The vision was to build a powerhouse of God's presence sophisticated in design, loaded with artistry, and adorned with beauty. Approximately double the size of Moses's tabernacle, it took seven years to build and would stand for almost four hundred years. The leaders of Israel had given costly offerings to help finance this project whose impact would ripple through the land, releasing wisdom

to change every area of society in ways that had never before been seen on the earth.

Divine concepts that rock the world are often costly. What is God asking you and me to co-create with Him? What will we need to devote to it in terms of time, skills, and funds? There were no shortcuts for David and Solomon—their hearts were all in—and the results were historically electrifying.

Solomon raised a vast army of workers from the existing alliance with Tyre and their famed craftsmen. As with the tabernacle project, another master craftsman emerges to lead the team. Huram is acclaimed to accomplish any plan given to him, exhibiting supreme gifting from tactical project management to the hands-on expertise in metal, wood, stone, and textile work. That's a lot of talent for one person. But here's the key—he had wisdom! (See 1 Kings 7:13–14.) Enter again the Master Craftsman of God's Spirit.

The same Hebrew word for wisdom, *chokmah*[6], that is used for the Master Craftsman of Proverbs 8 and of Bezalel in the construction of Moses's tabernacle is used for Huram. We find that Huram and Bezalel are equipped to carry out projects entailing identical elements: architecture, interior design, craftsmanship, artistry, beauty, presence, mystery, metaphor, and holiness. When the wisdom of God is present, divine creativity is ignited. Huram's wisdom and skill, together with the fact that King Solomon exhibited more wisdom than anyone alive, caused an outpouring of creativity that pointed toward God and commanded the attention of the surrounding nations.

THE POSITIVE POTENTIAL OF DEMONSTRATIVE WEALTH

Today, someone might ask how such an effusive display of worldly wealth and opulent art could possibly help solve the world's problems. This is the precise question Jesus tackled when His disciples objected to a woman's emptying a bottle of costly perfume over His body at the home of Simon in Bethany. (See Matthew 26:6–13.) The disciples indignantly demanded, "*Why this waste? For this fragrant oil might have*

6. *Strong's* #2451.

been sold for much and given to the poor" (verse 9). Jesus corrected them, stating that the poor would always be with us in this life. He knew there are all sorts of reasons for poverty. Not only did He rebuke the disciples' assumptions, but He commended the woman for her lavish demonstration of devotion, an act that pointed toward His own sacrifice for humanity—and an act that was to be remembered for all time. (See verse 13.) A more glowing endorsement would be hard to find.

God is not interested in helping strictly those living in financial hardship. Jesus came to save people at all economic levels of society, but He also knew the affluent and influential could become part of the solution for poverty. The Bible shows little evidence of God loathing beauty or wealth when they are used for the building and advancement of His kingdom. What He loathes is their misuse for human greed. If giving money to those in lack was all that was needed, we would be much farther along with efforts to tackle poverty. The source of all problem solving is the Spirit of God.

JESUS CAME TO SAVE PEOPLE AT ALL ECONOMIC LEVELS OF SOCIETY.

SIGNS OF SOLOMON'S WISDOM

What were some of the indicators of Solomon's wisdom around his kingdom? During the course of his reign, Israel grew five times its current size and was considered one of the principal seats of power on the earth. Many of his subjects lived in abundance and comfort.

> *So the Lord exalted Solomon exceedingly in the sight of all Israel and bestowed on him such royal majesty as had not been on any king before him in Israel.* (1 Chronicles 29:25)

The following advancements are recorded in 1 Kings, chapters 4 through 10.

- *Philosophy:* Solomon penned a prodigious three thousand proverbs that explored truths of life. (See 1 Kings 4:32.)

- *Science:* He bought understanding regarding a broad spectrum of nature, including many different types of trees, animals, birds, insects, amphibians, and fish.

- *Creative Writing and Musical Composition:* He wrote one thousand and five songs. (See 1 Kings 4:32.)

- *Architecture, Interior Design, and Art:* Following the temple project, Solomon kept the work crew moving as he began to develop a magnificent palace complex for a further thirteen years; its sheer scope and opulence were mind-boggling. The complex contained the magnificent House of the Forest of Lebanon paneled with cedar and featuring a great hall of pillars with light streaming through numerous columns, composing a scene of ethereal splendor. Solomon's throne was a masterful work of ivory and gold with carved lions lining the stairs to his seat. (See 1 Kings 7:1–7.)

- *Artistry:* The temple, palace complex, and entire kingdom abounded with high-level artistry. Solomon's voracious love of the creative extended into Israel's numerous trading ventures with other nations as it embraced the exploration of the new and exotic. Solomon clearly understood that creativity gives us a fascination to explore the unfamiliar. Without it, we become stuck in cyclical grooves.

- *Cities and Buildings:* The empire grew and extended by force, engulfing existing settlements. Solomon built cities with fortified walls, heavily guarded by Israel's impressive army. He built everything he wanted throughout his empire, constantly strengthening, modernizing, and advancing. It seemed that nothing could stop him; the favor of God was like the wind at his back. (See 2 Chronicles 8.)

- *Economic Power and Trade:* Solomon increased commerce with other countries, and trade flourished by sea. Daring adventures

to far-flung places gleaned gold by the bucketload. In turn, traders poured in from around the world, risking journeys of hardship and peril to dazzle the provincial Israelites with rare wonders of ivory, jewels, exotic foods, textiles, and creatures. Tributes from visiting royalty, conquered enemies, merchants, and governors piled up as Israel thrived to the point that silver was rendered almost worthless.

+ *Military Might:* Solomon's army was a well-honed military machine. Legions of soldiers, chariots, and horses maintained territory and deterred enemies.

+ *Justice:* Solomon's wisdom extended into his reformist systems of justice and surpassed the logic of men, as exampled in the famous case of two women trying to claim rights to an infant. (See 1 Kings 3:16–28.)

The Bible goes to great lengths to detail the evidence of divine wisdom in Solomon's reign. It does not just outline Solomon's wise leadership practices but also the artistry, design, culinary arts, and even fashion that exploded under his auspices. The true kingdom worth of these things lies diminished today, some casualties of wrong motive and misuse across the centuries. It's time to cast a fresh eye on their value through a biblical lens. Today, we might consider Solomon's matchless wisdom to have been mainly related to intellect and prowess in logic— and we might assume that someone with such skills would fix their thoughts on "loftier" disciplines than art and beauty. Yet Solomon was just as interested in those things as he was in governmental affairs and trade. Assigning weight to the whole scope of God's language, he experienced a nerve center within the tabernacle pattern as the temple blueprints came to life. As a result, the kingdom under his reign thrived like no other on the earth in its time.

THE TEMPLE TEMPLATE

A visit to Solomon's temple surely leaves a stunning impression on the senses with its fragrances, prayers, rituals, songs, and artistry. Almost twice the size of Moses's tabernacle, it is the nucleus of worship

for the Hebrew world, with an impressive range of metaphorical visual revelation.

For fuller definition of the pieces of furniture found in the temple, please refer to the descriptions in chapter 4, "Stage Two: The Tabernacle of Moses."

THE OUTER COURTS

In direct contrast to the clatter of daily life in ancient Jerusalem, the temple stands still and sacred within a walled complex on Mount Moriah. The spacious piazza of the outer courts surrounds a majestic stone building, set at its center like a cherished jewel. Around its three sides, three floors of storage chambers support its core. (See 1 Kings 6–7; 1 Chronicles 29:1–9.)

THE BRAZEN ALTAR

Much larger than its counterpart in Moses's tabernacle version, this immense bronze altar makes an imposing welcome. This 30-foot-square trough stands 15 feet in height with four heavy horns adorning the corners, representing the authority of God's kingdom that redeems our lives from the fatal fire of the enemy. (See 2 Chronicles 4:1; 1 Kings 8:22, 62–64.)

THE MOLTEN SEA AND THE LAVERS

Beyond the altar, a gigantic bronze basin stands 7.5 feet high, raised on the backs of twelve full-sized bronze Assyrian bulls, which embody the strength of the tribes of Israel. This is a spectacular upgrade to the brazen laver of Moses's day. Contrasting these robust dimensions, the tender life of Eden rims the bowl as molded flowers, representing the offer of new life as we pass through the waters, redeemed and cleansed, exchanging our filthy rags for holy garments. The huge laver provides a water source for ten cleansing stations for the priests and their tools. These sizeable mini chariots contain basins heavily embellished with beautiful bronze detail. (See 1 Kings 7:23–38; 2 Chronicles 4:2–6.)

THE PORCH

Two enormous bronze pillars adorned with sumptuous bronze wreaths and four hundred pomegranates frame the entrance to the inner chambers. Appropriately named *"Jachin,"* meaning "solid," and *"Boaz,"* meaning "strong," they signify attributes of God's kingdom. A connecting porch continues the sense of grandeur with its towering ceiling, while resplendent folding doors of wood and gold adorned with cherubim, palms, and flowers provide a taste of the visual feast beyond. (See 1 Kings 6:15–22; 2 Chronicles 3:4.)

THE HOLY PLACE

This next room must steal many a breath with its brilliance. Sixty feet in length, 20 feet in width, and 45 feet in height, much of its internal structure is constructed of cedar and cypress wood garnished with molten metal. Walls drenched with the finest gold are ornamented with symbols of Eden's origins. Chains reach across the panels to connect as gems glitter through the crafted details in a scene of regal splendor. The familiar furniture designs of Moses's tabernacle occupy their usual places, only some are significantly amplified in scale and number.

Both the table of shewbread and the menorah have increased from one to ten of each. An even number is distributed on each side, forming a corridor of flickering light toward the holy of holies. Increased lighting flows from the addition of small windows high in the walls. The golden altar of incense has remained the same, smoldering with the incense of prayer before the final hallowed chamber.

Last, the veil breaks the golden flow with a wall of dazzling color at the far end of the space, reaching across the entire width and height of the room with immense weight and density. The same design of blue, purple, and scarlet and of cherubim has been woven with the skill of many crafters in a masterpiece of textile accomplishment. (See 2 Chronicles 3:8–14.) Passing through the cherubim represents a return to Eden's perfection and an advance toward the concluding destiny for all God's people—the final temple of eternity.

THE HOLY OF HOLIES (1 KINGS 6–7; 1 CHRONICLES 3)

In the temple, this final space is elevated by steps from the previous room, with golden folding doors presenting a final boundary. Its 30-foot cubed dimensions support staggering quantities of gold that envelops the walls, furniture, and decorations that festoon this space with similar decoration to the previous chamber.

The original ark of the covenant occupies a central place with its original, consecrated contents topped with the mercy seat of gilded cherubim. However, this symbolic representation has much progressed with the presence of two additional sculpted angelic forms whose out-stretched wingspan measures 30 feet, shadowing the small mysterious box. Their combined reach encompasses the entire width of the room in a formidable display of strength.

The construction of the temple took seven years. In a lavish opening ceremony, amid the untarnished gleam of new metallic splendor, Levite priests erupted with instruments and voices in a feast of sound. The Lord was delighted with this offering. A cloud of His shekinah glory charged the house with such intensity that the priests could no longer stand. Solomon dedicated the nation to the Lord's hand as fire from heaven miraculously struck the sacrifices. (See 2 Chronicles 5–7; Ezekiel 43:5.)

PROTECTING THE TREASURE

Solomon's kingdom was a whirl of magnificent discovery. He was a king captivated by what other nations had to offer, and he sought to expand Israel's scope of cultural possibilities. A creative heart will always reach for unique influences to inspire. And God knew protective measures would need to be put in place as a result—measures Solomon himself wrote about in the proverbs he penned. On the one hand, we find that God's wisdom triggers creativity and artistry; on the other hand, it activates discernment and understanding to protect what is produced. When Solomon was flowing in wisdom, both these sides were in balance, transforming and guarding.

However, the end of the story yields a critical warning for all of us who would pursue the creative wisdom of God. Solomon had a weakness

he did not address; his attraction to the foreign and fascinating stepped beyond God's parameters, and he married a wealth of women who not only came from other societies but worshiped other gods. Sadly, this toxic turn in the road caused him to lose focus, vision, and even hope. He ended his spectacular reign much diminished with severe consequences for Israel, despite God's repeated warnings.

Solomon's mistake was to mix the holy with the profane, which began to taint the stream. He lost the divine flow as he began to draw from the wrong sources. What seemed like exciting diversity in the world was also mixed with contaminated origins of inspiration. He mingled with other cultures that idolized evil principalities in a way that allowed them seeping access to his heart. This all led Solomon into creeping disillusionment, causing him to conclude, *"Vanity of vanities, all is vanity...there is nothing new under the sun"* (Ecclesiastes 1:2, 9). The entire book of Ecclesiastes reveals a soured heart—the polar opposite of the zeal for life that God's fresh, creative life should bring us. If we embrace this same warning today, we can protect the treasure God grants to our own lives; with great wisdom comes great responsibility: to learn how to dwell in one's culture and deliver a relevant message without drinking the poison. Navigating such terrain, in itself, leads to God's wisdom—the pearl of limitless price. (See Matthew 13:45–46.)

7

STAGE FIVE: THE MESSIAH

The original temple stood for around 400 years before being razed to the ground by Nebuchadnezzar II in a siege on Jerusalem in 578 BC, marking the beginning of the seventy-year Babylonian captivity for the Jewish people. A simple version was rebuilt on their return, but it was missing key elements, such as the tablets of the Ten Commandment and the ark of the covenant. Later, Herod the Great became governor of Jerusalem and carried out a massive refurbishment to cope with the swell of visitors during the festivals. A herculean workforce upgraded the temple to an ostentatious complex, the size of six soccer fields, and it stood for an additional 585 years.

Yet Herod's motivation was logistical, not spiritual. His tyrannical rule enforced heavy taxes and labor to make the project a reality. There were no holy blueprints, no co-creation with divine devotion. Instead, the updated temple was built through the controlling forces of leadership and religion, as a status symbol of their powers. This same Herod had ordered the massacre of all male children under two years of age in an effort to weed out the Messiah. (See Matthew 2:16.) When Jesus entered the world, He

came to shine as a much-needed light in shadowy and malevolent times. (See John 12:46.)

RECLAIMING THE TEMPLE

This previously hallowed meeting place had become shrouded with rules and immorality. The people must have been very disillusioned with their spiritual leaders. In response, God sent an eternal remedy—a bridge to repair His lost connection with humanity and to elevate the relationship to a new level. Enter the Messiah, rattling the corrupt religious scene with the gift of redemption.

Disgusted with the defilement of the temple, Jesus violently chastised the marketplace of wheelers and dealers within its consecrated grounds. (See Matthew 21:12–13; John 2:13–16.) He healed the sick and maimed, bearing witness to the true light and love of God. Yet the priests showed no enthusiasm; in the dullness of their hearts, they could not recognize the Messiah-light. Jesus messed with their theology, stating that if the great temple was destroyed, He would raise it again in three days. (See John 2:19.) Outraged, they asked how this was possible; it had taken forty-six years to build! (See verse 20.) *"But He was speaking of the temple of His body"* (verse 21), for He knew His imminent crucifixion and resurrection would lead to His becoming the new temple touchpoint between heaven and earth, a Spirit switch from a building to a human.

THE PATTERN BECOMES A PERSON

As the fifth stage of the tabernacle pattern, Jesus sweeps in like a wave of revival, transforming the spiritual landscape and exposing corrupt, manmade religion that used the temple as a status symbol. He course-corrected its design back to its original intent. His life built a bridge to a new era—an era that released people from the strictures of the law, which had become distorted through twisted motives and empty-hearted rituals. Its impossible burden was no longer effective in guiding the people to follow God. Through a sinless life, Jesus became

the great High Priest of the tabernacle, and every stage of the pattern represents a part of Him.

In thinking about the earthly life of Jesus, we often focus primarily on His three years of public ministry, perhaps forgetting the preceding three decades. When we consider how pivotal a role those three short years played in humankind's history, we must conclude that His training to reach that stage must have been significant. Although He was fully divine as a member of the Godhead (see Colossians 2:9), Scripture attests to His having been fully human during His earthly life. (See, for example, Hebrews 4:15.) Like us mere mortals, He had to learn and grow up before he was ready for His time in the public eye.

PREPARING FOR THE MISSION

God is never haphazard in His plans, including that of sending His only Son on a mission to save the world. In my early days of seeking evidence of God's creative mandate, I asked Him to show me where this truth was demonstrated in Jesus's life. Eventually, a simple but profound question landed in my spirit: "Why was Jesus a carpenter and not a shepherd or a farmer?" The effect was like the sound of a key clicking in a sacred lock. If Jesus could have been anything, wouldn't it have made more sense for Him to have been, say, a literal shepherd, to help people relate more readily to Him as the Good Shepherd? Why didn't He train to be a teacher? He could have worked in any profession at all, yet God chose for Him the trade of carpentry and craftsmanship.

When we consider that the tabernacle design was a building pattern and not a bunch of detached chapters in biblical history, this question bears even more weight. We can recognize that Jesus was taking us to the next stage, extending the range of co-creation examples. How do we know this? Because Jesus's life was full of the creativity of God! There is no dividing line between the Old and New Testament that negates the power of Scripture before Jesus's arrival on the earth. After all, it was God who supplied the artistically ornate tabernacle blueprints. The pattern simply continues to advance, stage upon stage.

First, Jesus's entrance to the world was far from standard. Through the language of prophecy, His coming was proclaimed to the world. (See, for example, Isaiah 7:14–16.) Next, the Holy Spirit performed the creative miracle of new life in Mary's virgin womb. Dreams were God's chosen form of intel to save the infant Jesus more than once. (See Matthew 1:20; 2:12–13; 27:19.) Then, for thirty years, Jesus simply grew up in a family.

JESUS PICKED UP THE CHAIN LINK ENDORSING THE STAGES OF THE TABERNACLE PATTERN THAT PRECEDED HIM.

TRAINED AS A *TEKTON*

Initially, Jesus took the traditional route of training in the family business. It was common for fathers to pass their skills to their sons. But at thirty years of age, he left home to travel and teach. What was it that Jesus needed to learn through those early years to prepare Him for those crucial three years of public ministry? The Hebrew word used for someone in His father Joseph's line of work was *tekton*, describing a craftsman or artisan, someone who would have worked with wood and possibly also stone.

Many people have the impression that Jesus was poor, yet the profession of *tekton* was well respected and compensated. Remember, the craftsmen who worked on the temple were classified as *tektons*, working with cutting-edge techniques to form structures of excellence, both practical and decorative. Few poor people would have been able to afford employing a *tekton* to work on their meager abodes.

The work of a *tekton* was time- and labor-intensive, requiring many hours of designing and crafting unique pieces for each brief. Projects were hands-on and potentially tedious, for there were no power tools or mass-production assembly lines available; you couldn't just pop into the hardware store for some pre-cut wood or a packet of two-inch nails.

Tektons would likely have been employed by the middle to upper classes of the day, skilled in communicating with clients, designing solutions and plans, and building complex forms. An experienced *tekton* could become a master craftsman who supervised teams and managed projects. Consequently, one school of theological thought places Jesus within the middle class as part of a valuable profession.[7]

God intentionally chose the vocational route for Jesus as a craftsman and artisan. His work with wood and stone would have given Him a direct connection with God's creation. Just as merely gazing at the photographic finish of a spectacular meal does not allow you to taste its delights or connect to the smells and textures of the cooking process, Jesus had to work in direct contact with the ways of craftsmanship to learn its nuances. The Scriptures say, *"Jesus increased in wisdom and stature, and in favor with God and men"* (Luke 2:52). He had to undergo an evolving process every bit as much as we do. In those early years, He was also mastering the ability to hear the Holy Spirit's voice and co-create—listening, designing, and chiseling something manifest upon the earth.

CREATIVITY ON MULTIPLE SCALES

Jesus's work as a carpenter helped created a link from one stage of the tabernacle pattern to the next. He was simultaneously training to be a literal, earthly *tekton*/master craftsman—such as those that worked to build the tabernacle and the temple in the stages preceding His—and being instructed in the ways of kingdom wisdom by the ultimate Master Craftsman.

He took the baton and illustrated anew the value of creativity, while also endorsing the pattern stages that preceded Him. More evidence lies in what happened next—Jesus's departure from home and from His vocation as a *tekton*. Did He leave behind all His creativity? Not at all! Even though He ceased to work with His hands, He continued to model co-creation in many different forms.

7. See, for example, Wilson, A. N., *Jesus: A Life* (London: W. W. Norton & Company, 2004).

A CREATIVE COMMUNICATOR, HEALER, AND MORE

Jesus frequently taught in parables—stories full of symbolic riddles and enigmas. Why not just speak in a straightforward manner? The point was to reveal the ways of Father, unfolding understanding through nurturing relationship. There was also an essential link to the imagination: every story He told activated this gift, underscoring its value.

Jesus broke in and blew the roof off limitation with new and dynamic approaches to problems, making it so that His followers were called *"these who have turned the world upside down"* (Acts 17:6). The recorded miracles He performed were hardly formulaic: He changed water into wine (see John 2:1–12), caused the disciples to catch an unprecedented multitude of fish (see Luke 5:1–11), divided a few fish and loaves of bread to feed thousands of people (see, for example, Matthew 14:14–21), calmed a stormy sea (see, for example, Mark 4:36–41), healed a woman "unknowingly" when she touched his cloak (see Luke 8:43–48), healed people from a distance or up close (see, for example, Luke 7:1–10), used mud made of dirt and His own saliva to restore sight to a blind man (see, for example, John 9:1–7), directed Peter to find money in the mouth of a fish (see Matthew 17:24–27), raised Lazarus from the dead (see John 11:1–44), caused an ear of an arresting guard in the garden of Gethsemane to grow back (see Luke 22:49–51), cursed a fig tree that immediately withered (see, for example, Mark 11:12–25, and rose from the dead (see, for example, Mark 16:6).

People have struggled for centuries to organize Jesus's earthly activities into tidy patterns. Some theologians have gotten so flummoxed, they gave up on any attempts at organization and decided that such things were options for Jesus alone, and not for us today. But Jesus said that His followers would do even greater things (see John 14:12), a statement that did not imply such activities would cease upon with His death.

If we consider the Creator's essence and Jesus's training program, we can see that what He modeled for us was a life of co-creation, of hearing and obeying the divine flow that brought Him unique instructions for each situation. We must learn to embrace the ingenuity of God to see results. When we insist that God's ways must make sense through the

filter of human logic, we reason away His presence, replacing it with a religious spirit that strangles creative life.

EMBODIMENT OF WISDOM

Jesus is granted the mother lode of wisdom, an even bigger dose than Solomon received. (See Luke 11:31.) If we want to know what wisdom looks like, we simply look to Jesus and consider the ways He taught, healed, worked miracles, enacted social reform, fought for equality and justice, birthed the church, and more.

His wealth of wisdom points right back to the pattern's purpose: a transformational trek of holy proportions to change the heart's inward motives. Jesus lived in a time when people had a literal temple of great splendor, yet they were spiritually distant from the true kingdom.

THE ALL-SUFFICIENT SACRIFICE THAT GRANTS US ACCESS TO GOD'S THRONE

Jesus bore the full horror of humanity's sin with the ultimate cost of His life. He became the eternal sacrificial lamb upon the brazen altar. No longer would animal sacrifices be needed to atone for the people's transgressions before a holy God.

Jesus endured untold agony to buy our freedom. (See Isaiah 53:3–5.) The depiction of His final sacrifice in the 2004 film *The Passion of the Christ* gives us a sliver of a sense of just what it cost Him. Darkness fell across the land for three hours as Jesus hung on the cross, His life ebbing from His physical frame. When He finally gave up His spirit in death, a ferocious earthquake shook the ground, graves split open, and the deceased came alive, walking the streets. Jesus's life regained power over death and hell, returning our authority to advance the kingdom of God across the earth. The immense temple veil barring access to the Holy of Holies tore in two from the top. At that moment, everything changed. We were given unhindered access to our Father God.

> *I am He who lives, and was dead, and behold, I am alive forever-more. Amen. And I have the keys of Hades and of Death.*
> (Revelation 1:18; see also 1 Corinthians 15:54–57)

As we grapple with the complexities of the cross, we often try to shrink God into the manageable box of our minds. But this is the God who formed both the intricacies of human life and the labyrinthian solar systems whose magnitude we can never comprehend. Some questions require a wisdom that supernaturally stretches our minds before we get an answer.

8

STAGE SIX: HUMANITY

As the Lord Jesus departs the earth and makes His ascension to heaven, He gives the disciples a legacy of hope. Although He can no longer be with them in mortal form, something amazing is about to take place: the Holy Spirit will be gifted to every believer, awakening the world to sin and teaching the ways of God's kingdom. (See John 16:13.) This incredible indwelling has been amplified in billions of souls across the ages. The Spirit activates believers to do the kind of creative, restorative works that Jesus did—and even *"greater works"* (John 14:12)! There is more to come! On the day of Pentecost, there was a spectacular passing of the baton. (See Acts 2:1–4.) Humanity was filled with the oil of the Holy Spirit and set on fire from heaven to become the next stage of the tabernacle pattern. Now we are the tabernacle; we are the temple.

> *Do you not know that you are the temple of God and that the Spirit of God dwells in you? If anyone defiles the temple of God, God will destroy him. For the temple of God is holy, which temple you are.*
> (1 Corinthians 3:16–17)

TAKING THE BATON

The ticket to this temple life is salvation, by which the Holy Spirit fills our spirit and makes us to become walking, talking houses of worship, just like our Messiah was. The preceding parts of the pattern contain the pieces we need for carrying out our assignment. The punch of cross power tore open access to the ark on our behalf, but we still need to choose to draw close with our whole heart, intentionally and regularly.

We have been warned of the consequences of a lukewarm faith. (See Revelation 3:15–16.) God's grace never seeks perfection, but it does ask for our devotion. In exchange, He has made us His kings and tabernacle priests—what a tremendous tradeoff! (See Revelation 1:5–6.)

PAUL THE *TEKTON*

At the inception of humanity's becoming the current stage of the tabernacle pattern, the apostle Paul brings a message of action, telling believers it's time to build the kingdom of God:

> *We are God's fellow workers; you are God's field, you are God's building. According to the grace of God which was given to me, as a wise master builder I have laid the foundation, and another builds on it.* (1 Corinthians 3:9–10)

This golden nugget of Scripture unites several key elements of the ancient tabernacle. Paul speaks of being a *"master builder,"* with Spirit-given wisdom as his construction materials. He uses the Greek word *tekton*, linking himself with the chain of *tekton* master builders and craftsmen throughout the pattern. As a *tekton* master craftsman, Paul, working with the Spirit Master Craftsman (wisdom), seeks to build the church of Jesus Christ in a process of co-creation.

He knows that any efforts to build the kingdom apart from God will come to naught and that worldly wisdom is as durable as straw in the building process. (See, for example, 1 Corinthians 3:18–19.) Even if a manmade work seems dazzling or particularly skillful, God is not fooled. If we quest for people's approval or work from wrong motives,

it will be exposed in the end. All our works will be tested with the fire of purity. (See 1 Corinthians 3:12–15.) But if we seek to co-craft God's kingdom, training as *tektons* of faith under the Master Craftsman, our efforts will yield eternal reward.

WE THE TEMPLE

Immediately following this workshop in kingdom construction, Paul spells out how the Holy Spirit has shifted His dwelling place from a temple building to the believer's body. The next stage of the pattern unfolds through humanity. This idea was staggering to the people of his day. For centuries of church history, all that believers had ever known was a physical building, whether the tabernacle or the temple. This high jump across the historical system have been a lot to wrap their heads around. Their world was rapidly changing, turned upside down by a radical, pioneering Prophet who had visited planet Earth.

> *THE HOLY SPIRIT HAS SHIFTED HIS DWELLING PLACE FROM A TEMPLE BUILDING TO THE BELIEVER'S BODY.*

Next, Paul urges diligent stewardship of God's mysteries. (See 1 Corinthians 4:1–5.) As the next part of the pattern, we are to draw from the reserve of tools and weapons made available in the preceding stages, shunning nothing to reach our full potential. Spirit-filled to co-create, we must embrace all the tabernacle elements, building together as a diverse and multifaceted body. What will we do with our time on earth as the living tabernacle of God's Spirit? No challenge need hinder our efforts as we engage in kingdom construction. We simply start where we are, with what we have, and enter the joy of the tabernacle team of building believers.

ACCESSING THE GIFT OF IMPARTATION

As we embrace a new panorama of creative evangelism, the gift of impartation can act like invisible ammunition against the powers of darkness. However, as with any weapon, unless you're aware that it's hanging in your holster, you won't intentionally use it to power-pack your creative works.

To *impart* means to give away or transfer something. Jesus set the first examples of how to use this gift—imparting to people, matter, and nature—and His disciples demonstrated their understanding of it soon thereafter:

- *People:* People were healed when they touched Jesus (see, for example, Matthew 8:1–4, 14–15), when they were simply in the vicinity of Him, near enough to touch His clothes or at a distance (see Matthew 14:35–36; Mark 5:25–29; John 11:38–44), and even when they were far away from Him (see Matthew 8:5–13).

- *Matter:* He turned water into wine. (See John 2:1–11.)

- *Nature:* He told a raging storm to be calm, and it obeyed (see Matthew 8:23–27); an abundance of fish suddenly gathered in an area of water where He instructed His disciples to let down their nets (see Luke 5:4–8).

In a similar way, Peter imparted healing through his own shadow (see Acts 5:12–15), and Paul imparted through cloth handkerchiefs (see Acts 19:11–12).

Filled with the Holy Spirit, believers can impart God's Spirit to others; we often call this ability "anointing." We can do this through acts of physical touch or simply by our spoken words, our smile, and even our shadow. Most of us are probably familiar with the practice of laying hands on people as we pray for them (see, for example, 1 Timothy 4:14); perhaps we have felt literal energy being transferred to us as someone prayed for us (see, for example, Acts 8:14–19). Beyond these widely recognized practices, Jesus showed us that impartation can go past physical touch alone.

PURPOSEFUL AND PURE IMPARTATION

Impartation through testimony and teaching raises faith for healing, provision, courage, and more. We can impart through our creative works in sounds and visuals. As with any spiritual gift, impartation needs intentional practice, is limited by the scope of our understanding and the maturity of our faith, and is directly impacted by the influences we draw from. If we are going to make holy offerings, we need to draw our resources through a cleansing filter.

Our lives are influenced by many factors, including the Holy Spirit; our individual skills, gifts, victories, challenges; revelation knowledge; and so forth. When we impart into someone or something, we give away from that collection of influences, whether positive or negative. The world is full of things that others have imparted into. Books, films, political strategies, education systems—all these and more contain impartation from all sorts of people.

We obviously don't want to impart any negative aspects of ourselves into others; goodness knows they have enough of their own negativity to grapple with! We want to be able to give away that which will empower them to follow Christ and fulfill His call on their lives. Thankfully, we have the Spirit to help us. In response to our prayers, the Spirit can filter the flow of our impartation so that we release only that which is positive to others. We can also intentionally sow or not sow things into our works. If we sow striving and frustration, we will impart these things. But if we sow prayer for people to find salvation and healing, for example, they will carry that impartation.

POINTING TO GOD

The practice of impartation through created objects is not to be confused with the crafting of images for the purpose of idol worship, a practice vehemently forbidden in the Bible. (See, for example, Exodus 20:4–6, Deuteronomy 4:23–24; Romans 1:22–25.) I am not suggesting we pursue co-created works with God to worship the works themselves. I am talking about creating beacons of light to point people to God. When the apostle Paul healed the sick by impartation through a piece

of cloth, it did not result in people constructing a handkerchief altar but only prompted them to lift their eyes to Jesus, the true Source of healing. God is not against our making things that lead others to seek and find Him.

> ## GOD IS NOT AGAINST OUR MAKING THINGS THAT LEAD OTHERS TO SEEK AND FIND HIM.

The Ten Commandments, one of which forbids idolatry, were given to Moses around the same time as the blueprints for the tabernacle of Moses—a set of designs containing three-dimensional artworks. Yet none of these designs endeavored to encapsulate the image of God Himself. Herein lies the difference: the Scriptures on idolatrous images have been used across the centuries as a justification of the quashing of artistry and craftsmanship within the church. The pre-Reformation Christian church was loaded with statues of Christ, saints, and martyrs, all made with a mixture of motives. Some of these works did indeed turn into idols, mainly those touted for their supposed spiritual energy. Such claims shifted the emphasis of these pieces from the Creator to the creations themselves.

During the Reformation, which we will soon discuss, art in the church was stained by association with idolatry, and this perception became ingrained in doctrine and practice for centuries. We still live in the fallout of this purge, perhaps embracing the creative works of yesteryear but infrequently seeking the value of fresh expressions.

THE UNLIMITED POTENTIAL OF THE ANOINTING

Anointing is a term we use a lot in church culture. To *anoint* means to smear, sprinkle, or rub with a substance. We can literally disperse the essence of the Spirit on people, matter, or nature, with transformative results. In the context of co-creation, this ability opens a vault of options. What about impartation through financial practices and investment

strategies, through a community sports program, or through techno-logical innovation? The list of possibilities is endless because God's people possess a tremendous range of callings. Many believers impart the Spirit-life they carry without much awareness. When we become intentional and seek to understand what we can release, the power dials up.

Over many years, our teams have witnessed the healing power of God restore people through divine creativity. At times, my fellow believ-ers and I have prophesied through teaching, books, sculpture, textiles, dance, design, painting, poetry, music, and more. A more comprehen-sive range of options is not only valid but crucial for the times ahead. When modern restrictions hamper the sharing of our faith at work, in schools, and elsewhere, we need to seek an understanding of the wider range of options available for advancing the kingdom.

Anointed co-created works can often go where believers can't. They can break down barriers, stir questions, and point people's hearts toward heaven. Art and design are amazing methods for delivering a message. As routine fixtures in every culture, they don't usually come across as strange or threatening to people; therefore, they can enable believers to communicate God's love in unique ways. Not all artistry needs to be loaded with overt religious symbolism and explicitly evan-gelistic wording to have an effect. In fact, such features can repel the unchurched, whose idea of God may be very different from ours and rife with misconceptions. Creative works infused with the Spirit, yet not overtly religious in appearance, can be highly effective in opening hearts and conversations, restoring truth through metaphors and mysteries that illuminate God. People today don't just want a theoretical God but the experience of a living deity. And it is our job, as the sixth stage in the tabernacle pattern, to do what we can to spark such an experience.

9

STAGE SEVEN:
THE RESTORATION OF ALL THINGS

In today's church, there is a lot of talk about "bringing heaven to earth"—plumbing heaven's resources to bring something tangible into the earthly realm, such as healing or compassion through Holy-Spirit gifts and fruits. Therefore, the more understanding we can gather of heaven's dynamics, the better. It is hard to release something with conviction if we don't see its value.

As the current tabernacle of God's presence, we are a connecting point between the two realms. The Bible gives us glimpses into the heavenly realm, like portals for us to engage with its force. But heaven can also become increasingly real for us as we seek connection with the Trinity.

A COMING CITY

Revelation 21 brings us to the seventh and final stage of the tabernacle pattern. This chapter describes in glorious detail the end of days and the holy city of the New Jerusalem. Its construction, dimensions,

and materials are laid out for us in a glance of their glory. This is where we are going to live for all eternity, but, in a metaphorical mystery, it is also the bride of Christ—who we are now and also what we will become.

If this chapter in Revelation describes heaven itself, then the details reveal crucial information for what we are to release upon the earth to help usher in the end of days, at which point will come *"the restoration of all things"* (Acts 3:21). Scripture teaches that in the new heavens and earth, there will be a blend of the familiar revived with the completely new. There will be no physical building called the tabernacle, nor will there be either sun or moon; the shekinah glory will pervade every nook and cranny as the whole city of Jerusalem becomes the divine tabernacle. (See Revelation 21:23.) Pain, sorrow, and death will be banished in the new creation that rises out of the darkness and decay of today's world. (See verse 4.) When the kingdom of God touches earthly things, it regenerates and restores.

A CITY WHERE BEAUTY IS PRIZED

Strangely, nothing about this city seems particularly practical by our standards. Today, when we assess a building's suitability for a church gathering, we consult a list of priorities. Feeling smug at the top end is often function, practicality, ease of maintenance, and seating capacity. On the low end of the importance scale is where we'll often find such considerations as aesthetic appeal. When we think of the construction of a city, we turn our thoughts to stone, concrete, and rebar. Yet Revelation 21 describes a city of mythical proportions and mind-blowing beauty around every street corner.

The materials seem completely impractical by earthly standards—a city made from the purest gold with a massive wall of Jasper, like quartz crystal, 1500 miles in length and height, 216 feet in depth, reflecting the colors of the rainbow like a prism. Colored gemstones fill the foundations of the wall, joining the symphony of light-filled colors bouncing from the gleaming surfaces. Here, no tarnish can settle, just like the lives of redeemed believers in their eternal state. The city "[shimmers] *like a precious gem, light-filled, pulsing light"* (Revelation 21:12 MSG).

The design of this city was God's choice, and the details are very revealing. Many of the features bear similarity to His selection of architectural and interior-design elements of the tabernacle and the temple. This is the final stage of the pattern—the end of days, the restoration of all things. God's passion for creativity explodes! Beauty takes priority; no expense is spared in this lavish and exquisite masterpiece of artistry. There is a commission for us to reach into this ethereal beauty and release its power—to see the kingdom come on earth, as it is in heaven. (See Matthew 6:10.)

REVELATION 21 DESCRIBES A CITY OF MYTHICAL PROPORTIONS AND MIND-BLOWING BEAUTY AROUND EVERY STREET CORNER.

A CITY OF RAINBOWS

The colors of the rainbow are referred to very rarely in most biblical translations. In Genesis, the first rainbow was given as a sign of mercy after the great flood. (See Genesis 9:12–14.) Both Ezekiel and John recorded visions of God upon His throne that mention rainbows, their presence representing His glory being disseminated from His person. (See Ezekiel 1:26–28; Revelation 4:1–3.)

God is light (see 1 John 1:5), and within pure light all the colors are contained. Most of us have probably conducted the popular grade-school experiment of shining light through a prism and seeing it dispersed into all the colors of the rainbow. Just like light, God is not one-dimensional. His wisdom is described as manifold; it is multilayered in a diverse God with endless possibilities. (See Ephesians 3:10.)

ECHOES OF JOSEPH'S COAT

Theologically, Joseph is often identified as a type and foreshadow of Christ because of the many parallels between them. When people think of Joseph, they usually also think of his famous coat of many colors.

(See Genesis 37:3.) Joseph's life story drips with wisdom to help us forge ahead into the mountains of current culture. His administrative and governmental gifts were developed through his youth, while his impeccable character was forged on the anvil of testing during his time in Pharaoh's palace. This dynamite combo prepared him to walk through the doors of extreme influence when the clock struck favor.

Why perceive special significance in this particular garment? It could easily be explained away as merely a cultural symbol of Joseph's father's approval, but I believe there is more to it. Remember, God is never random. Throughout biblical history, Joseph's life story has achieved extraordinary attention that has included his coat. There must be meaning behind this seemingly random "fun fact" in the tale.

The word *"many"* from Genesis 37:3 that is used to describe the colors of Joseph's coat also means "manifold" or "multifarious." And it was the manifold colors of the rainbow that signified God's glory in Ezekiel 1:26–28 and Revelation 4:1–3. I believe Joseph's many-colored coat was a sign that God's glory would be released through His multifaceted nature during the last days. A full-spectrum release of God's character will activate the full breadth of His glory, giving value and space for every expression of His nature to reveal who He is to the world, rather than a narrow range of graded gifts with a restricted narration.

> **TO BE CONSIDERED RELEVANT IN REGARD TO THE ISSUES FACING PEOPLE TODAY, WE NEED TO HAVE BOTH FRESH SOLUTIONS AND A PERTINENT PRESENTATION OF OUR FAITH.**

The prophet Habakkuk wrote, *"For the earth will be filled with the knowledge of the glory of the LORD as the waters cover the sea"* (Habakkuk 2:14). If the glory of God is indeed going to cover the earth, we need to allow God to shine through His church in all His multifariousness, a wholeness of the body. The church is often accused of being

old-fashioned and irrelevant, with prudish morals that no longer apply. But it's sometimes the packaging around our values that proves misleading. To be considered relevant in regard to the issues facing people today, we need to have both fresh solutions and a pertinent presentation of our faith.

Joseph is a prophetic prototype for us today, and the colored coat is an essential ingredient. He operated with wisdom for government, administration, management, strategy, and economics at an exceptional level. But he also shone in the gifts of prophesying, interpreting dreams, and understanding God's creative, metaphorical language. The breadth of his gifts and abilities hearken back to those of David, Solomon, and Jesus. Like they did, Joseph found the key to the door of God's creative powerhouse. The multicolored coat is a symbol that represents this dynamic. None of these individuals made a distinction between what we now tend to deem "creative" versus "noncreative" gifts and abilities. These endeavors were never intended to be split but to work together in a divine fusion that radiates God's glory. To divide them and assign varying degrees of value is to judge the character of God.

GOD, THE AUTHOR OF BEAUTY

Beauty can mean many different things to different people. As Christians, we can tend to limit expressions of God's beauty to Spirit-led character attributes, such as kindness or faithfulness. As important as those are, there is a wider landscape. Revelation 21 focuses on Jerusalem; this city was also the epicenter for the eras of David, Solomon, Jesus, and the dawn of the new church, forming a nucleus of unique creativity throughout biblical history. Different elements have unfolded in the tabernacle pattern to yield a treasury of tools we can activate. But God has even gone a step ahead, allowing us to glimpse what we are becoming and where we are going.

The completion of all things described in Revelation 21 reveals a staggering level of creativity and beauty, the kind that soars far beyond the parameters of our imagination, its visual brilliance fused with living light in connectivity with all elements of creation. The force of this

spiritual dimension lives within us now—the Holy Spirit. Our commission to impart something of this into the earth and its people is possible through any and every example given to us through God's tabernacle design. Therefore, beauty and artistry have no less value than any other element when they are made to reveal God's light in some form. The implications of this are truly exciting; there is much we have yet to understand.

THE ORIGINS OF BEAUTY MANIFEST

In Eden, nature explodes with an extravagant quantity and quality of divine beauty. It's hard to comprehend the details contained in just one flower, let alone the countless varieties. Many of them have practical properties, but let's face it—they didn't *have* to be quite so exquisite. Their intricate beauty is an undeniable expression of who God is. If the myriad varieties of flowers are not baffling enough, there are plants, animals, stars, sunsets, weather patterns, and roaring seas—an orchestra of coalescing scents, colors, textures, patterns, and light all around us. We have been given the gift of living amid extraordinary beauty and wonder.

God formed humanity in Eden; He wanted Adam and Eve to experience it, to see, touch, taste, and smell this tangible expression of His creativity. Yet the average human will encounter only a sliver of such voluminous innovation in the course of a lifetime, so why has God formed so much of it? Why craft everything with such variety and visual magnificence? A quick Google search of tropical birds leaves us reeling at a mere snippet of God's exotic imagination. Clearly, beauty is important to God and carries a power I believe we simply do not currently understand in today's church.

BEAUTY IN THE TABERNACLE AND TEMPLE

The tabernacle of Moses was a riot of exquisite artistry and design, ornamented with the gleam of precious metals, dazzling gemstones, and vibrant colors, as the sweet aroma of incense painted the air with its scents. Sculpted furniture pieces sat bathed in the same iridescent gold

as the walls that framed them, with the reflection of menorah flames dancing across their surfaces. Much like living in Eden, to enter the two inner chambers was to be enveloped with beauty through the senses. God addressed practical needs in the tabernacle design, but He also highlighted the other crucial element—a beauty that releases glory. (See, for example, Exodus 28:2.)

David layered musical praise and prose upon the existing tabernacle elements, his heart full of blueprints for the magnificent future temple. He did not consider God's beauty as only prayer or patience; he understood that presence also released a physical beauty from a full spectrum that included artistry as well as political strategy, craftsmanship as well as justice. Far from excluding beauty, he cherished its treasure and sought God for an understanding of its power. (See, for example, Psalm 27:4.)

The temple of Solomon came next, as we know, elevating the scale of innovation and artistry with an indisputable focus on visual and experiential beauty. No expense was spared in this whopping investment of finances. The temple became the new hub of worship for Israel, from which another creative outpouring took place across the nation.

JESUS AND BEAUTY

Jesus's earthly life was the next link in the chain, exampling yet more forms of creativity to add to the developing layers. It is wrong to assume He did this in a way that rejected physical beauty as if it were connected to the corruption of wealth. Although He raised a salient point about the dangers of loving mammon (see, for example, Matthew 6:24), if He had been referring to all aesthetic beauty, He would have been flying in the face of Scripture. He didn't have a problem with finances being used as fuel for a righteous act. (See Matthew 26:6–13.)

Mistakes are made when the links in the pattern are disconnected. Jesus came to bring us additional examples of God's creative power and to birth His church. Our current grade scale is out of kilter. To reduce the aesthetic arts, beauty, and other creative areas as second-class citizens in God's kingdom makes no sense if one considers the full breadth

of Scripture. If Jesus had intended to do away with aesthetic expressions of His character, then why did He present the spectacular finale of Revelation 21?

BEAUTY'S ETERNAL SIGNIFICANCE

The tabernacle pattern models for us a cache of such elements of creative expression as nature, humanity, sculpture, textiles, architecture, design, decoration, craftsmanship, music, dance, costume, cuisine, trade, engineering, governmental strategy, trade, commerce, business, justice, healing, miracles, poetry, prophecy, teaching, storytelling, parables, and more. Surely, we have been given examples of everything we need. God's essence has seeped through the centuries, transforming the world through every touchpoint believer. There are millions of us across the planet; our collective potential is designed to see His glory fill the earth.

> LIFE LIVED IN THE TABERNACLE PATTERN WAS DESIGNED TO CRAFT THE CHURCH INTO THE STUNNING BRIDE OF REVELATION 21.

Beauty is a manifestation of God's presence. When darkness is present, decay, poverty, and disease follow. When something is transformed, it becomes more beautiful, and within that beauty, there is always a practical impact on the quality of life. When we envision the transformation of something, we don't think of making it appear uglier, regardless of whether it is a person, place, or object. We wouldn't dream of restoring a dilapidated building with a dose of termites and a pack of rats. When we advance the kingdom of God, we not only touch the lives of people, but we also touch things in their environment that consist of matter. The Spirit of God within us emits transformational power, and beauty is released.

Jesus imparted the Spirit into people, nature, and matter. Thus, when we carry His kingdom into our workplaces and communities, we can impart the Spirit and produce a manifestation that bears evidence of beauty. This perspective can revolutionize our lives. What could this look like for a doctor, dance instructor, primary school teacher, hairdresser, accountant, social worker, or builder? Our work roles are not just a way to pay the bills. Life can become full of Spirit-led adventures when we connect the dots, seeking God for creative ways to impart light into our world. The most exciting people I know are those brimming with passion for God. Regardless of age or the challenges they face, they seem to effervesce with innovation.

The creation strains beneath the curse of a fallen world. (See Romans 8:18–25.) Even so, we live in the promise of a full restoration one day. Some believe this world will be destroyed entirely and be replaced by a new one, but that does not appear to be the meaning of restoration. The dictionary defines *restoration* as "the act of…renewal, revival, or reestablishment; a return of something to a former, original, normal, or unimpaired condition." Scripture links us to the rest of creation, and God's exciting plan is for us to be regenerated with new bodies, free from the effects of sin and decay. Salvation allows us to access this restorative force and become touchpoints to discharge it upon the earth.

When the creation is healthy and working according to design, it is also corrective. Rainforests have been deemed the "lung" of the earth, helping to maintain the earth's climate as their expanse absorbs carbon dioxide from the atmosphere to produce much of the oxygen humans and animals depend on. Yet beyond their remarkable functional qualities, they house wild and striking beauty. I believe God wants to do something special through beauty on the earth in these last days.

We are not talking about opulence for opulence's sake. It is not about money, and it never should be; but we can see from the pattern that money is clearly needed at times. When this is the case, we should pursue our profits with faith. God's transformative beauty could be anything from a basket woven with grass to a multimillion-dollar building. The key is to be Spirit-led and open to the full spectrum of His

expression. Imagine spaces like hospitals, offices, and schools designed in co-creation with God. Envision the restorative spirit of beauty that could be co-created for such spaces through any element of God's choosing. Now, consider these pursuits as evangelistic, capable of changing the spiritual climate, dispelling fear, and opening hearts to seek God and ask questions.

What do we consider beautiful? What inspires us? If we sever the flow of sacred originality in our own lives, we will live carrying out the great ideas or trends set by others alone. If you feel caught in a humdrum existence, stop and ask God what were you made for. What is the unique light He put inside you that the world needs to see—a light that will reveal more of His heart to people? It is time for God's people to bring victory with the restorative force of beauty.

PART III

HISTORICAL PERMUTATIONS OF THE PATTERN

10

RENAISSANCE

Although the Bible is teeming with evidence of the importance of creativity, there seems a strange minimization of creative elements in many parts of modern church culture. Whatever happened to the emphasis on exploration, artistic innovation, and beauty? Where did we misplace their value? When did we begin to blunt the quill's nib and leave the paint palette to dry out, constraining God to a more restricted range of communication methods?

There was an era in history that saw a tremendous surge of culture-shaping creative life. The events of that time frame, much like Solomon's kingdom, have much to teach us. It was a time when some of the most prolific scientists, thinkers, inventors, and innovators openly professed to be divinely inspired by God, a time when the church was a nucleus of dynamic design and artistry. Many of these pioneering groundbreakers had to wrestle against the popular tide to bring progress, yet they advanced multiple areas of western culture.

THE ITALIAN RENAISSANCE

It was a volcanic time in church and cultural history, and the two were still very much intertwined. Not long after the death of Christ until the early fourth century, Christianity was a banned religion in Europe. It was only in 337 AD, when Emperor Constantine II and his two brothers came into power, that the ban was lifted across the Roman Empire. History moved through a political division of Rome in the East and West. The West championed Christianity through Roman Catholicism, led by a ruling Pope. Rome's political stronghold across Western Europe disintegrated over time, but the Catholic Church continued to increase in power, with Catholicism the most dominant religion on the continent. By the mid-fourteenth century, something new was bubbling up across culture, something fresh and groundbreaking, and it later became known as the Renaissance.

The French term *renaissance* combines two parts: "naissance," meaning the birth or growth of a person, idea, or movement; and the prefix "re-," indicating a repetition. During the period of the Renaissance, there was a resurgence of fascination with ancient philosophers and the products of early Greece and Rome.

I would also like to submit that there was evidence of a reawakening of tabernacle-type creativity during that age. Solomon's kingdom was a sort of biblical renaissance, ignited by the Genesis spark and lighting the way to advance the surrounding culture. In the same way, the Renaissance that began in Italy tapped the same dynamic to pioneer a new epoch of creativity.

The creative DNA of God that humankind received in Genesis 1:26 has flourished at every stage of the tabernacle pattern. It is as if God breathed awakening on this stage of history. Wisdom sparked the kind of inventions, scientific discoveries, artistic masterpieces and social progression that had never been grasped before.

TURNING ON THE LIGHT

Leading up to this time of progress in European history, the Middle Ages—also called the Dark Ages—had been a period of conformity,

superstition, and fear. To deviate from the acceptable methods of thought or behavior was to be treated with suspicion and even punishment. The Catholic Church reigned supreme, wielding utmost influence and power across Western Europe. Education was church-led and taught strictly through the perception of its leaders, and exploration was not willingly embraced.

The church's leading powers set strict biblical interpretations; to dare voicing a different perspective was to commit heresy. Extreme measures of public punishment strived to prevent any divergence from the church's iron grip, including burning at the stake. Ignorance prevailed through a lack of education, as many people could not read or access written information for themselves. The Bible remained incarcerated within the language of Latin, primarily understood by the Catholic priests, who were the educated scholars of their day. Most people outside their tight circle could not interpret Latin. The people relied on the priests to translate the Word of God and bring spiritual guidance. However, a detrimental domino effect began to ripple from the top down as the church became increasingly corrupt.

Many people remained in abject poverty while the church employed exquisite art and architecture to portray an elevated, divine status over ordinary people, generating a mysterious gulf that kept the two firmly separated. Rome became filled with fleets of builders, craftsmen, and artists commissioned to fashion achievements of staggering skill. The closely intertwined state and church joined forces on many large projects. Art forms were used as status symbols between Italian cities competing for rank and recognition.

In the thirteenth century, Italy was transformed as merchants brought an influx of trade that provided new ideas, materials, and wealth. The Italians were famed for their love of beauty and artistry. Lucrative merchants and bankers like the Medici family of Florence became benefactors of lavish creative projects, often partnering with the church. But they also dominated many governmental decisions, their influence reaching across society like an impenetrable net. A new guild system allowed artisans to rise through the ranks of society. Cityscapes

were transformed by breathtaking beauty as innovation and the arts thrived on every level.

MIXED MEDIA

Many wealthy benefactors and supporters of the arts genuinely believed their money was being spent righteously to magnify God's glory. It was an era of prodigious seeking to understand both the visible world and the spiritual one beyond. Because most people could not read the Bible for themselves, the arts brought the pages of God's Word to life with visual depictions that explored the relationship between Creator and creation.

THE ARTS OF THE RENAISSANCE ERA CANNOT BE SUBJECTED TO A SIMPLE DIVISION BETWEEN THE HOLY AND THE PROFANE.

The art produced in this era cannot be subjected to a simple division between the holy and the profane. Many of the masterpieces express diverse influences, a veritable mixing pot of ancient Greek mythology, humanism, and intellectualism blended with the divine. It would be unfair of us to point a finger back in time and decide which works of art are "acceptable" from a Christian perspective. People were searching for a more meaningful relationship with God than was conveyed in the confines of the religious system. Keeping the Bible locked in Latin and forbidding translation held the people in separation from God and under the control of a church system that was bleeding poison. It was as if God reached out to stir the waters, stimulating a desire for truth to break the stalemate. In the quest for wisdom and knowledge, spiritual life seemed to rise through the wrestling to find a true depiction of God. How can we learn if we cannot explore and question? God has never been afraid of questions.

ARTFUL EDIFICES THAT ENDURE AND INSPIRE

City development became hugely significant in the bid for independence between the towns and cities of Italy. The more affluent a city became, the more extravagant were its creative works on display. City design and planning evolved with improved water and sewage systems, roads, public squares, and sweeping colonnades. Buildings were constructed with the aim of glorifying God while stretching the limits of human capability, as experimentation with new forms demanded new engineering techniques. Many famous artisans were also civil engineers, and the heady cocktail of design, craftsmanship, fine art, and engineering led to some of the world's greatest technical and visual masterpieces.

Filippo Brunelleschi introduced the principles of linear perspective, a rediscovery that gave rise to fresh capabilities in building design and engineering. Blueprints became more detailed and accurate, and buildings were therefore able to be crafted with greater complexity while avoiding prior pitfalls. Brunelleschi's Dome at the cathedral in Florence is one of the finest domes ever constructed in Christendom. Built without scaffolding, it holds millions of bricks in a feat of sheer brilliance. It took historians four centuries to discover how this work was even possible, and even the machines Brunelleschi invented to complete the task were considered technical marvels. These breakthroughs in engineering and design inspired a host of new architects across Europe. Many cathedrals, churches, and other magnificent buildings that proliferated in that era still stand today, yet they were built at a time when machinery and tools were extremely rudimentary and the work painstaking.

A plethora of contributors to these projects certainly brought a mix of motives—a blending of the sacred and sinful—as the players tussled to understand life and religion. Yet, despite the journey to actualize such spaces, it's as if some of the sacrilegious slipped away through time. The results still daily inspire reverence of God, drawing visitors' eyes heavenward and causing them to at least consider a connection with God. As with the tabernacle of Moses and temple of Solomon, we find an abundance of imaginative interpretation. To survey some of Rome's surviving

grandeur is to be awed by overwhelming beauty, skill, and effort. It can be hard to find a free space among the frescos adorning soaring ceilings with their details so out of reach to the human eye that they were clearly not made for humanity's satisfaction alone. Walls festooned with painted masterpieces of Bible scenes; sculptures of holy heroes, mysteries, and saints; triumphant floors decorated with marble—all these inspire awe with their excellence. God pushed beyond the limitation of words, igniting a revival of exploration, and again He chose the arts as a central language for expressing Himself.

CROSS-DISCIPLINARY CREATIVITY

Today, many people seem to perceive a clash between science and faith. But during the Renaissance, the two were dynamically interlinked in an eagerness to investigate and understand the natural world—and many of the scientific minds of that day were also artists! For example, the famous Leonardo da Vinci made notable contributions in the fields of art, sculpture, engineering, and invention. Although many of his paintings depicting biblical scenes were commissioned by the church, he struggled with aspects of the religious order of his day. In the heat of corruption seeping through the church, he could not condone what he saw—the misuse of divinity as a facade to mask a power struggle. Instead, he sought to explore the proof of God's omnipotence. Numerous drawings of his still exist, and some even lie unfinished; "The Last Supper" is among them, stirring endless debate, as if the very essence of da Vinci's constant questioning still leaks from the canvas.

DURING THE RENAISSANCE, SCIENCE AND FAITH WERE DYNAMICALLY INTERLINKED.

Michelangelo Buonarroti was another voracious seeker and artisan of the Renaissance era who used art to express his faith. In his words, "The true work of art is but a shadow of the divine perfection. Only

God creates. The rest of us just copy."[8] His Sistine Chapel frescos tell the story of creation, embellishing expansive walls and ceilings with the workmanship of a maestro. He was a notable force in turbulent times through the voice of his art and architectural works whose impact endures to this day. Through a life of remarkable talent and soul searching, he concluded in his final years that Christ was the only way.

The explorations of faith and science were inseparable for many Renaissance minds seeking to understand the world and its Creator. In the seventeenth century, Sir Isaac Newton made a huge impact in the world of scientific discovery—and publicly credited his faith in God for the stimulating force of his quest. He penned more about biblical interpretation than either mathematics or science. One of his greatest works, *Mathematical Principles of Natural Philosophy*, explores the dynamics of our world together with planets and galaxies. When Newton discovered the force of gravity, he viewed his finding as additional proof of God's majesty.

Music was another area profoundly impacted by advances in technique and new understandings of theology during the Renaissance and in the decades that followed it. German-born Johann Sebastian Bach, captivated by the writings of Martin Luther and the glories of David's tabernacle, penned over a thousand compositions with a faith so strong that three-quarters of them were written as worship music.

In the same era, George Frideric Handel composed timeless pieces with the Word of God as his driving force. Like Bach, he persevered through great highs and lows in his career. His dramatization of Bible stories through music and prose was considered outrageous, and some of his so-called scandalous works were even banned by the Bishop of London. Handel powered through the controversy, and some of his performances were even attended by royalty. Yet the contention between Handel and the church shattered his reputation and led him to the verge of financial ruin. As a hail-Mary pass, he was hired to compose a score to complement biblical text written by a friend Charles Jennens,

8. "Michelangelo," *The Art Story*, accessed August 5, 2021. https://www.theartstory.org/artist/michelangelo/.

and Handel's *Messiah* was born. Written in just twenty-four days, this piece is considered to be a feat of pure genius. Handel conducted thirty performances of this masterpiece.[9] When he had completed the movement now famously called the "Hallelujah Chorus," he said, "I did think I did see all Heaven before me, and the great God Himself seated on His throne, with His company of Angels."[10]

A LEGACY OF EXPLORATION AND INNOVATION

Over the years, the Catholic Church was forced to lessen its choke hold on society. Liberated from previous constraints, science took greater leaps. It was considered noble to seek truth using one's natural, God-given talents. Many scientists made it their mission to study the universe, signaling the dawn of a new era of scientific exploration and technological advancements.

What is striking is the way Renaissance creativity has continued to impact our modern era, over 500 years later. St. Peter's Basilica and the Sistine Chapel in Rome still net millions of visitors a year. In 2018, a painting believed by some to be an original Leonardo de Vinci, called the "Salvator Mundi" (meaning "Savior of the World"), sold for a record-breaking $450 million. It was restored by expert conservator Dianne Dwyer Modestini, who worked painstakingly for many years to restore its original brilliance. She said that saying good-bye to the painting after its completion felt like a painful breakup. In the words of Modestini, "It was a very intense picture and I felt a whole slipstream of artistry and genius and some sort of otherworldliness that I'll never experience again."[11]

9. "George Frideric Handel," *Christian History Magazine*'s book *131 Christians Everyone Should Know*, accessed August 5, 2021, https://www.christianitytoday.com/history/people/musiciansartistsandwriters/george-frideric-handel.html.

10. "The History of 'Hallelujah' Chorus from *Handel's Messiah*," *The Tabernacle Choir Blog*, February 22, 2016, https://www.thetabernaclechoir.org/articles/history-of-handels-hallelujah-chorus.html.

11. Allsop, Laura. "Living up to Leonardo: The terrifying task of restoring a da Vinci," CNN.com, November 10, 2011, https://www.cnn.com/2011/11/10/living/restoring-leonardo-da-vinci/index.html.

The sculptures, paintings, writings, music, and more from this productive time period resonate strongly with people today. The same can be said of the publications and theological breakthroughs that occurred during the Reformation, which we will explore in the next chapter.

RENAISSANCE CREATIVITY HAS CONTINUED TO IMPACT OUR MODERN ERA, OVER 500 YEARS LATER.

11

REFORMATION

In the early sixteenth century, the spiritual wheels in Europe began to turn through the dynamic teachings of a fourth-century saint called St. Augustine. He believed in salvation through grace, not the crushing burden of good works, and he deemed the Bible, not the church, to be the final authority. This position was diametrically opposed to the church's stance, which taught good deeds as the ticket to paradise; the harder you tried, or the more you paid for the purchase of indulgences, the better chance you had of avoiding the scorching pit of hell.

As the deadlock of ingrained beliefs began to slacken, people experimented increasingly with new ideas and theories. A surge of secularism arose, demanding a separation between religious authority and the workings of society. Freedom of thought fueled the Renaissance juggernaut that thundered through the culture. There was a bid for liberation from the fire-and-brimstone teachings that had paralyzed pioneering. It was an increasingly tense and incremental shift toward change, like the stacking of dry wood for a potential bonfire, until it finally ignited in a movement that would change the course of history forever. It was called the Reformation.

LUTHER LEADS THE WAY

In 1483, a trailblazer entered the world who would challenge the religious powers of the day. Martin Luther was born in Germany during an era when poverty and a dearth of education caused great hardship for ordinary people. The bubonic plague could wipe out entire towns, and people were desperate for hope. Church teachings assured believers that obedience to its rules and rituals would ease their troubles with the promise of eternal happiness in the next life. Church laws and restrictions permeated every aspect of daily life. During Luther's childhood, the Roman Catholic Church wielded the greatest power in Europe—a power tainted with corruption and tyranny. Luther would become a force that defied this religious fortress, unleashing a voice of freedom that still resounds through our world today.

MONASTIC BEGINNINGS

It seems that Martin Luther was aptly named: Martin means "servant of Mars, god of war,"[12] and Luther means "army of the people."[13] Born in a small German town to parents who hoped to see him practice law, he changed course after nearly being struck by lightning in a storm in 1505. The event brought him a dramatic encounter with God that soon had him packing his bags, turning his back on studying law, and joining a local monastery of especially strict order—much to his parents' chagrin.

As he entered into the frugal and rigorous existence of a monk, he embraced the belief that redemption could be attained only through self-denial, and he accordingly subjected himself to a life of abstinence from even the most basic of needs and comforts. Yet in his commitment to live a righteous life, it was as if the smile of God's acceptance always eluded him. He grew terrified of a God he could never seem to please.

12. Babynames.com, s.v. "Martin," accessed August 5, 2021, https://babynames.com/name/martin.
13. Babynames.com, s.v. "Luther," accessed August 5, 2021, https://babynames.com/name/Luther.

Cyclical striving and self-debasement led him to the tipping point that became his personal catalyst for change.[14]

DISILLUSIONMENT AND REDIRECTION

The head of Luther's monastic order sent him on a commission to Rome. For Luther, this city was the famous epicenter of the church and its ethics, the embodiment of the leadership he followed—the supreme example of God's presence on the earth. He had poured out his life to pursue the holiness and justice it represented. But, to his horror, Rome was far different from what he expected. The bedrock of his beliefs lay shattered as he witnessed painful poverty cheek by jowl with the staggering opulence of the church's creations. He arrived in Rome at the height of the Renaissance, when Michelangelo was painting the Sistine Chapel and Raphael was busy decorating the Pope's glimmering apartments. Luther came from the lowly provinces, where life was harsh with deep and prevalent poverty. To be confronted with the contrasting lavish grandeur of domes and palaces was simply overwhelming, especially when such wealth originated in the very institution that claimed to hold exclusive salvation of the needy.

Luther's efforts of self-deprivation and monastic chastisement had been in response to church doctrine—a system he had not only espoused but passionately repeated. The Bible taught that the love of money was the root of all kinds of evil (see 1 Timothy 6:10), a lowly demeanor the highway to holiness. Yet here, he saw the mouthpieces of such teachings live like self-appointed royalty among pomp and palaces.

THE CURTAIN PULLED BACK

What he discovered was a very earthly-minded institution siphoning money from the poor in the form of tithes, offerings, and fees. Swaths of wealth were funneled to Rome to increase the showcase of power through capital and ceremony. The nucleus of spiritual pilgrimage was run by very unspiritual people. The church taught that purgatory was

14. See Voschezang, Hans. "A Lightning Strike, Which Changed History: The Lord and Luther," Christian Library online, accessed August 5, 2021, https://www.christianstudylibrary.org/article/lightning-strike-which-changed-history-lord-and-luther.

a place of purifying punishment between death and the entrance to heaven. Luther discovered its dastardly scheme to cash in on the terror of such teachings by the sale of "indulgences," or passes to lessen the penalty of purgatory. The more passes one purchased, the greater one's absolution from sins, presumably yielding less suffering. In an age of ignorance and lack of direct access to biblical truth, these lies thrived, filling the pockets of the papacy.

Luther returned home deeply grieved after witnessing a horrifying mix of the holy with the profane. He became desperate to find answers and salvation for his own soul. In 1511, his order sent him to a smaller monastery in Wittenberg, where he became a professor of biblical studies at the new university. In his search for absolution, he came to share the central belief of St. Augustine that salvation was a gift of God.

A CHANGE OF THEOLOGICAL COURSE

Finally, the implications of Jesus's sacrifice on the cross began to sink in. Eureka! Salvation was something to be received, meaning there was no need for an intermediary, such as a priest, to carry one's confession to God like a bargaining chip. He realized that salvation was not about faultlessly fulfilling the rituals and doctrines of the church, or walking a tightrope all the way to the pearly gates after passing through painful purgatory. Eternal life came through the cross, not the church; through grace, not good behavior. The liberating life of God's unconditional love transformed his heart. He saw the truth but also the scandalous robbery taking place through the lever of control and fear.

Meanwhile, the sale of indulgences was spreading from Rome and out through the provinces like a plague. A highly corrupt new pope had taken charge. Julius II intended to elevate his status with an excessive project to rebuild St. Peter's Basilica. He used a terrifying message of hellfire to raise money for this immense project. The people eagerly bought up indulgences, believing themselves to be purchasing near escape from torturous flames. The cash was rolling in, creaming money from the poorest in society to create opulent signs of power—a man-made religion for the benefit of the ruling few.

THE WRITING ON THE DOOR

This practice disgusted the newly enlightened Luther and drove him to write his famous 95 Theses of biting points challenging the church. He is said to have pinned the document to the door of All Saints' Church in Wittenberg for all to see. In this revolutionary document, he shared his new understanding of the Bible as the pivotal authority and of salvation as a free gift received by grace through faith, and questioned the practice of selling indulgences as well as the parameters of papal power.

It was common practice to pin documents to the doors of churches to raise healthy debate. It seemed as if providence caused this event to occur on the tails of a revolutionary new invention: the printing press. Without Luther's knowledge, his document was translated into German, printed, and distributed widely, launching a blistering attack on the great power of the western world. Luther probably had no idea he had released a tornado that would change western civilization forever. But when he realized the potential powerhouse of this new machine, with its rollers and sticky black ink, he went on to intentionally publish more material that exposed corruption in the church and changed the minds of the common people. He also gathered support from powerful German nobility for his efforts to purify the church.

Rome kicked back and demanded he publicly recant his accusations, even threatening ex-communication. To be cast from the church and branded a heretic meant becoming an outcast of society and risking the constant threat of violent attack and death. But even in the face of such grim prospects, Luther's conscience would not permit him to recant. In a series of political moves, he was given a voice to speak in parliament and concluded his statement with the famous and defiant words before the Imperial Diet of Worms on April 16, 1521:

> Unless I am convicted by Scripture and plain reason—I do not accept the authority of the popes and councils, for they have contradicted each other—my conscience is captive to the Word of God. I cannot and I will not recant anything for to

go against conscience is neither right nor safe. God help me. Amen.[15]

A RIPPLE EFFECT OF REFORMATION

By this point, Pope Leo X had taken power. He voted to excommunicate Luther, while then-Holy Roman Emperor King Charles V ordered his writing to be burned. Interestingly, Pope Leo X died the same year. Luther was carried away into deep hiding by his supporters. At the very point when all seemed lost, he began to work on one of the major achievements of his life—a German translation of the entire New Testament, which took ten years to complete. About a year after going into hiding, he emerged to find that a Protestant revolt had exploded far beyond the bounds of his expected influence. It was a time period primed for religious revolution, and Luther had been like a spark to dry tinder. The Protestant Reformation blazed across Europe and splintered the Roman Catholic Church as people rose up against religious corruption, burned places of worship, and assaulted monks and nuns who fled for their lives.

The revolt sought to purge everything the Catholic Church had represented. Art and architecture had been used for good and tainted by evil, but no one was interested in defining the difference in the whirlwind of revolution taking place. Many magnificent churches and cathedrals were razed to the ground and exquisite works of art decimated. Rome and Florence were battered and pillaged.

Luther had never envisaged change with such aggression, and he spoke out against it, distancing himself from the violence. Even so, the surge of reform he had helped to unleash took various forms in different nations. Luther's ideas inspired zealous Reformation leaders like George Wishart, John Calvin, and John Knox. Many people fled to escape the destruction that pulverized Europe, even seeking safe harbor in the newly discovered land of America, a blank canvas of fresh possibilities. The Reformation was a volcanic catalyst that broke the dictatorship of

15. Wittenberg, KDG. "Luther Before the Imperial Diet of Worms (1521)," 1997, https://www.luther.de/en/worms.html.

one representation of Christianity, allowing diversity through the rise of Protestantism and the birthing of denominations within the Protestant church.

NO PERFECT RECORDS

In his later years, Luther took on increasingly radical views against the Jewish people and other groups. He is remembered for his skill and courage as a vocal wrecking ball against the corrupt church institution of his day., and his theological input and vast achievement in translating the New Testament into a language ordinary people could read truly shaped history. Sadly, he is also remembered for his scathing attack on the Jewish people, which has left a bad taste in the mouths of many.

His life, like the lives of David and Solomon, serves as a lesson that, in our human frame, we can achieve greatness in our callings, enabled through a relationship with God; but, in the same lifespan, we can also wreak great destruction and commit grievous error.

12

ENLIGHTENMENT

On the heels of the Reformation, a period in history known as the Age of Enlightenment continued to investigate and improve culture. Firmly rooted in intellect and philosophy, it explored new ideals such as liberty, tolerance, constitutional government, and separation of church and state.

A movement known as the Scientific Revolution also emerged toward the end of the Renaissance, flowing into the Age of Enlightenment with an exciting swell of scientific discovery through mathematics, physics, astronomy, and biology. The result was a restructuring of society's views about nature and the human body, with many medical advances that improved quality of life. A team of more than one hundred scientists, philosophers, and artists came together to compile one of the most famous publications of the era: *Encyclopedia, or a Systematic Dictionary of the Sciences, Arts, and Crafts*. This prolific work consisted of twenty-eight volumes, published over twenty years, with over 70,000 articles and 3,000 illustrations. As the government and church jockeyed for control within society, this explorative work was seen as a controversial threat. Its

liberating concepts encouraged people to expand their thinking, easing the hold of the better educated over the working classes.

SPIRITUAL REVIVAL ALONGSIDE INTELLECTUAL

Across history, many individuals and groups have used the name of God in an effort to control others. During the Renaissance, a wave of demonic power arose within the church. Disguised as religion, it aimed to discredit God, depicting Him as a controlling tyrant. Yet while this destructive swell was gaining momentum, something extraordinary was happening. Another force was rising—a wave of the Holy Spirit inciting people to break free and find new spiritual territory for their faith, to explore, to pioneer, to create! As in other times throughout history, God loosed a spirit of revival that seeped through the minds and hearts of people legitimately seeking Him not just for power but for relationship.

These seekers discovered more of the Father's true character and the genius in His creation through their journeys. God has never feared the swirl of seeking that seems inevitable as humanity wades through a mix of influences. It's a journey of emerging truth as we cultivate connection with the Father. Truth may take time and perseverance to sink deeply into the heart, but when it does, it carves new boundary lines for a holy life. To co-create with God in a voyage of exploration is one of the most thrilling experiences—the discovery of His destiny for our lives.

WHAT COMES NEXT?

The kingdom of Solomon was a sort of biblical renaissance; and, just like the Italian Renaissance, it began with a quest for divine wisdom and knowledge. In both cases, we find similar results from a pursuit of the Master Craftsman. There was a torrent of creativity, innovation, and enlightenment that transformed culture across the board. History records the activating role of the arts in every culture, shaping society and stirring a longing for wisdom in many other areas. During both time periods, we find the same key to success: open arms to the full spectrum of language and character of God. The Spirit's pure and potent creativity evokes questions, fueling a desire to search for life's meaning.

Let's consider once more the Italian Renaissance, this time seeking to understand what God was doing. Why was there such a productive impact on world culture in those times? We can learn a lot by contrasting the church of that era with our modern church. Currently, we lack a volume of true explorers and pioneers in the church. We frequently quench the change they were designed to supply by substituting the age-old familiar. Nobody wants to rock the boat. Yet Jesus invited us, as He did Peter, to join Him outside the boat among the high winds of change and waves of risk and faith in a quest for new opportunities.

We must pose an honest question: Are we falling behind the times and our ability to influence the world around us by clinging to the familiar, to that which makes us more comfortable? The world is full of seekers grappling to understand truth amid the messy layers of world culture. People need answers to modern problems with a faith culture that connects with the world they live and work within.

THE SPIRIT'S PURE AND POTENT CREATIVITY EVOKES QUESTIONS, FUELING A DESIRE TO SEARCH FOR LIFE'S MEANING.

CONNECTION THAT BOTH GENERATES AND RESULTS FROM CREATIVITY

It's time for an upgrade—time to equip God's people to seek the missing wisdom needed for making a spiritual splash in modern culture. It is time to co-create with the divine dynamo of Spirit genius. The results will gather seekers into the excitement of new possibilities and point people toward the Author of their life's purpose. What if some of the greatest scientific minds and most prominent technologists attributed their advances to God? The world would sit up and take notice. Our Christian quest is to connect with today's culture and seek to demonstrate God's kingdom in ways that genuinely reach contemporary society with hope.

Both the renaissance under Solomon's reign and the Italian Renaissance generated a whirlwind of seekers stimulated to sift their surrounding influences till the truth came to light. However, when we knowingly mix divine wisdom with the sacrilegious, there are serious consequences. We have been appointed as ambassadors of the kingdom of God on the earth. (See 2 Corinthians 5:20.) We can't take wisdom's pearl of limitless prize and mix it up with anything we feel like; we must guard it with our lives.

God is not looking for a flawless finish. In fact, perfectionism lands among the prime barriers to real relationship with Him, and it is a ruthless killer of creativity. The Father seeks a connection with us that endures sin and storms. Grace is given for our grapple to live an honorable and creative life.

REVIVAL ON EVERY LEVEL

A surge of revival rose through the Italian Renaissance as innovative energy that changed society. We frequently have a fixed concept of what constitutes revival. We sometimes restrict it to healing services or look to the revivals of old to dictate the moves of today. To *revive* means to restore something to life with vigor and strength. Large sections of the church have rejected certain past revivals because they were full of unfamiliar activity. They stayed in the proverbial boat, despite its violent rocking.

By the time Jesus arrived on the scene, many people had a fixed view of how the Messiah should come—bursting in majestically on a cloud of glory to seize all earthly thrones with power. But He slipped in the back door, took a lowly seat at the table, and flummoxed them all. His presence slowly permeated the culture like yeast through bread, causing everything to rise. Jesus arrived at an earlier time when the spirit of religion dominated, a time when the church was contaminated and did so poor a job representing God that sin and desperation swelled among the people. Jesus rose like a punch of revival power to meet this religious spirit head-on, resulting in mind-boggling change.

The revival taking place during the Italian Renaissance happened in much the same way. The religious spirit found a wide-open doorway through human greed, producing a destructive force through the church. God had to build a bypass route to skirt the tainted religious institution and counteract its tired traditions with a rush of creative genesis. Revival came by way of the wisdom hunters like yeasty ferment through dough, changing the culture completely and pushing back the nefarious forces in the church with a process of purification. The results of that era have lasted centuries and still shape our society today. The Age of Enlightenment is said to have moved the world from the long and restrictive Medieval age into the Modern Age, and it all began with a hunger for God.

COMING REVIVAL

I believe there is a coming wave of revival containing the same creative energy as Genesis that will crash upon the world's cultures in unexpected and extraordinary ways. This futuristic renaissance may not necessarily be all about "super tech"; the times ahead will likely bring a paradoxical mix of levels of sophistication with a breadth of solutions. It will come through a company of people willing to lay down old assumptions and embrace the eternal—through the innovators, inventors, artists, and idea people ready to embark on a journey of co-creation.

WHAT DOES GOD WANT TO DO IN OUR CULTURE TODAY?

How does God desire to shape our culture, and what part would He like us to play? If we want to see revival energy, we must be willing to see it happen on God's terms. What if it looks completely contrary to what we expect? If another revival of God's creative power is to rise through our culture, then it may have a whole bag of unexpected goodies thrown in for good measure. Are we ready for a tide of seekers rolling in, messy

and grappling with the profane and the holy? Will we let them question and search till the truth emerges? Can we learn from the renaissances past that allowed people to explore through a broad spectrum of avenues, as humankind was created to do?

HARNESSING REVIVAL POWER

God is speaking through arenas we consider as having world-class quality, but they contain kingdom-class values: music, film, politics, business, education, and more. Do we see what He is already doing in our culture? There is a world full of the Spirit at work. God is looking for us to become excellent stewards of revival power.

Historically, the church is infamous for being more resistant to change than just about any other part of society. It seems paradoxical that we should struggle to lead the charge toward innovation when we consider that God's people have direct access to the Creator Himself! Of course, the power that results from that access is the thing the enemy does not want us to get our hands on. It's time to hunt for revival treasure as God's creative energy intensifies in the earth. Let's pray for eyes that see its form glistening in the clefts of modern culture. The refreshing winds of change are blowing again, their chill rousing the beloved out of sleepy sameness. It is time to become an innovative army, careful custodians of a harvest revival.

PREPARING FOR BATTLE

The Protestant Reformation sought to purge the church from anything associated with Roman Catholicism. Art and architecture got caught in the crossfire, left to bleed out on the battlefield of church culture, never to be recovered. The new reformers bolted in the opposite direction, stripping away decorative devotion and condemning it as idolatry and excess. The church denominations that later emerged diversified, but a common thread was a stark lack of artistry in their church buildings, liturgies, and so forth.

The word *reformation* often implies the correcting of something inherently wrong. Artistry and design within the church are not

implicitly wrong or evil; indeed, they were created by God. They are simply vehicles for communication. It is what we do with them that determines their moral value. Because of their ostentatious use by a corrupt and all-powerful institution such as the Catholic Church in the years leading up to the Reformation, they became stained by association. Over 500 years later, we are still dealing with the fallout. Yet the modern church seems to little understand the devastating impact of these historical events on creativity and on our way of living out our faith. It's almost as if the pages of history between then and now have been ripped from the book.

The enemy is well familiar with the potential of these hidden pages of history. And so he attempts to keep them concealed, lest the church awaken to reality and seize its true potential. Satan's nefarious influence was central to the rot of the Renaissance period. If he could not utterly destroy the church, he at least hoped to destroy us believers' link to the creative genius of Genesis power and to restrict our ability to influence people by limiting our languages of expression. If artistic and creative innovations formed the explosive nucleus of both the renaissance of Solomon's reign and the Italian Renaissance, then their suppression today will have a profoundly devastating effect. Instead of a ripple outward from an ingenious core, there will be a diminishing of innovation across all fields. Influential creativity feeds on the freedom to investigate.

FORGING AHEAD WITH CREATIVE FORCE

Can you envision a world that remains content with what it has and looks no further? Can you imagine a world without music, visual arts, fashion, film, literature, architecture, explorative research in science and medicine, new ideas, new inventions, advances in technology, and so on? These are the very building blocks of our culture, and their diversity across the globe is what gives this life its flavor and also contributes crucially to the progress of mankind.

And yet, while the secular world seems to embrace a broad spectrum of creative expression and pioneering discoveries as it forges ahead

into future, daily influencing millions of people, the church seems sometimes to tiptoe forward nervously. No wonder its influence on current culture appears to be decreasing! Many believers long for change but struggle to break from the established system with no apparent alternative in view. The enemy has blurred our vision for too long, causing Christians to lose sight of the historical sequence of events that led to the dearth of creative energy we're now experiencing. Remember, we are the ones with unlimited access to the greatest power in the universe! We have the potential to co-create beacons of innovation that will light a path to God, just as they did in the times of earlier revivals.

Although the world may operate with a broader spectrum of expression, it draws from many wells of inspiration, saturating itself in soulish desires, flaunting darkness freely, and glorifying humanism. It mass-produces imitation, filling society with excess that injuries both the planet and its people. The creative works of heaven have something entirely different in mind. They carry qualities that heal as we move toward the restoration of all things. Free from unholy entanglements, they will glorify the Creator who is calling His sons and daughters home.

We are designed to be the head and not the tail. (See Deuteronomy 28:13.) A co-creation movement is arising that will require a panorama of cultural areas as its playing field for transformation. The creative army of God must be free from a dated perspective, carrying tools and weaponry for the modern age we are called to reach. We are to become known for unleashing a flood of spiritual beauty—not infamous for what we say no to. The attention must shift to what it is we're contributing that rocks the world. People are less inclined to attack the source of stunning, selflessly motivated change and more likely to ask about its origins.

PART IV

PERPETUATING THE PATTERN

13

THE JOURNEY OF CO-CREATION

*Why do we need art? Why do we need the lyric poetry of the
psalms? Because the only way we can approach God is,
if we're honest, through metaphor, through symbol…
so art becomes essential, not decorative.*
—Bono[16]

What would happen if we began to dream freely and co-create with
wonder? When the lies lift and the view clears, what will the Spirit show
us for our lives, workplaces, and communities? What can become possible? Apprenticeship with the Master Craftsman in the wisdom workshop will teach us what we need to know. At times, we should feel the
discomfort of being out of our depth to develop increasing interdependence on the Spirit. Our story can become a diving board of encouragement from which others can bounce. Tales of our successes and
accounts of our nosedives can inspire their high dives. In the economy
of God's kingdom, nothing is wasted. All we have to do is model courage
and a willing heart.

16. Bruce, Clare, "Bono Shares His Heart for God With Eugene Peterson" (video),
Hope103.2, April 29, 2016, https://hope1032.com.au/stories/faith/2016/bono-shares-
heart-eugene-peterson-video/.

THE PROCESS BEGINS

At the beginning of the journey comes the awakening and release of creative DNA for every believer. This can be expressed, celebrated, and developed from any level of skill. Following this stage, the levels build as people invest in training and practice to progress skills and develop experience. Arriving at a significant level akin to a professional standard takes a great deal of personal effort and resources. These people have a specific commission to use their craft for particular areas such as music, writing, film making, fine art, architecture, and so forth.

FOLLOWING GOD'S LEAD

Concocting a plan and hoping God will back it up is a familiar approach—one that never yields fruitful results. We can't just stick a label marked "God's" on our own handiwork, believing that alone will make it holy. We need to learn to work with the Spirit, following His lead in such activities as brainstorming, crafting blueprints, and co-creating through friendship.

Practically speaking, there are all sorts of mechanisms to help us take initial ideas through the stages of development and on into completion. One process that many people find helpful is to begin with a vision or objective, then develop a strategy of specific tactics to reach that goal.

Practicality aside, working with God is a process that is full of unexpected surprises. His ways are simply not our ways (see, for example, Isaiah 55:8–9), so we must remain flexible. As we progress in this process, a metamorphosis takes place within us, rearranging our thought processes. We begin to approach every project with divine expectations, not earthly limitations.

Relationship leads to enlightenment. The Bible is stuffed with examples of God working with people in partnership; at times, minute details are recorded to track the methodology, but His approach rarely falls into our rational framework. If Moses needed to ask God for a daily game plan, why wouldn't we? Life's pilgrimage gradually replaces our earthly eyes with a spiritual pair. Adored and adopted into a royal family, we learn to walk in its ways.

PUTTING THE PIECES TOGETHER

When an original idea or blueprint begins to land in our spirit, it often arrives in a disjointed manner, like the individual pieces of a jigsaw puzzle. Unless we faithfully collect the pieces, the full picture will evade us. These "pieces" may be divine nudges, knowings, Scripture verses, bite-sized intel from conversations, dreams, visions, sermons, and more.

When God begins to draw my attention to a new plan, I sense the pieces moving around me. I have learned to respond practically and collect them in a database of some type, such as a journal, file, or folder. Then I spend time in prayer and worship, seeking further revelation until I can see the intended form emerging more clearly. I will sketch, diagram, type, write, order, and re-order until the vision, strategy, and tactics are clearer. This process often requires a long succession of brainstorming sessions with the Spirit.

CONTINUAL COMMUNION WITH THE SPIRIT

Bumps in the road require discussions with my co-creation Partner, from whom I seek wisdom to navigate any challenges. God may work in mysterious ways, but He likes to keep His friends in the loop. (See, for example, John 15:15.) God is not a mean-spirited chess player; when something doesn't make sense, we can simply stop, seek His wisdom, and listen. What is really going on in the spiritual realm? What response is He asking us to make in the situation? What do we need to learn? Did we leave the cadence of heaven's plan for our own? We may not get all the answers we are hoping for, but we will get all the answers we need.

COOPERATION WITH THE SUPERNATURAL

When God gave Joshua the strategy for taking Jericho, it probably sounded like utter nonsense. (See Joshua 6.) But Joshua did not live with his eyes on the ground. He listened closely to his divine instructions, and he carried them out without protest. Israel's army was to circle the city once daily, marching in silence behind the ark of the covenant; then, on the seventh day, they were to make seven loops around the city, culminating with the fearsome war-cry of trumpet and voice. When they

did this, the impervious walls disintegrated before them, and their victory was secured.

This story is like a treasure hunt with prizes for our modern times. The ark represented God's manifest presence, and Joshua received a truly unique creative strategy for the situation he and his people were facing. Without questioning the sheer eccentricity of the plan, they carried it out. The energies of heaven collided with their obedience, co-creating a wild scheme that seized new territory.

THE REWARDS OF OBEDIENCE

Time and again, Israel's army was led into the battle for territory with the ark held high and leading the force. When they advanced to take to the promised land, they ran smack into a truly immovable obstacle: the Jordan River in full flow at harvest time. What was God's plan? Send the ark ahead of the army. The priests held the golden box at the river's edge; once their toes touched the waters, the river receded in a miracle of epic proportions. (See Joshua 3:5–17.) The entire army was able to cross where a torrential river had once raged. No laborious, three-year bridge-building project necessary, thanks to supernatural intervention in response to human obedience.

When we embark on ark-led endeavors, God cuts us a key to His storehouse of smart stratagems that have no earthly limitation. Unusual, creative, and downright strange instructions are pretty much guaranteed, at times. We have a choice—to process them through our earthly logic (and likely dismiss them), or learn to recognize His fingerprints on the design and follow through with it. Our obedience will open access points for kingdom forces to engage with us in the process.

WELCOMING INNOVATIVE CREATIVITY IN THE CHURCH

A popular view among many church leaders is that if we allow more freedom for creative expressions in our services and other church events, the potentially unusual and "weird" results may repel unchurched individuals.

In my experience, an opposite scenario seems more common. The world is hardly devoid of artistic expressions and impassioned responses. A single visit to a football game or a music festival will clarify this nicely. Cheering, heartfelt dance, the waving of the arms, and more—all these are part of a language people understand—and they may struggle in an environment lacking in such vocabulary. The good news is that creativity and art can actually be very effective at removing barriers and drawing people to God. They allow space for investigation, the embrace of mystery, and symbolic communication.

FREEDOM TO CREATE

The arts have been prey to so much competition and critique, with many artisans having to compromise their very souls in order to sell their work. But God's creative mandate liberates people from such prisons. If He commissions a project, we can trust Him to carve out the route for its completion and trajectory of influence.

Whatever you hold in your hand today can become seeds for transformation. Just open your hand and let the Spirit-breath blow them far into the future. The most inspirational people in history had no idea how their own stories would help others through time; they just followed their heart's conviction. When we conquer the misconceptions around the value of our gifts, we don't need to question their purpose and procrastinate. As we embark on each project, God teaches us the dynamics of co-creation, tuning our spiritual senses to His frequency. This process restores our creative DNA piece by piece.

Freed from performance pressure or people-pleasing, we become capable of a whole different type of innovation. At times, our projects may have to comply with the specifications of a workplace brief, satisfy a client's request, or be commissioned for a specific role. There may be other restrictions imposed on our efforts. God knows the constraints and the reasons behind them. But whatever the framework, we can still invite the Spirit into the process.

This is how we touch culture through our workplaces, schools, neighborhoods, communities, and more. At other times, we have a

blank page that can take us in any direction. It's is a journey worth fighting for. We deepen our connectivity to God's Spirit with each assignment we undertake because it is not just about what we have made; it is about who we made it with during the hours of collaboration. It's about accepting the invitation to be part of His eternal plan.

SPACE FOR TRIAL AND ERROR

God is not looking for perfection, just partnership. Where we run out of skill, favor, and imagination, His supply knows no bounds. He is the architect of all things, from the beginning of time to the great halls of eternity. He will craft with our courage, paint through our patience, and engineer with our enthusiasm. For a wave of creatives to arise and explore, we must be willing to embrace the wheat with the chaff. An artist's first attempt is rarely his greatest masterpiece. Most scientific discoveries emerged following many failures. If we invite people to try something, we must allow them room to fail and learn from their mistakes.

A preschool is one of the most inventive places on Earth. Young children want to play, paint, write, sing, and dance, all at the same time! There is constant productivity requiring preparation and clean-up. Research has shown this untethered creative process to be vital for the healthy development of all children. It is not about producing an army of miniature professional artists but instilling essential skills for every area of future life and work roles. It is no different for God's children: environments where messes, whether spiritual or physical, are prohibited do not foster creativity.

SPACE FOR FRESH INSPIRATION AND EFFORT

Creativity needs space to materialize and flourish. Have you ever opened a cupboard in your house to store something in, only to find its shelves are already jam-packed? If we run our faith communities in a similar way, there is no space for the fresh to emerge. Is the church cupboard heaving with centuries of traditions, patterns, and programs we feel must never be discarded? While none of these things are wrong in

themselves, they frankly become "wrong" if God has not told us to keep them going. Do we ask Him what is needed for each timeframe, or have we decided they are holy within themselves without that conversation?

When we make tradition and pattern into immovable sacred cows, we rely less on God's daily connection for direction. Are we afraid that laying down some traditions will make us more worldly, forgetting that it is not our rituals that make us holy; it is our lifestyle of being salt and light (see Matthew 5:13–14)? The pursuit of heartfelt connection with God helps us receive up to date direction for our commission. (See John 10:27–28.) If there are traditions and schedules in place, and God is happy for us to continue them, then that's great—they still have a purpose. At times, however, we maintain them because we want to fill the space with certainty. If we generally know what will happen when we gather or when we pray, this takes less faith if we are honest. We endanger diminishing our experience of our extraordinary God.

The outcome of Spirit-inspired investigation cannot be predicted or controlled ahead of time. It requires a relinquishing of our own rule and a willingness to enter the unknown. If we let Him, our Creator will astonish us. It is hard for new creativity to unfurl when it has to jostle its way through decades or centuries of inflexible systems. If we do not let the new and relevant rise, we are in danger of staying stuck with the distance between us and modern culture growing wider. We live in a rapidly changing world; if we allow our faith to flex us through life like living water, we can show others, in a relevant manner, how to follow the Father. Jesus told us to be in the world, helping people, but not sharing in its nature. (See, for example, John 15:19.) To live this way, we need equipping to bring kingdom stability right into the middle of changing chaos. We are not talking about learning to run the rat race but instead at being adept at hearing God's wisdom for each situation, as Jesus modeled for us.

SPACE WHERE HIS PRESENCE IS PRIZED

We talk about entering the presence of God, but what does that really mean? God is always with us; ever since Pentecost, people have

been living as tabernacles infilled with His Spirit. However, we can also enter into levels of God's presence where He surrounds us, infills us afresh, and moves in specific ways. At times, He may initiate a wave of healing or prophecy. Millions of meetings have witnessed God doing millions of different things across the ages. We can engage a little or a lot, depending on our hunger. God's presence is not offered in just one type of experience; a plethora of possibilities awaits us in the journey toward eternity, when we will stand before His throne in the ultimate encounter. There is much we can do to prepare ourselves and host His presence. We can forge places in our hearts and gatherings that show how much we long to know Him more. It becomes a passionate pursuit through daily life.

A real key is not to repeatedly seek God's presence with a hidden agenda—a desire to be healed, a request for eased financial strain, or a plea for our dream job. What can He do for us? God knows what we need and cares about your next paycheck or health issues. Beyond that, there is a superior plan in play. To seek His company just to know Him more opens our lives to unparalleled bliss, lifting us above the short-sighted focus on self to the expansive focus of eternal purpose. That is when we truly tabernacle with God, and many things in our earthly life go well as a result—healing happens, provision pops up, and joy is never too far away. (See Matthew 6:33.) If we practice His presence, we can learn to open sacred files anywhere, anytime, yielding timely answers in any environment.

SPACE FOR PROPER SPIRITUAL NOURISHMENT

As we embark on the journey of co-creation, we have a responsibility to nourish our spiritual lives with the good stuff rather than greasy, additive-packed garbage. We can't just wait for a drive-through binge on Sunday mornings, with someone else doing all the cooking. Fresh, daily food is on offer; the platter is not limited to cyclical cheese sandwiches. Close and consistent time spent with God, in prayer and in His Word, fills and fuels us for creative feats. If we are going to be an army of innovators and activators, we must be intentionally feeding to stay motivated and moving. We need to burn those spiritual calories to keep

getting hungry for fresh food. Regular hunger opens up new choices on the banquet table, past the cheese sandwiches, and into the succulent seafood section and delicious desserts.

The spirit of human-made religion is the enemy of God. It masquerades as the Father, presenting Him to the world as a dull disconnected God of rules. The enemy urges us to filter God through a stronghold of intellect, sifting out the supernatural, symbolic, and creative. Their outcomes cannot be calculated or controlled; they require the faith of growing love. The Bible was always meant to be a portal to the divine dimension, not just a theological lesson in church history. It reveals the nature of a Father who champions a young man with radical faith and a slingshot. Let's not be fooled any longer! The doorway stands before all believers, an invitation to search the multidimensional culture of heaven.

SPACE FOR REFRESHMENT AND RENEWAL

The stepping-stones leading to our destiny can feel slippery at times; the enemy can buffet and bombard. Stay strong, for Satan is just terrified of what will happen if we reach the other side. One tactic he likes to employ is using the ticking clock to crush our creative space. Most of us probably know the challenge of juggling ministry and family. The peaks and plateaus of health and energy come and go. The good news is, God has not left us to tackle this ever-changing terrain on our own.

THE GOLDEN HOUR

One day while I was in the middle of a project lasting months and requiring hundreds of hours to complete, the Lord showed me a secret weapon He called the "golden hour." He showed me that I should stop waiting for the "perfect day" or a five-hour block of energized, uninterrupted time—practices that actually make us vulnerable to attack and time theft. The golden hour principle changed everything for me. God assured me that if I could set aside just one hour to co-create with Him on a given day and would willingly sow it as an offering (accepting the single hour of time when I would have preferred having five hours), He would multiply the offering. I lost count of how many times a single hour miraculously expanded as subsequently scheduled tasks

or appointments melted away, whether by the sudden cancelation of a meeting, someone's unexpected offer to prepare dinner, or another way.

Practically speaking, it can be very tricky to pick up some creative projects for only an hour at a time. How this plays out for each of us is a Spirit-led journey of trust. But as I walked and trusted, my time seeds multiplied beyond imagining. Practicing the golden hour also keeps us in a connected flow with our project so that when we have more hours to devote to it, we find it much easier to enter in again to our creative space. The key is to see the time as sacred and guard it with resolve.

Many commissions God has given me have been miraculously completed through this practice. Take the pressure off, just sow what you have, and God will do the rest. The golden hour is a principle, not a magic number; it maybe thirty minutes or two hours for you; it may change with different times of life and various projects. Ask the Spirit to show you what your time seed for each particular day or season ought to be.

SABBATH REST

The connection between the tabernacle pattern and a Sabbath rhythm of rest is inseparable. From the very dawn of creation, rest has been a crucial part of the creative process. If it was important for the God of the universe to observe a rest, how could we ever consider ourselves above having such a need?

> *Then God blessed the seventh day and made it holy, because on it he rested from all the work of creating that he had done.*
> (Genesis 2:3 NIV; see also Exodus 20:11)

God's people are not supposed to live according to the cadence of world culture but within the rhythm of heaven's rest. In our modern, fast-paced society, that is easier said than done. There was once a time when most stores, restaurants, and other establishments would remain closed on Sundays; shops stood silent while larger numbers of people gathered for church services, part of a core culture of Sabbath rest that was observed in many nations. Even those who did not regularly attend

church benefited from the slower pace, freed from the expectation to keep the wheels of work turning in a never-ceasing cycle.

Following the trend that pushes God and faith to the fringe of society, the world comes flooding in to fill the void. Now we run in a relentless mass-consumer culture with a ferocity that neither our health nor our planet can sustain. If throwing out a Sabbath slowdown was the answer for humanity, why are we experiencing a health epidemic of stress-related illnesses and mental health challenges? A dig for some antidotes has led to the rise of trends like mindfulness and environmental firefighting schemes. Mindfulness simply encapsulates the principles of prayer. Even without acknowledging God as the focus, its benefits are enormous. Kingdom dynamics always bear fruit in the hope that they will eventually lead people to see the source of true peace.

In the words of rabbi Abraham Joshua Heschel,

> The meaning of the Sabbath is to celebrate time rather than space. Six days a week we live under the tyranny of things of space; on the Sabbath we try to become attuned to *holiness in time*. It is a day on which we are called upon to share in what is eternal in time, to turn from the results of creation to the mystery of creation; from the world of creation to the creation of the world....
>
> Labor is a craft, but perfect rest is an art. It is the result of an accord of body, mind and imagination.[17]

Historically, the Sabbath polluter of a religious spirit has wreaked damage, turning the observance into a controlling ritual for some believers—freedom exchanged for fleshy discipline, fun for boredom, close connection with the Creator drowned in the resentment of enforced ritual. It was never meant to be like that. Recent decades have kicked back at such an assault on the freedom Christ died for.

I think the church is on a journey to restore the genuine delight and power of the Sabbath. Initially, we seem to have joined the world

17. Abraham Joshua Heschel, *The Sabbath: Its Meaning for Modern Man* (New York: Farrar, Straus and Giroux, 1951), 10, 14.

in throwing the bathwater out when they threw out the baby. Church culture turns at a frenetic pace, producing many tired, overworked Christians. Activity is rewarded by merit; lack of visible involvement is criticized as lack of effort. When did we get so confused? Some courageous pioneers are picking up the gantlet to fight back. For further reading on this topic, I highly recommend John Mark Comer's book *The Ruthless Elimination of Hurry*, the title of which quotes a pivotal piece of wisdom from Dallas Willard.[18] This book draws from life experience and past inspirers, alerting us to the dangerous crush of modern mechanisms. Its insights hit the destructive forces of world culture head-on, posing open questions many of us were frankly too busy to ask, such as, "Why are we all running so hard?"

Hebrews 4 speaks of a Sabbath rest still alive and kicking for God's people after the cross.

> *There remains, then, a Sabbath-rest for the people of God; for anyone who enters God's rest also rests from their works, just as God did from his. Let us, therefore, make every effort to enter that rest, so that no one will perish by following their example of disobedience.*
> (Hebrews 4:9–11 NIV)

God urged us to strive to enter into His rest. He knew we would have to fight for some real R and R.

Daniel 12:4 records a vision Daniel was given of the end times. He saw that people would run to and fro, and knowledge would increase. That pretty much sums up our modern age. The Internet and advances in technology have opened us to information saturation with lightning speed. However, instead of saving ourselves time and energy, we have only increased expectations and demands that are placed on us. We truly have to make an effort to swim against this raging river flowing in the wrong direction.

18. See Comer, John Mark, *The Ruthless Elimination of Hurry: How to Stay Emotionally Healthy and Spiritually Alive in the Chaos of the Modern World* (Colorado Springs, CO: WaterBrook, 2019).

Sabbath rest is part of our genesis as human beings, designed to help protect us from sin. There are two threads of thought here: a day of rest in the rhythm of the week and a general reduction of hurry. God may be limitless, but we are not. We have been given a gift of time and energy limits within our human frame. We cannot do it all, and neither are we supposed to. When we overstuff our schedules, we need to speed up to keep up. Living in high gear makes us more prone to mistakes, inclined to squeeze out God, love ourselves and others with less intentionality, and become swamped in stress—all things that make us more vulnerable to the enemy. He looks for the open doors of exhaustion to sneak in illness, fractured focus, burnout, and failure.

God gave Israel a Sabbath day to teach them to shift from a life of slavery in Egypt with a pattern of unrelenting work. (See Exodus 20:8–10.) Egypt represents the world system for us today, and we cannot produce creative works of eternal power from a striving system. Observing a Sabbath rest presses our reset button and helps us regularly recharge and recalibrate with God. Then we can feed the goodness of this refreshment as we fashion and form works of co-creation throughout the remainder of the week.

Exodus 31—the chapter that introduced us to Bezalel and his team of builders who would work on Moses's tabernacle—significantly includes a strong reminder of God for His people to observe a Sabbath rest. (See verses 12–17.) Work and rest are so interconnected that we cannot achieve one without the other. Interestingly, when people take time out to rest from work, they frequently plug into creative activities such as reading books, gardening, cooking for friends, or playing sports. True Sabbath is not a set of religious rituals; it is intended to be a delight of time and rest with God, during which we enjoy Him, count our blessings, and lay down the burden of work. Obviously, we still need to eat, look after the kids, walk the dog, and so forth; but there is unique freedom for each of us to find within the details of our day. This is a topic that other authors address with great skill, and I highly recommend your digging further into this area for life-changing revelation and creative release.

DIVING INTO SEAS OF UNCHARTED SPACES

It should be pretty clear by now that our main action point should be to make space for God. Fostering rich relationship, learning His language, and building a repertoire of interaction. We are the tabernacle, individually; but as we come together to seek Him, our fusion creates an intensity of God's presence. We are familiar with the concept of gathering to worship and learn; what we do in such times defines their fruit. Different meetings have varying purposes. A Sunday gathering usually has the mandate of trying to reach people at differing stages of their journey. We also need to gather with specific intention at other times, but we can't expect to keep doing the same thing and get new intel. Like Moses and David did, we must kneel before the ark, probing God's presence and finding the wisdom and inspiration we need to fulfill our callings.

Exploratory spaces lined with permission will be vital for us to progress as we follow the cloud, expectant of solutions as well as surprises. Such spaces may look diverse from group to group, nation to nation, with various mandates, but liberty for exploration should be the common goal. There will be meetings of specific inquiry for particular areas: business entrepreneurs seeking blueprints, politicians investigating governmental game plans, filmmakers looking for media maps. Whatever the meeting, we should aim for a fusion of tabernacle elements to prevent us from narrowing the field of answers. For example, an artist in a room of businesspeople will aid innovation; atmospheric design can help stir solutions for education; dance can bring healing for weary workers. The range of combinations is immense. The key is to ask God what mix of elements He requires for the gathering, then co-create.

If we dive into deep water with all our clothes on, afraid to enter naked and vulnerable, we will be dragged downward by the cumbersome weight of excess garments. Their porous fabrics can be perilous in such a situation, demanding all our energies to fight against the strain of their restrictions. In deep water, we will drown unless we allow God to take us through the process of putting to death those things that

hamper our hearts. Then our spiritual lungs will expand and, in a meta-morphosis of faith, we will learn to breathe underwater.

This can be a scary process because it is outside our control. The old, familiar garments pull and drag us down with their limitations, and we feel terrified of drowning. When we finally learn to let go and float, relinquishing control and releasing the safety net of familiar repetition, we begin to explore a wondrous world of deep "see" diving. Practice develops the ease of a diver's life, ready to plunge whenever the opportunity opens up. This is a picture of friendship and co-creation—God and us, priests in His presence. It was in such a fashion that Moses discovered the treasure of the tabernacle design, David heard sacred symphonies, Solomon unearthed secrets of science, and Jesus found the Father's heart for miraculous healing. What magnum opus of eternal value awaits your discovery? I dare you to ask!

14

CONNECTED CREATIVITY FOR WORSHIP AND BEYOND

True liberty comes with the abandonment of self in our worshiping God, freeing us to worship in His way, not ours.
—Ray Hughes, *Sound of Heaven, Symphony of Earth*[19]

The restoration of all things will see a holistic reunion of creative elements through God's people. Currently, many components stand divided: some are in the spotlight, while others have been kicked to the corner. We can learn important lessons from the paradoxical times of the Italian Renaissance—half medieval squalor, half supreme sophistication; the raw and refined, colliding in a quest for advancement. Connectivity between divergent areas was seen as a pathway to improvement, producing works that still baffle us today with their genius and originality.

Fast-forward through the centuries, and we see a gradual separation of divine tools in the church, while the rest of the world is making connections and strengthening them in forward movement. We are still in a stage described by the apostle Paul when he wrote, *"The creation waits*

19. Hughes, Ray, *Sound of Heaven, Symphony of Earth* (North Charleston, SC: CreateSpace, 2017).

in eager expectation for the children of God to be revealed" (Romans 8:19 NIV). Creation continues to wait for God's people to be fully revealed for who they are and what they carry.

Why would creation be waiting for us? Our destiny was forged when the earth was formed, and we will be involved in its final reparation. We have a part to play right now as carriers of God's light on the earth—a light we are charged with sharing, through our co-creative acts, with those who need it, radiating its regenerative power for all to see. In this process, a unity of diversified parts will be key.

To reinforce this idea, I would like to share with you an account I heard from John Paul Jackson, the founder of Streams Ministries. Years ago, he had a metaphysical experience—a collision with God that transformed his approach to life and ministry. In an unexpected and somewhat terrifying encounter, he was transported to the throne room of God. This was not the fluffy experience of a warm, fatherly hug but the knife-edge realization he stood before a sovereign and omnipotent King. His holy terror was palpable. Proximity to such intensity left him crying for mercy, deeply aware of the poverty of his own soul.

THE RESTORATION OF ALL THINGS WILL SEE A HOLISTIC REUNION OF CREATIVE ELEMENTS.

The Word of God was heard audibly in the atmosphere. John Paul watched the unfolding of a wisdom he could barely conceive of. Each word connected to a color, a fragrance, a sound, and a mathematical equation. Angels swirled in the movement of worship, their wings sending vibrations through the air. He realized this correlated with fabric flags on the earth, mirroring adoration in both realms. Wisdom illuminated a perfect synergy among created areas. Musical notes were not separate from mathematical numbers or movement from color. After all, God is light; the essence of all things was fluid and connected. Each

element of Creation is essential in the current of life. Some components required for the arts are critical in science, while others interlink across music, mathematics, medicine, and so on. A glance through immortal lenses made John Paul conscious of every molecule in his body, alive and resonating every microscopic atom in the universe. Who could remain unchanged after such an experience? Following this encounter, he studied to gain understanding, grappling with these mystical glimpses of another world—a world that we can bring to earth by forming connections between various disciplines and art forms.

LIGHT-RELEASING CONNECTIONS

Like the synapses of a brain linking together to transmit information, a relationship with the Holy Spirit fuses different combinations of messages and directions for various results. Without consulting the Spirit, the most stunning revelation in the world would lie scattered and wasting. Think of an electric circuit—the component parts do nothing without connectivity, no matter how strong the battery that supplies their energy.

Each of us is born a unique collection of component parts, and it is up to us to connect those with God in a coalition of humanity and Spirit. This union results in new expressions of the creative DNA He has placed inside us, whether through prayer or pottery, veterinary medicine or ventriloquism, speech therapy or rocket science. Every contribution we make to our culture, when we're connected to the ultimate Creator, releases light, restoring and regenerating the world while causing the darkness to recede.

COOPERATING WITH THE SPIRIT

As we learn to listen to the Spirit and receive His strategies, we will often find they combine the familiar with the truly unexpected. For example, what does it look like to mix politics with presence, mystery with music, beauty with finances? What does it look like to paint sound, map out a marketing plan received in a dream, invent something based on a vision, or change the atmosphere with art?

Our potential is boundless when we work with an infinite God. Peace comes from understanding that all we have to do is what God has called us to do. Trying to push beyond our call causes us to strive, soon becoming weary and overloaded. It is not our job to save the world. Our life call is to journey with God through the piece of history He has given to us. We have access to unimaginable wisdom through the mind of Christ—such things as eye has not seen nor ear heard. (See 1 Corinthians 2:9).

STAYING OPEN TO UNIQUE COMBINATIONS

There is much interplay yet to be explored between various areas of creativity. In our ministry, for example, we have had artists painting on easels while dancers "paint" the air as the shifting colors of the fabrics they wave catch the light. We invite musicians to explore new sounds during our worship times. Revelation and joy are freely birthed, not just among the music team members but throughout the gathering, as people are drawn into a unique worship experience. It is as if the dove of the Spirit is in flight, landing here and there, perhaps upon a prophecy or some freestyle prose, on an explosive drum solo or a single trumpet's blare breaking the silence. A well-loved worship song may emerge, happily giving way to another expression in the ease of experimental flow. It's like the glee of a grown-up nursery where God's children get to explore and get to know their Father better in the process. As worship leaders, our role is to discern where the dove has landed and make space for the voice of that expression. There may be a proposed schedule, but we invite God to change the plan if He wishes. If our faith gatherings are too rigid, it's hard for the Spirit to originate. The danger is that we can learn to become Christian creatures of habit rather than initiators of originality.

As I have traveled to teach in ministry, God has increasingly led me to open a time of exploratory worship. It's one giant risk for us all; many have never experienced an invitation to such a space. New vision and healing frequently break out, and some experiences have literally rearranged our perspective. In the flood of testimonies, we have realized

the extraordinary takes place as we allow a place for the Spirit to move with unhindered spontaneity.

CREATIVE WORSHIP

To worship is to express adoration. When we adore someone, we express our love through who we really are, not through some sanitized version of ourselves. Bakers love by making cakes; singers write love songs. When we share God with the world, we can do this with our gifts, whether we are designing buildings, educating children, or starting an organization to help the victims of human trafficking.

Worship is not limited to singing familiar songs; it should spill over into every expression of our lives. Spirit-led improvement of our skills and gifts is important in the mix. Recall that from a team of four thousand tabernacle musicians, God picked a core team of 280 people with a great combo of character and skills honed through dedicated learning and practice. (See 1 Chronicles 25:1–7.)

PROPHETIC WORSHIP

An exciting range of worship expressions was birthed through the tabernacle of David—through sounds, words, and even prophecy through musical instruments, all guided by the Spirit. Scripture outlines various types of prophecy—some is for us to understand, some is a mystery to God, and both are legitimate. (See 1 Corinthians 14.) Prophetic messages are rarely black-and-white. A person can operate as God's spokesman, enabling others to hear from Him through a variety of mediums, such as sound or metaphors in art or prose—it's all in the pattern. When humanity became the tabernacle infilled with the Holy Spirit, we were primed for direct communication with the King of Kings. Thus, the essential role of a New Testament prophetic leader is not solely to act as translator but to teach others to hear God for themselves.

WORSHIP ENLIVENED BY THE BREATH OF GOD

The Holy Spirit is often referred to as wind in the Bible. (See, for example, John 3:8.) In the Old Testament, the word for Spirit is *ruach*.

In the New Testament, it is *pneuma*, which means "wind or breath from the mouth or nostrils." At times, the breath was soft; at other times, it was more violent in nature, such as a whirlwind or tornado. (See, for example, Acts 2:2.) This same breath gave us life. (See Genesis 2:7.)

There are new sounds to come that carry the *pneuma* breath of the Spirit to break strongholds, open revelation, and rouse the army of God to its feet. This will not come through words and well-known songs alone. As we explore combinations and interactions between diverse elements, we will all need latitude to risk. To explore is not to alight on a slick, finished product in a short time; it is to throw that kind of constraint out the window. Aiming for a polished performance, then playing it on repeat with little fresh input from the Holy Spirit, will only carry us to a certain depth in worship.

If we want to experience more of God's unpredictable and creative power, we must give Him more space to move among us—to be unpredictable and innovative. He is the Master Artisan. If we devise a predesigned plan for a gathering in His name that is tightly scheduled and safely predictable, we must honestly ask: Is the gathering for us or the Creator? No master artisan likes to be given a brief that leaves little room for creative input. Do we lack the wild power of the Acts church because we leave little opportunity for the Master Creator to get creative among us? Jesus left space for the Father to innovate through miracles, healing, and wonders, in whatever way He wanted, on any given day. Let's be sure to do the same.

SHAPING THE KINGDOM THROUGH SOUND

The church is called to be the craftsmen that terrify the enemy, and sound is to be a major part of our weaponry. Israel broke through the impenetrable walls around Jericho with a God-directed warfare strategy of sound and action. They didn't just burst into some well-loved worship songs. First, there was to be vocal silence, so the terrifying sound of thousands marching and marking out territory would dominate the air. Inside the city walls, people became panic-stricken as it broke down their mental defenses. Next came the indigenous sound of the shofar

in seven blasts and the roar of Israel's warriors ready for battle. The response? The supernatural forces of heaven joined them in the fight to defeat a seemingly impervious stronghold. This account is not just in the Bible as an exciting bedtime story for our kids. It's loaded with tools for us today. (See Zechariah 1:18–21; Joshua 6.)

THE POWER OF MUSIC

Music is a sound that holds an extraordinary power to influence our world. Frequently combined with other media, such as film, advertising, and political campaigns, it has extended the scope and duration of its impact through advances in technology. A familiar song can catapult us back in time to a specific event we remember, generating a rush of emotions we associate with that event. Sound, in general, is connected to just about everything; the very molecules in our bodies quietly respond to a host of noises all day long. Music is also an area where God has broken through, His voice resonating in our hearts in such a multidimensional way that it defies words.

THE EVOLUTION OF CHURCH MUSIC

It is said that an opera house in Germany bears this transcription: "Bach gave us God's Word, Mozart gave us God's laughter, Beethoven gave us God's fire. God gave us music that we might pray without words."[20] Many famous classical composers wrote timeless music that glorified God. They would hear music from God at night and in daydreams like the works of Beethoven, motivated by Bach before him. Co-creation with God can affect generations: one book or piece of music with the favor of God at its back can be propelled through the centuries and even gather momentum in the process.

A CALL TO INVIGORATE CHURCH MUSIC

Sadly, some Christian musicians feel very limited in the current worship culture. In many churches, strictly defined lists and meticulously

20. Johnson, Cathy. "Tuba Bach: It's Music to Our Ears," *Pioneer*, September 23, 2016, https://www.bigrapidsnews.com/lifestyles/article/Tuba-Bach-It-s-music-to-our-ears-14158695.php.

timed songs provide little space for Spirit-led spontaneity during worship services. Church culture has developed its own music genre across the ages, from the rousing rhythms of gospel to the catchy tunes of contemporary Christian pop artists. If we can sing it in a church service, then it must be Christian, right? Beyond this test of legitimacy, many people grow suspicious. For some believers, indulging in music that does not carry a Christian label can feel like a guilty pleasure.

Currently, we seem to embrace as acceptable the sounds and styles of an extremely limited group of songwriters. Neil Bennetts' research on this subject discovered that about 80 percent of contemporary songs sung in the church come from only seventeen songwriters across the globe.[21] With little crossover between the worship band and other expressions, there is an absence of creative iron sharpening iron. Restriction can lead to a default worship mode rather than an impassioned response and resulting stretch. In turn, this also inhibits our ability to explore new dimensions of God because we expect nothing new, no surprises. He is a multidimensional God eager to reveal more of who He is to his people, but, like any creative artist, He wants His handiwork to be invited because it is considered important.

Some of the most influential musical styles have emerged through adversity and pioneering. Gutsy, edgy, and full of originality, they have captured hearts across the globe for centuries. We need some plucky Christian sound pioneers in the church as well as the world, releasing light-soaked sound into secular places.

HOLY AMID THE PROFANE

A few years ago, I wanted to make a playlist to aid in some ministry sessions I was teaching. Rooting through the usual choices of modern Christian instrumental music, I felt frustrated. The options seemed limited compared to the feast available from the rest of the musical world. Suddenly God broke in, revealing my ingrained belief that spiritually

21. Bennetts, Neil. "Healthy Worship: Countering Consumerism (Part 2)," Medium.com, June 23, 2017, https://medium.com/neil-bennetts-worship-coach-consultant/healthy-worship-countering-consumerism-part2-e334d748cdcc.

acceptable music must be labeled "Christian" and reminding me that impartation could rest on any matter of His choice.

The clouds cleared, and I saw that God had intentionally reached into certain secular films and other areas of entertainment to touch pieces of music with His presence. I began to think of compositions with a staggering impact that ignited a kingdom reaction, such as the theme from *Gladiator*—who doesn't want to rise to fight another day after listening to that? As another example, the score of *Braveheart* ignites warrior passion and tender beauty all at once. Right in the middle of movies without a Christian label or moral message are pieces of music through which the Spirit soars, awakening the conscience and inspiring the hearer to press on in faith. It occurred to me that, of course, the enemy would not put these qualities in a piece of music; only God would! He sends rain on the just and the unjust (see Matthew 5:45), continually reaching people in unique and unexpected ways. (See Matthew 5:45.)

I began to research anew through cleaned lenses and discovered exciting sounds that are helping evangelize the world. Interestingly, it is frequently sound that grasps people's attention before words. As an unchurched child, I loved many seemingly secular songs, only later to realize just how full they are of godly messages. Their power carried me along until the day I found their ultimate Composer.

This principle could apply to any calling. We live in an era where creative methods of evangelism are becoming increasingly important. Some of us are called to "stealth missions" in places where we cannot be as vocal about our faith as we would like to be. We will need an increased understanding of what is valuable from heaven's perspective—and that is any effort performed from a pure heart.

SIGNIFICANCE IN NONMUSICAL SOUND

Scientific developments linking vibration, sound, matter, and color are unearthing a wealth of potential in different areas such as healing. Proverbs 18:21 tells us that words can literally carry the power to produce life or death. The sound waves they emit can alter aspects of our physical being. All of us have experienced the power of words, to some

degree—the way they can cut us to the quick or cause our heart to soar. Jesus displayed the power of anointed sound when He caused a fruitless fig tree to wither and die just by speaking to it (see, for example, Matthew 21:18–19), going on to explain that words spoken in faith can move mountains. (See verse 21.) His teaching ad example carry both a literal and a metaphorical meaning for us today.

German scientist Ernst Chladni was a groundbreaking pioneer of experimental acoustics. One of his inventions, Chladni's Plates, uses a flat piece of metal sprinkled with sand. Subjecting it to sound waves from different noises, such as the bow of a violin against the plate, causes startling results. The sound waves form curious patterns in the sand that change as the sound changes, revealing that sound affects physical matter. Chladni's work paved the way for the development of the acoustic theory of waves.[22]

Later experiments used the sounds of languages. One study used Ancient Hebrew, a pictorial language rather than a letter-based one. As word sounds were read out, they formed an image similar to that of the Word! Every single piece of matter makes a specific sound that affects the atmosphere it is discharged into.

MORE RECENT DISCOVERIES

Dan McCollam, international director of the mission organization Sounds of the Nations, has performed studies on this subject, revealing that God created many different laws; some of these laws, we can see, while others, such as the laws and principles of motion and prayer, are invisible. (See Genesis 1:3; Colossians 1:16–17.)

Ray Hughes is another Christian musical pioneer who has explored biblical evidence related to scientific findings. On his website and in various books he has authored and contributed to, he explains how light and sound exist in wavelengths together, linked in the same electromagnetic field. As humans, we are only able to see 3 percent of the entire light spectrum, with over 90 percent of invisible light being categorized

22. See "Chladni Plates," *Smithsonian National Museum of American History*, accessed August 5, 2021, https://americanhistory.si.edu/science/chladni.htm.

as electromagnetic light—including radio waves.[23] According to Ray, "The first time God said, 'Let there be light' (Genesis 1:3), He was also proclaiming the beginning of sound."[24]

TAPPING THE POTENTIAL

Sound is crucial in the creative restoration. Sparked by the Spirit, it can interplay with other artistic areas, as well as with teaching and prayer. If a sound can change matter, this has thrilling possibilities, and we can become more intentional with its use. We acknowledge the power of Scripture and the importance of speaking truth into people's lives, but beyond our words lies a wealth of other sounds.

As our teams have explored different Spirit-led sounds, combined with a variety of creative expressions and artistry, the results have been charged with a strength of God's presence that feels fresh and electrifying. If we remain firmly fixed on Jesus, we need not fear the accusation that we have strayed into New Age territory. God is the Maker of all things; let's pray for eyes to see and ears to hear what needs to be redeemed from the enemy's clutches.

SYNERGIZING SOUNDS FOR KINGDOM IMPACT

Music, sound, and vibrations are all deeply connected. When a person loses one of the five senses, commonly, one or more of the other senses is enhanced to compensate. Evelyn Glennie, a world-famous Scottish musician, is unique in that although she is profoundly deaf, she can feel vibrations from the world around her with crisp distinction— and she issues a stunning assortment of sounds through percussion in response to other instruments. A GRAMMY award-winning artist, she has performed across the globe.[25]

In the late 1880s, American Helen Keller, a famed author, speaker, and political activist, was rendered deaf and mute by a childhood illness;

23. See Hughes, Ray, "Chapter 7: Sound of Heaven, Symphony of Earth," Heaven's Physics, accessed August 5, 2021, heavensphysics.com/chapter7/.
24. Hughes, Ray, "Chapter 7: Human Sound of Heaven," in Judy Franklin and Ellyn Davis, *The Physics of Heaven: Exploring God's Mysteries of Sound, Light, Energy, Vibrations, and Quantum Physics* (Shippensburg, PA: Destiny Image, 2012), 66.
25. See *Evelyn Glennie: Teach the World to Listen*, https://www.evelyn.co.uk/.

yet, with the help of her teacher, Anne Sullivan, she learned to communicate using a modified sign language that involved pressure on her palms. Although she could not hear music, she had a great appreciation of it because she could sense the vibrations in her body. She "listened" to a performance by mezzo-soprano Gladys Swarthout by holding a hand to the singer's throat, and when she experienced a radio broadcast of the New York Symphony's performance of Beethoven's Ninth Symphony, she wrote the following letter to the orchestra:

> Last night, when the family was listening to your wonderful rendering of the immortal symphony someone suggested that I put my hand on the receiver and see if I could get any of the vibrations. He unscrewed the cap, and I lightly touched the sensitive diaphragm. What was my amazement to discover that I could feel, not only the vibration, but also the impassioned rhythm, the throb and the urge of the music! The intertwined and intermingling vibrations from different instruments enchanted me. I could actually distinguish the cornets, the roll of the drums, deep-toned violas and violins singing in exquisite unison. How the lovely speech of the violins flowed and plowed over the deepest tones of the other instruments! When the human voices leaped up thrilling from the surge of harmony, I recognized them instantly as voices more ecstatic, upcurving swift and flame-like, until my heart almost stood still. The women's voices seemed an embodiment of all the angelic voices rushing in a harmonious flood of beautiful and inspiring sound. The great chorus throbbed against my fingers with poignant pause and flow. Then all the instruments and voices together burst forth— an ocean of heavenly vibration—and died away like winds when the atom is spent, ending in a delicate shower of sweet notes.[26]

Clearly, music has the power to affect far more than our ears. It may surprise you just how many different reactions, from different senses, a singular sensation can produce.

26. Hogstad, Emily E., "Helen Keller: A Great Lover of Music," *Interlude*, November 21, 2017, https://interlude.hk/helen-keller-great-lover-music/.

Synesthesia is a perceptual phenomenon by which the stimulation of one sensory or cerebral pathway leads to automatic, involuntary experiences in a second pathway. Some people may perceive letters, numbers, or sounds as color. All sorts of combinations can occur in any number of senses or cognitive pathways. Scientists still understand little about how this phenomenon occurs.

Melissa McCracken is an artist who loves to paint the sound of songs as she sees them through synesthesia. Her stunning artworks depict sounds in extraordinary ways, full of vitality. She describes her artistic endeavors in this way:

> I believe that we too often view the world through a singular and narrow lens, only allowing our habitual and empirical experiences to inform our perspective. Through my work, I hope to widen that lens, even if it [sic] at the smallest degree.
>
> By incorporating elements of synesthesia, I create a visualization of music. My hope is to transcend traditional interpretations of experience and to reimagine the familiar....[27]

Another phenomenon, called resonance, occurs when sound, played at a certain frequency (the resonant frequency), is amplified and physically displayed in nearby objects; combining multiple objects yields all sorts of variations. Our individual and collective sound has a vibration, a resonance. When we gather to worship, we are not alone; we merge with an angelic force in exaltation. During such times, there is an exclusive combination of human and angelic life. The sound of unity has a resonance—every preached message, every testimony with its own vibration. If we respond to these vibrations in visual form, their effects can remain long after the sound has ceased.

What if a divine resonance from a blend of elements could spark a revelation for business that would, in turn, vibrate human molecules to bring positive transformation in people's lives? We become increasingly changed in the resonance released from the King of glory. In his

27. McCracken, Melissa, *Wescover*, accessed August 5, 2021, https://www.wescover.com/creator/melissa-mccracken.

enlightening book *Emerging Worship*, Roland Worton urges us to find the sounds and music across culture that "awaken a generation and speak to the deeper human condition."[28]

Dan McCollam uses the example of the Tacoma Narrows Suspension Bridge in his teaching "God Vibrations." Built in Washington State in 1940, it collapsed the same year it opened due to an everyday wind sweeping through the Puget Sound, which, because it matched the bridge's natural frequency, caused the bridge to shake so violently as to end in destruction. This event provoked a great deal more research into the aerodynamics of bridge building for future projects with a lasting effect on science and engineering. If this one combination of sound waves and matter could cause such volcanic results, what about the potential for God-given combinations? There are so many fusions yet to come with diverse ramifications.

In my journey of leading creative teams, God has taught me to ask Him which combination of instruments, artistry, teaching, team members, mystery, beauty, and so forth was required for an event or purpose. The slightest adjustment to the Tacoma Bridge would have caused an alternate outcome, such as using different building materials or employing longer suspension cables. God is the Creator of all science; there are no boundaries to what He can do. If we hit a limit in the natural world, God can take us beyond it when we follow His purposes.

COLORING THE KINGDOM

God is light (see 1 John 1:5), and white light consists of the entire spectrum of color—the rainbow, which, as we have discussed, forms a critical link to God's glory. (See Ezekiel 1:28.) Color is a huge source of symbolism in the Scriptures. More than something designed to make our world more exciting and decorative, it is part of the language through which God communicates. As we explore the interaction of different elements, we must pursue the meaning and purpose of colors

28. Worton, Roland, *Emerging Worship: Becoming a Part of the Sound and Song of Heaven* (Shippensburg, PA: Destiny Image, 2008), chapter 8.

in the mix. As American artist Susan Card, a friend of mine, has said, "Color has an address in the Spirit."

Colors are known to affect the emotions. Advertising companies pay big bucks for research that reveals how they can attract customers through campaigns featuring specific hues. Some colors and combinations of colors are seen to be peaceful and pleasing to the eye, while others may be jarring or motivating. Research has shown that specific colors have similar meanings for many people.

At the same time, we may harbor a set of very subjective associations with certain shades. Color affects us all probably far more than we realize. Imagine spending a week in a grayscale world. I think we might all end up a bit depressed! Rather than relying on the experimental research of human wisdom alone, we can connect with the Creator to find out more. Colors are an influential force, made from the white light of God Himself. When we look at color from this perspective, it changes how we see and use it. This has exciting implications for our co-creations to come.

THE POWER OF STORYTELLING

The power of story is undeniable. Through film and television, today's media play a central role in how we perceive the world we live in and how our society functions, driving cultural change. Their ability to impact but also shape culture is enormous. They draw from every facet of the arts, often initiated through creative writing and story, which is then told in a visual feast of costume, scenery, cinematography, music, sound, and special effects that make the impossible seem possible.

Christian writers such as C. S. Lewis and J. R. R. Tolkien would never have dreamed of their novels being made into cinematic masterpieces. Both authors were considered highly controversial by many of their Christian contemporaries. Back then, fiction was a risky vehicle for kingdom message. Yet they plowed through the critiques with pioneering stamina, convinced that their unusual ideas were Spirit inspired. Their messages have been read or watched by millions to date. God can give one person a story and then breathe increase on

that offering by combining it with other offerings in unexpected ways, creating a tag-team of unstoppable force that can span peoples and epochs of history.

CRAFTING CREATIVE PRAYERS

From his harp, David released sounds and words of worship and petition that moved God's heart and prompted action from other people. Are not brush strokes on a canvas or a dancer's nimble movements equally valid means of praying and worshiping. When our actions become enacted prayers, it frees us to view our entire days, whatever we're doing, as intentional prayers that keep us in touch with God and also radiate His light to the world around us.

To pray in a creative restoration, we will need creative prayer. Through creative prayer, the intentional actions of believers can release soundwaves of intercession that stir heaven. This shines a very different light on the instructions to *"pray without ceasing"* (1 Thessalonians 5:17). Let's become liberated in this area. Prayers can be spoken, danced, sung, sculpted, typed on a keyboard, or even baked! This book has a resonance. It is a fusion of words, concepts, and experiences through attempted co-creation with God to carry a prayerful message.

SOUNDING A CRY FOR CHANGE

Change always creates tension. As we seek to restore the significance of creativity and the arts in the church, it may feel like a stretch to accommodate the missing pieces. The Bible likens change to making new wine. Its enthusiastic new energy bubbles and swells, requiring a new skin to swell with it. The rigidity of an old skin will crack under the strain of expansion. But the effervescent new wine brings the promise of new life, tastes, and experiences. God's artists bring a concentrated dose of Spirit language and essence. I believe they have a unique part to play, and their absence is one of the key reasons the church is not creating at a level it was intended to.

SOME CAUTIONS FOR CREATIVES

Different nations need different approaches; they have distinctive cultures, each one encompassing a wide spectrum of spheres. Throughout history, missionaries have made the well-meaning mistake of imposing the culture of their own land upon the people they were trying to reach because they believed it was of a higher order. While we should share advances we have made, we must be careful not to quench the global flavors of history. In our church culture today, certain worship music styles have become so promoted and mass-produced, they have dwarfed indigenous sounds. Generic songs are sung as weekly worship across the globe, sometimes in cultures radically divergent from their source. This exclusive format can threaten to squelch the fresh breath of creative diversity.

The new creativity to rise is not solely from a few with the most global airplay. This is not an intended stab at successful worship leaders, for some of them are highly anointed, and their contribution to the body of Christ is invaluable. It is simply time to consider whether we have produced a slick system that tends to stifle indigenous originality in the mix of well-loved songs. Familiar songs rouse a force of community and have their place, without question. But copying a format with no freedom for shifting does not particularly stretch us in the Spirit.

I think one of the main reasons this pattern has developed is due to the demise of our creative DNA and our understanding of it. A failure to foster divine innovation leads us to seek someone else's ideas to fill the void. I believe God's intention is to wake the sound and creativity ordained for individual lands and peoples that will discharge spiritual resonance across the earth, unleashing a compelling call to a harvest of souls. As part of the restoration of David's tabernacle, there are unique expressions to rise from Africa, Scotland, Spain, the United States, New Zealand, and every nation God has made. Cultures and influences will mix together in beautiful harmony.

Please keep in mind that the sound of a revival harvest is not to be the exclusive work of musicians and singers. Divine frequencies and sounds will not be generated by musicians alone; they will rise from the

restoration of a creative army. This cannot occur through a mere handful of talented people at the front. We will always need leaders to help point the way, but believers will grow through participation, sharpening the blade they take out into the world. Jesus was the perfect model of action after meditation. He kept shaking off the clutter of human expectation that can collect in layers like the weight of clinging mud.

THE SOUND OF A REVIVAL HARVEST IS NOT TO BE THE EXCLUSIVE WORK OF MUSICIANS AND SINGERS.

Through years of experimentation, our teams have witnessed that the most powerful devotion comes through whole-body collaboration. The collective creative energy of worshipers can disseminate a Spirit power beyond anything we can anticipate. Although the musicians may be a primary vehicle to release the sound captured by human ears, if that sound is a result of collaborative exploration, it will carry far more than their imprint alone.

It is a mistake to think that the revival sound of Scotland or any other nation can be coined by a particular group of musicians. The sound of nations must come from the land and the people rising together; each has a language of God-given sounds for their own particular calling. Replacing or diluting that with the sound of another people group will decrease its potency. This is entirely different from simply playing the music of our ancestors. However, we will need to look to the culture and history of our nations to find the spiritual inheritance buried within them like ancient treasures. It is about finding the inherent sound of a land and its people for an appointed time in history. Nations mix around the globe more than ever in our modern times. The collective of cultures is part of the exciting possibilities in this mix; many sounds and musical notes carry between lands in harmony. The ancient soundscape can converge with the current to show us the sounds of fresh glory for our times.

A CALL TO REFINED CHARACTER

The contribution of musicians, artists, prophets, and others may seem highly metaphorical at times and therefore misunderstood; yet, that is precisely how God often speaks to us. We have examined multiple biblical examples of the power of artistic gifts. They play an integral part in awakening innovation right across the body, but their inclusion will require a shift of mindset—a refusal to continue accepting common stereotypes about professional artists and musicians, such as that they are disorganized and unreliable, with their head in the clouds. While it is true that artisans are commonly dreamers and pioneers who thrive on the flexibility to respond to inspiration, it doesn't necessarily mean their character is lacking or that they won't get their work done.

As in any other area of ministry, creative individuals must be held to a high standard of character. Those in church leadership must be willing to extend permission and offer protective covering for progressive pioneers, shielding fledgling explorers from the inevitable opposition to change that comes in many guises. King David did this for the tabernacle artisans. Significantly, he also made sure the results infiltrated other areas of his kingdom, from temple planning to political strategizing to wartime planning and more. Leaders of this rising creative restoration will not stand at a distance in the old wineskin; they will get their hands in the mud, the paint, and the glory.

15

REIMAGINING OUR WORLD

*Imagination is more important than knowledge. For knowledge is
limited, whereas imagination embraces the entire world,
stimulating progress, giving birth to revolution.*
—Albert Einstein

While I was first dabbling in metal sculptures, a ministry leader from the United States came to visit. At this point in my artistic journey, I felt bashful about showing my projects to anyone. The practice of intentional co-creation was still very new to me, and I was making these metal enigmas in sheer obedience, still personally mystified by their purpose. I had one recently finished and another in process on a frame. They were too large to tuck away in the cupboard during this leader's visit. He arrived weary from his journey, but when his gaze fell on the sculptures, he revived immediately. "Where did you see these?" he asked in an escalated pitch.

Admittedly feeling self-conscious, I explained that I had seen them in visions from God, who had then asked me to make them. I inhaled, waiting for his smarting look of disbelief. "I saw art like this in heaven!" he exclaimed, going on to share that he had seen artworks of the same style as mine when visiting heavenly places in prayer but had never seen

anything like them on the earth. We were both dumbfounded. That day, a divine door swung wide, and I gazed through its opening to see a vast space of new potential.

A TOUCHY (ALBEIT INTANGIBLE) SUBJECT

In Christian culture, the topic of imagination is often avoided or little understood. Sometimes it is thought to carry negative association, largely due to a misinterpretation of 2 Corinthians 10:5, which speaks of *"casting down imaginations"* (KJV) in order to keep one's thoughts in line with the mind of Christ. Other translations substitute for *"imaginations"* such terms as *"arguments* [that contradict the Word of God]" (NKJV, NIV), *"proud obstacle[s]"* (NLT, NRSV), and *"warped philosophies"* (MSG)—all things that we are rightly urged to take a stand against. Clearly, the rendering of the word *"imaginations"* in this verse is not meant to signify the fundamental part of our human design of imagination, which God has given us to use for good.

PART OF OUR DIVINE DNA

Evidence of God's astounding imagination is all around us, from the geologic masterpiece that is the Grand Canyon to the Great Barrier Reef with its inscrutably complex ecosystem featuring over six hundred types of coral. The icy peaks of New Zealand's majestic mountains; the heavens abounding in planets, stars, and psychedelic gas formations suspended against their black canvas; the millions of species of insects creeping in camouflage or flying fearsomely across our planet…we will never bend our minds around the mysteries of created life, let alone in the heavens above, so intricately designed and incomprehensibly vast they are.

Yes, God has an undeniable imagination, and that is a faculty He wired us with in making us in His image—a gift intended to help us join with Him in co-creation. To imagine is to see something before it exists. Without imagination, we would change nothing because we wouldn't be able to perceive what is not yet manifest. Lacking imagination, we would merely replicate, incapable of all originality.

All areas of art and design are pursued through this gift, but imagination is hardly limited to arts and crafts. Pay close attention to your thought life, and you will see just how often you employ your imagination, whether envisioning a scenario before it occurs, picturing how a certain outfit will look on you, or dreaming up the details of a big trip. Our world is impacted daily by the power of imagination, for good or bad. Solutions that shape our society were achieved with its input, including advances in the areas of medicine and technology. Cars, airplanes, phones, and computers are all inventions that came into being through radical leaps in engineering and science made possible by a big dose of imagination.

A KEY TO CO-CREATION

Why would God integrate this gift into the human DNA if He was perfectly capable of creating anything and everything by Himself? Because He never truly created anything "by Himself"! Remember, God is triune: Father, Son, and Holy Spirit. The Trinity is a family; and family is not a solitary person but an ecosystem of life and interaction, with different parts contributing to a fully alive whole. After creating the world in an act of trinitarian collaboration, God desired the continuing joy and journey of creating with us, His children, much like human parents delight in helping their young children create something new, such as a painting or a clay sculpture. We all approach and assemble things differently. If you have ever visited an art classroom at a school, you will see thirty different versions of the same project. As God's children, we are a one-off combination of traits. How we use our traits and what we connect them to has a direct impact on the results.

INVITATION TO IMAGINE

Jesus frequently taught using stories called parables. When we hear someone tell a story, almost involuntarily, we start to create pictures in our mind's eye of its characters and scenes. No two people will catalyze the same images for the same story. Jesus was well aware that His tales of farmers scattering seeds and burying treasures in fields would spark the human imagination across the millennia, bringing these stories to life

like mini movies in the minds of His listeners and readers. Why would He do that if not trying to teach us something essential? Imagination is an extraordinary gift allowing words from a voice or a page to become multidimensional in our thoughts.

Our imagination is intended to link with our spirit. Salvation breathes life upon this link, restoring our spirit's connectivity to the Holy Spirit, which enables us to experience God's spiritual realm. At times, we may be able to "see" elements of this divine sphere that can manifest in the earthly realm through our co-created works. Heaven contains treasure troves packed with the things yet to be discharged upon the earth, and God is searching to see who will grasp the possibilities on offer and embark on the imagination-fueled faith journey of apprenticeship with the Master Craftsman. (See Colossians 1:16–17; Hebrews 11:1.)

STEWARDING THE GIFT

We can train our imagination, intentionally connecting it to the Holy Spirit. When I pray, I ask God to show me the things of His kingdom and to give me a sense of expectation. It is the Spirit who reveals the kingdom, but our imagination is the ability He has given us to receive visual information. Our sanctified imaginations can be shown astounding innovation and artistry.

True co-creation is a beautiful partnership of conversation, questioning, brainstorming, and strategizing with Holy Spirit. In the tangible workmanship of our head, hands, and heart, an adventure of eternal dimension opens before us. A journey peppered with experiences and memories becomes the riveting plot of an ever-building story of us and God, going through the highs and the lows, in it together like business partners, co-laborers. Even if there is teamwork with others at times, there remains always the component of unique intimacy, "just you and Him."

A GIFT DEMANDING DISCERNMENT

As with any gift, it is what we connect to the imagination that directly impacts the course and quality of its flow. It comes back to the

two trees in the garden of Eden. God gave a clear warning to avoid tapping the Tree of Knowledge of Good and Evil, for He knew its fruit would contaminate body, soul, and mind, including the imagination. He wants us to develop sharp discernment to distinguish between bad, good, and God.

If we give our imagination free rein to venture down the fleshly paths of immoral activities and pornographic images, the snares of sin are sure to snap tight. If we head down the hellish highway of horror movies, we are likely to form an affinity with darkness. If we invite our imagination to walk the lofty halls of human knowledge and intellectualism, that's better, as long as we avoid the prison of pride. However, if we head toward Eden, allowing our imagination to feast on fruit from the Tree of Life, we can access the eternal realm of the Spirit.

PURE IMAGINATION

We know that we live in a world that bombards our senses daily with toxicity. What we may not realize is how much of a build-up this contamination can cause in our spiritual systems. We may not notice the gradual accumulation of moral and material toxins till the metaphorical warning lights flash red. In the area of imagination, an alert can flash repetitious images and thoughts we desperately wish would disappear, holding us in shame or guilt. Our creativity can also become sluggish or completely blocked, draining our motivation to produce and pioneer. Yet it is imagination that enables us to dream of something better yet to come, to soar above current circumstances. If our imagination and creativity are incarcerated, we can feel disconnected from God and stall out on our journey to our destiny.

IMAGINATION IS A BRIDGE TO THE UNSEEN REALM.

To co-create with God, we need a sanctified imagination. The great news that this is not something we must do all on our own. God is the

one who resets our imagination by cleaning it up. All we must do is ask the Holy Spirit for a power-packed detox treatment, during which we repent of the damaging influences we have listened to, looked at, or mentally entertained in a way that has corrupted our imagination. Specific things may come to mind or simply a general area of repetitive struggle. The Holy Spirit will help us work through these issues and to ask God for forgiveness and cleansing.

Daily follow-up instructions from the Spirit can teach us to become more watchful guardians of our imagination. Again, discernment is key; something that may be okay for you may not be okay for me. Some things are obviously dark, weird, and plain wrong. However, there are many instances where we find a blend of good and evil, light and dark. Our unique set of gifts plays a vital part in this process. For example, someone particularly gifted as a seer may be more easily upset by potentially disturbing or inappropriate imagery than someone else. The more we yield to God's purification and maturation of our gifts, the more heightened our sensitivity will become to the darkness that lurks in the gray areas.

ACTUAL EXPERIENCES IN THE SPIRITUAL REALM

Years ago, having just led a creative team during a national conference in Scotland, I was exhausted and drew aside for a time of prayer. In my spirit, I was on the ledge of a high cliff precariously overhanging a broad valley below. Jesus appeared and initiated a conversation. We sat together on the ledge, our legs dangling fearlessly over the edge, and surveyed the stunning beauty of the setting sun. The lush valley rolled for miles below us. Jesus told me it was time to "go up a level" in my spiritual journey. I understood this was not an invitation to a hierarchical system; its purposes were exploration and understanding. A new level would mean new challenges but also access to new opportunities.

Then Jesus asked me something astounding: "Would you like to see your level?" I'd had no idea that seeing a spiritual level was even possible! His invitation brought to mind this passage from the apostle Paul:

And God raised us up with Christ and seated us with him in the heavenly realms in Christ Jesus, in order that in the coming ages he might show the incomparable riches of his grace, expressed in his kindness to us in Christ Jesus. (Ephesians 2:6–7 NIV)

The vision was full of God's peaceful presence and expectation. Suddenly I was aware of a group of trees behind us beckoning investigation as to what lay beyond. Entering, we came to a large gate and passed through it. I wondered what could be in this place that God had handcrafted for this time and season.

The landscape stretched before me like wide-open arms, welcoming me into a new adventure. There were fiery red wheat fields, golden meadows, and trees in a harmony of nature and vivid beauty. Visions and dreams from God are not tethered to the restrictions of the earthly realm; anything can happen. We lifted into flight, rushing across the landscape. A pack of wild horses raced below us, and we swooped to fly above them, matching their speed, so that the air pummeled my cheeks. We explored a castle and its stronghold of refuge; we leaped from waterfalls and swam through the refreshing depths of their connecting pools. This was not like watching a movie; it was like entering into one that became an ethereal reality.

This experience left me amazed, yet it was not a solitary event. The invitation has recurred many times over the years, providing a meeting place where I may see, feel, and hear from a personal God who appears in many forms, each conveying a specific message for a specific time.

The Father is often in the mountain peaks and fiery colors that explode across the firmament. His embrace melts the heart, and the wrestling of this earthly life is replaced with the light of hope. He has walked peacefully beside me as a great lion, bringing steely strength on challenging days and imparting heavenly wisdom. Jesus may meet with me simply to talk, or He may take me diving through waters where my natural lungs should have otherwise faltered. A level may last for years, then change at a crucial juncture of my journey.

There is a heavenly realm that beckons exploration when the personal invitation is extended. But we can ask for the invitation, and when our heart makes such a request for the right reasons, we will find a doorway in.

EXPERIENCING AND IMPARTING THE SUPERNATURAL

Some of us are more keenly gifted in seeing in the spiritual realm, while others have ears better attuned to hearing from heaven. Still others may sense spiritual realities more vividly. Such giftings are part of our unique design that enables us to connect with God in different ways. His kingdom is full of the supernatural—to Him, supernatural *is* natural!

The Bible teems with examples of God's supernatural actions, from unleashing a series of nature-defying plagues upon Egypt (see Exodus 7–11) to giving a donkey the gift of speech to deliver a message (see Numbers 22:22–40) to strengthening Samson enough that he might slay a thousand Philistines with a donkey's jawbone (see Judges 15:14–16). Elisha was not fazed by the scary Syrian army, for he could see, in the spirit, the terrifying angelic force sent to save him. (See 2 Kings 6:8–23.) A hand appeared out of thin air and scrolled a warning for a wicked king—a mysterious message Daniel alone could translate, by the Spirit's help. (See Daniel 5.) Bent on running away from God and the assignment He had given him, Jonah was put back on course by a shipwreck and subsequent rescue in the belly of a fish. (See Jonah 1–2.) Jesus's everyday activities included such unusual feats as turning water into wine (see John 2:1–11), walking on the surface of water (see, for example, Matthew 14:22–33), healing thousands at a time (see, for example, Matthew 15:29–31), and casting out demons (see, for example, Luke 8:26–33).

This is just a small sample. The supernatural was not intended to be just an extracurricular Christian activity. As an essential part of who God is, it should be a normal experience for His people. Thus, it is crucial for us to understand this area—and not to ignore or abuse it. Scripture makes it clear that there is a heavenly host with us in the fight

of the ages. (See, for example, Psalm 34:7; Hebrews 1:14.) We tend to distance ourselves from that which we don't understand, but in the process, we miss opportunities to work with the celestial help God sends us. If we read or teach on these biblical examples without the fire of personal experience, we will struggle to inject faith in others.

INVITING OTHERS IN

Interacting with and imparting the supernatural spiritual realm is not about having cool encounters to tell our friends about, and neither is it a form of Christian entertainment. There is a protocol for partnering with the Holy Spirit. It must be handled with the utmost care, like a gift of immeasurable worth rather than a novelty toy. A lack of knowledge and widespread misuse have led to growing suspicion of this area from certain sectors of the church. Some have even attributed such experiences as divine dreams and visions to the New Age movement rather than legitimate Christianity, even though such forms of communication between God and His children are clearly recorded throughout the Scriptures. The enemy has merely attempted a heist so he can counterfeit kingdom currency. These things belong to the kingdom bank, and God's people need to be aware that they have a card to access the funds they need.

People around the world are fascinated with the supernatural. Once considered a taboo subject, it has become an accepted norm in the last couple of decades. The popular media, reflecting the temperature of the masses, has evidenced an explosion of TV shows, films, and books carrying this theme. Is this a disaster for the Christian faith, or can we take a different perspective?

Joel 2:28 speaks of the Spirit of God being poured out on all flesh with prophetic words, dreams, and visions. A great stirring of spiritual activity has begun. The hungry are not looking for just any supernatural experience; many are genuinely looking for the meaning of life. In a world fraught with difficulties and a sense of powerlessness, the notion of possessing supernatural power is tantalizing. What many people don't realize is the connecting darkness, so they taste and see, looking

in all the wrong places. But just one authentic experience of God's pure, supernatural light, and all shady imitations are exposed as perverted. What comes next is to learn a lifestyle of light with increasing maturity that helps one to access spiritual power for the right reasons.

Solid teaching in this area opens an unlimited world of the Spirit. If we live primarily in the dimension of our five natural senses, our spiritual lenses will become dulled, diminishing our experience of the fullness of God. I can't imagine a Christian journey without access to the Lord's supernatural kingdom. If we seek to understand this area with the help of the Spirit, it becomes increasingly vivid.

PAIRING THE PRACTICAL WITH THE MYSTICAL

In the church, we have become excellent at the practical. Church-sponsored hospitals, long-term care facilities, charitable organizations, and more see legions of believers pouring into the lives of those in need. We are also good at teaching. Centuries of study and theological instruction have equipped many believers. However, in all our charitable acts and educational pursuits, we are often less adept at the inclusion of the mystical and supernatural part of God's kingdom. It often sits on the sidelines, hoping for a spot on the team.

Jesus and the apostles modeled educating people, offering practical help, and addressing physical needs, all the while flowing continuously in the supernatural with no separation. A telling example occurs in the Gospel of Matthew. In chapter 14, we read that Jesus had been teaching thousands of people about His kingdom; after a long day, the people were hungry. Jesus told His disciples to help care for their physical need by feeding them. The disciples point out the obvious—they don't have nearly enough food for *thousands* of people! (See verses 16–17.) It's no problem for Jesus, though. He draws on the supernatural power of heaven; intertwines it with a practical solution, small though it was (just five loaves of bread and two fish); and, by a mystery of multiplication, feeds everyone present—with twelve baskets of food left over! (See verses 18–21.)

Jesus is our ultimate example for the Christian life, and He said that our works would even go beyond His own. (See John 14:12.) We will struggle to aspire to this promise if we resist experiencing the supernatural power of God. The apostles successfully reenacted the intertwining of supernatural power and practical solutions, healing people and working many signs and wonders. (See, for example, Acts 3:1–10; 5:12–16.)

PRACTICE MAKES PERFECT

As with every discipline, practice in this area is needed for improvement. Thankfully, we can ask God to guide us to good training resources. I have been part of evangelistic prophetic teams that help people experience the reality of God—people whom God has met with astounding, life-changing encounters, after which we have invited them into the journey of joining a church family and beginning the essential, admittedly harder, work of changing more and more into the image of Jesus. But if our church culture offers little of the supernatural God such people meet during their initial encounter, why are we surprised when they tire of the mundane and depart? This was not the door presented to them. We need to be able to embrace the full reality of a God who asks us to pick up our cross (see, for example, Matthew 16:24) and serve, as well as the invitation to a thrilling life of the unexpected. The Bible tells story after story of divine help and tangible encounters outside the boundaries of the earthly realm.

AS WE EXPLORE GOD'S MYSTICAL REALM, THERE IS NO EXACT MAP TO FOLLOW.

If we want to explore the celestial realm where God has seated us with Christ (see Ephesians 2:6), we must be willing to work on our character and gifting. Accountability to a community of believers and to sound spiritual leaders is our ground control, keeping us in touch with the importance of daily life on Earth. As we explore God's mystical

realm, there is no exact map to follow. The whole point of investigating is to find what is unknown to you. But we do have a brilliant Tour Guide and a ticket that is cross-shaped and crimson-colored. The Spirit can expound the world of prayerful encounters with masterful precision. We will learn more and more, living with our feet standing on the bare earth of the tabernacle floor, our gaze fixed on the ceiling of the eternal kingdom.

PAVING THE WAY

People all over the world are experiencing dreams and visions from God. They are also dabbling in darkness and encountering light with little idea of how to divide the two. They are devouring media full of otherworldly themes to escape the dullness of life with its harsh realities. I believe an understanding of the supernatural character of God is one of the very things we need in order to help them. It is said that you cannot lead others where you yourself have never been, at least to some degree. In balance, there is a danger in pursuing the supernatural purely for the experience. But this is not something to fear; it is simply remedied. When we seek Jesus with all our heart and aim to embrace His kingdom, supernatural elements and all, He will direct us, inviting us in. (See Jeremiah 29:13.)

We do not have a distant, austere God indifferently observing us as we muddle through life. Our heavenly Father longs to walk with us through the beauty of heavenly spaces. Sometimes we don't ask because we have never been told this is possible. Perhaps we have been led to believe that supernatural experiences were reserved for Bible characters alone and can never be ours. It is time to correct these misconceptions and ask God to reveal Himself in ways we may have never considered possible.

When we diminish the prophetic, our perspective becomes limited to earthly facts and knowledge. When we diminish the supernatural, we become mainly practical, leaning excessively on our own strength and abilities. When we diminish the mystical side of God, we fill the space with human control. When we diminish divine creativity, we

lose the ability to access cutting-edge solutions and ideas to impact our world. Fear seeps more easily through earthy minds than supernaturally charged spirits. But an embrace of the eternal realm lifts our eyes, turning small thoughts into limitless opportunities.

EXTENDING GOD'S KINGDOM INTO THE SPHERE OF ENTERTAINMENT

Of all the areas of culture, one has such far-reaching impact it could be considered the most influential. This area often defines the cultures of nations, molding the mind of the masses and shaping popular opinion in such a way that precipitates changes in education, government policy, and family structure. In fact, it touches every area of culture on some level.

The sphere of arts and entertainment, with its combination of crafted words and visual stimulation, is a force to be reckoned with. Art culture can be a forerunner as well as a reflection of current society because of its revelatory nature.

UNIVERSAL INFLUENCE

Who among us doesn't come home from a hard day's work, kick off our shoes, and connect with some form of entertainment to unwind? We may not all regularly immerse ourselves in the latest political agenda or academic debate, but most of us regularly listen to music, scroll through social media sites, read books, get lost in movies, or enjoy live productions with their exciting pageantry.

We are enticed by cleverly designed packaging around every corner that grabs our attention. Online shopping sites present billions of virtual shelves in millions of websites at the click of a button. In the cacophony of tantalizing visuals, sounds, and promises on offer, the lines become blurred to all sorts of things, including a moral plumbline and the ethics of mass consumerism. Today, poor presentation screams poverty of vision or talent in a world obsessed with professional entertainment. The days of black-and-white newspapers and TV shows have faded, replaced by the virtual, visual feast that is the Internet.

God designed humanity to be captivated by beauty and the power of creativity. These things are not evil within themselves but are simply vehicles that transport a message. They hold our attention in an entirely different way than other aspects of life that we consider more practical or mechanical. They can stir us to dream, awakening our imagination and carrying prodigious power to shape and mold the human race. There is a reason the tabernacle pattern explodes with their presence.

CHANNELING IMPACT

The enemy knows only too well just how powerful the sphere of arts and entertainment is, and he uses it cunningly to his advantage. In a world full of awe-inspiring entertainment, believers operating in this industry require special spiritual maturity and a keenly developed gift of discernment. To enact kingdom change, we first need to understand this area and how the enemy has used the talent within it to disseminate his message.

Returning to the two trees in the Garden: the arts and entertainment industry often draws from the Tree of Knowledge of Good and Evil. The roots of most mature trees penetrate an area much larger than the space occupied by those trees above ground. In the same way, the influence of satanically inspired entertainment can be much more far-reaching than people realize. For example, as people engage with certain books or computer games, they are often unaware of tapping dark and deceptive roots with an addictive nature that dulls one's discernment of right and wrong. Drawn into increasingly dark and fleshly pursuits, they see little problem with engaging in the profane, immoral, and distorted; it becomes their normal. A substantial part of this industry has become marked by a lack of purity.

SHINING A LIGHT

Christians who are called to the arts and entertainment industry have a lofty commission to bring a new renaissance of God's light to this area. Demonic entities exact their influence through the gates of the eyes and ears. We need holiness to guard those gates. Believers can form

creative works that release light through the visual and audible to drive back the darkness and illuminate the path to God. But, like Daniel and Joseph did, they must first earn favor within this area of culture to effect change. Dashing into a Hollywood boardroom to protest slipping moral standards has never gained much traction. But through building relationships, favor will grow, enabling believers to bring the antidote to the enemy's agenda. The roots of the Tree of Life are also far-reaching, supporting visible manifestations of God at work in the earth.

Church culture often views the arts and entertainment as irrelevant and even threatening. It is amazing the heckles that are raised when someone dares to do a worship dance or suggests that a prayer may be painted. At times, our gatherings resemble a business conference or a well-behaved rock concert rather than a feast of distinctive, divine creativity that motivates interaction. If we work to restore the full spectrum that God has given us, more options become accessible to influence this area of culture.

SPURRING A SHIFT

A future shift will see increasing works from these arenas communicating God's hope and help. Christians connecting across all areas of expertise could cooperate to bring stunning outcomes. Think of the creation of more collaborative works such as *The Chronicles of Narnia*, *The Lord of the Rings*, or *The Shack*, crossing from literature into the visual world of film with their messages. The impact of these works on millions of people has been awe-inspiring. Often criticized by the religious order of his day for being unconventional, C. S. Lewis perceived and enacted a strategy for kingdom impact that was ahead of his time, presenting a Christian message in contemporary packaging. Following the storytelling model of Jesus, he captured people's attention far beyond the church population of his era, demonstrating subtle yet powerful evangelism in action that stretches through the decades beyond his death into a lasting legacy. As much as it looks like the area of arts and entertainment is polluted beyond repair right now, God has a rising plan that will surprise us all.

TAKING OUR CUES FROM SCRIPTURE

The Bible is crammed with epic chronicles of heroes and heroines. Light counters darkness through strange plot twists of marvel and intrigue, knife-edge battles, and climactic victories. Humanity and God journey together in friendship and frustration, through peaceful days and gritty life-and-death moments. The forces of a supernatural God are unleashed upon the earth in stunning scenes of electrifying theater. God's Word lacks nothing of drama, and it was given to us to reveal His character. Add to this the surrounding drama and beauty of His creation, and we find that neither one points to a bland, colorless, minimalistic deity. It is time to ask ourselves why we convey God in such a pared-down presentations, suspicious of the generous array of creative language available to us. Is our viewpoint blunted by an eras-long past directly affecting our ability to reach a world fluent in the language of creativity?

THE BIBLE LACKS NOTHING OF DRAMA.

As Christians, we can't be crippled by the pressure of trying to have all the answers; that is "mission impossible." However, we can share the truth that God beckons us closer through mystery and metaphor, that their purpose is part of a plan we can trust. Enigmas are not sent to taunt us but to intrigue us, like doorways to a sacred realm of discovery. Today, people increasingly fight for independence and question conformity. Communities of faith teeming with creative life will be less afraid of allowing seekers to travel and grapple.

FASHION: SINFUL DISTRACTION OR LEGITIMATE OUTLET FOR CREATIVITY?

Let's dream a little, taking the area of fashion as an example. After all, most of us wear clothes. For some, they are a fascination; for others, their significance is strictly functional. But clothing is about so much more than cloth. Fashion has defined beauty across the ages—from

the Victorians with their killer corsets to the skeletal ideal body of the 1960s. For many, style choices are an important way of expressing identity and personality.

When it comes to women's fashions in the West, there is a resounding echo of shouts demanding the freedom to wear whatever clothes we want (and even to go without, if that is our preference). Films and other media are sending the message that the more revealing a woman's clothes, the more attention she gets, and thus the greater value she possesses. This notion has seeped into the psyche of our society, but the actual experience of many women has proved that real life is not like the movies at all, as they have attracted all sorts of unwanted attention and shows of a lack of respect. It is a cyclical slippery slope. Yet as the industries of music, film, TV, and gaming constantly sexualize women, there still seems to be little recognition of the link to the appalling sex-trafficking statistics. In order to shine Spirit-light on this stronghold and on others in our world, we need heaven's strategy.

The weapon of the opposite spirit is a sharp one. The biblical standard holds a contrary message to the industries of fashion and beauty. They promise approval through an elusive perfection that hovers just beyond reach, tantalizingly unobtainable and messing with the minds of millions. But all people, regardless of looks and style, are God's creative work, fearfully and wonderfully made. (See Psalm 139:14.) Because Jesus paid the price for our redemption, we can live in the freedom of being His beloved children, valued according to heaven's standards and unshackled from the impossible measuring stick of worldly definitions of beauty and worth.

Negative by-products aside, the world of fashion holds exciting potential. Anointing to heal and bring deliverance from darkness was stored in the apostle Paul's cloth handkerchiefs. (See Acts 19:11–12.) Aaron's priestly outfit was a work of art rife with symbolism. (See Exodus 28.) Garments can carry messages through shape, color, imagery, and words—an enormous scope of possibilities. Printing Scriptures and Christian symbolism on apparel and accessories is not the only way for Christians to make a mark in this industry. When we understand

the power of metaphor, impartation, and co-creation, we can access places in culture closed to an apparent religious agenda.

This approach can be extended to every area. Culture has a bewildering array of niche and mainstream expressions, but God can grant us strategy for any sphere if we simply ask Him. Believers knowledgeable in various fields can activate divine combinations and blueprints. Greater is the Spirit of God within us than the enemies in the world. (See 1 John 4:4.)

THE QUEST TO ENGAGE

As the secular world pushes God further from the core of culture, it shuns the true source of legitimacy. Trying to replace His stable standards with the shifting sand of humanism is a precarious position. Confusion is rife, and the age-old cry to feel uniquely made is a desperate one. We all want to know why we are here and whether our time on Earth holds meaning. As the world endorses a smorgasbord of ever-increasing choices, the church's urgent challenge is to reach a wide diversity of people with the good news. God's people are not unequal to the task, but we need to throw wide our arms to the plentitude of gifts and callings the Creator has given us.

One area that seems to be a constant struggle is how to keep younger generations engaged in the church, especially teenagers and young adults. Many modern distractions are blamed for today's mass exodus of young people from the church, but could it also be that the church is inadvertently repelling them with its apparent suppression of the arts and creative expression? Among Gen Xers and Millennials, the hunt for identity and the expression thereof hinges largely on creative ways to communicate their beliefs and personality. Young people pay religiously close attention to popular music, professional sports, TV programming, personal fashion, and the like. In this digital generation, social medial and technology have become one of their primary forms of communication. All their lives, billions of messages, photos, films, and more have been accessible at the mere touch of a button. If we can develop a more creative church culture, we can improve our apparent

relevance to these age groups. By speaking the language they value, we will draw them into the exciting realm of imagination, creativity, and supernatural power made possible by the Creator and Savior they need to know.

16

TAKING TERRITORY

Innovation is the calling card of the future.
—Anna Eshoo, U.S. Congresswoman[29]

Modern technology and its capabilities are constantly reshaping the workplace. With machines that can process unheard-of amounts of data in record time, outstripping human capacity, some industries are seeing certain vocations being rendered obsolete. Other positions that previously required full-time employees are turning into part-time gigs with robots breezing in and performing routine tasks. Today's students are being urged to think ahead and arm themselves. There is only one guarantee: working life has to change!

While technology can replace some physical and mental work, thankfully, it is widely recognized that technology cannot supplant uniquely human traits such as creativity, imagination, emotion, and integrity. As God's people, we possess far more than mere skill—we have access to life-changing, spiritual creativity.

Creative wisdom is a big part of the answer if we are to reach our multicolored world culture. We need spiritual spaces to explore with

29. Eshoo, Anna, "Innovation is the calling card of the future," accessed August 5, 2021, https://www.brainyquote.com/quotes/anna_eshoo_505470.

communities that cheer on experimentation and diversity—sort of like science labs for future solutions. Fresh inspiration is born from faith. The quest of co-creating with God builds resilience and flexibility, shaking us loose from the fear of change and the accompanying need for control.

When the cloud of God's presence moves again, we learn to shrug, smile, and change course; we don't need to see how every stage will play out before we jump in. The call of Christianity never promised us any of that. It asked us only to follow and believe. Christian pioneers and innovators can activate God's prophetic gift to glimpse the future and see beyond current blockages into potential solutions. And they are often among the first to notice when the cloud has moved.

CALLING ALL PIONEERS

For God's people to forge ahead, we need some stalwart pioneers at the helm. Fear of change is not a good foreman, but Spirit-led innovators and explorers will open a new panorama. We Christians sometimes lack a seat at the table of influence because we struggle to recognize our own prophets and pioneers and their potential to make vital contributions to future advancements.

What does it mean to be a pioneer? This calling can apply to individuals, as well as whole churches and ministries. It means to be first to enter a territory (a field of inquiry or enterprise) and open it up for occupation and development. Pioneers of old set out on gripping adventures to discover new lands. There was no taxi on the tarmac to greet them and whisk them off to a homey hotel. Their welcome party was the wild wilderness of jungles and fierce forests. Hacking a path through dense undergrowth and wandering across vast wastelands, they would explore the territory before attempting any building projects. Eventually, with more help and numbers, settlements would be developed and established. The rudimentary path would be widened with footfall till, one day, it became a paved road with taxis parked and ready to greet new arrivals. Pioneers carve a way that doesn't exist in the first footsteps to claim new territory.

Resistance to the change Jesus was trying to stir change came from within the church. A villainous religious spirit is frequently the first to combat kingdom pioneering. Subtly cloaked as righteous objection, it is harder to spot than blatant worldly opposition. Thus, the deadly weapon of all pioneers must be deep-rooted trust in God and their calling. Living for the affirmation of people is a calling killer. True pioneers urge others into the joy of exploration—of God, new concepts, and novel considerations. They lead the charge to explore uncharted physical, spiritual, and mystical territory. Maturing godly character must be the mission of a trustworthy pioneer, firmly grounded in love and church family.

THE DEADLY WEAPON OF ALL PIONEERS MUST BE DEEP-ROOTED TRUST IN GOD AND THEIR CALLING.

The church was designed to be the head and not the tail. (See Deuteronomy 28:13.) By the advance of pioneers and innovators among us, we will lead the charge with a creative kingdom revolution. The future invites a new renaissance. God's pioneers can mark new paths through the world's terrain, opening the way for others to expand and establish God-life smack-dab in the middle of secular society. It's time to get highly practical and highly spiritual at the same time. A fresh perspective will empower a presence-centered force to take its place amongst the mountain range of culture with the roar of the Lion of Judah ringing in its ears.

TAKING TERRITORY IN THE WORKPLACE

Traditional evangelism—usually involving Christians reaching into all areas of society, sharing their faith, and seeking to draw interested individuals into church culture—seems to have lost its efficacy in recent years. There is little denying the fact that some serious restructuring is required in our approach. We stand on the edge of a critical shift in

understanding the potential value of workplace callings. Many of God's people are strategically positioned in society as an end-times army, but they still require activation.

I have talked with numerous believers who feel that their professional callings aren't as worthy, in the kingdom of God, as those of full-time pastors or foreign missionaries. Many believers seem to perceive a deep divide between "church work" and everything else. Yet God has called each of us to a unique position—and to serve Him and His people wherever that may be, whether inside or outside the church. It doesn't help that the narrow scope of some current evangelistic methods leaves many believers frustrated by feelings of ineffectiveness in sharing their faith in the workplace, especially with many businesses and organizations forbidding all intimations of proselytizing.

ALL CALLINGS EQUALLY QUALIFIED TO ADVANCE THE KINGDOM

God does not value a single expression of His character over another, for all of them are needed to reach the diverse multitudes of people across the globe. All that matters is our motivation. It's not the title we hold or the nature of job description that counts; it's what lies beneath the surface. Jesus chastised the Pharisees for projecting a priestly veneer to conceal the cesspit of motives lurking in their hearts. (See, for example, Matthew 23:27.) Playing piety without purity of motive has never fooled God. Millions of believers are wired to express God in millions of ways, no offering less precious or valuable than another.

The biblical accounts we reviewed earlier of such master craftsmen as Bezalel, Huram, and their teams were not just about their dazzling skills; they were stories of real lives. God could have spoken a worship center into being. If He can arrange an orchestra of planets and stars with a single phrase, what's a little tent and some furniture? Instead, He chose to present blueprints to people and work with them, day after day, through thousands of hours of designing, sawing, hammering, and decorating. Every step of the divine design is about cherished connection between the Father and His children, crafting closely together to form redemptive beauty in the earth.

THE NEED FOR CHRISTIANS FILLING ROLES IN EVERY SPHERE

God positions believers intentionally in jobs across the board. If every Christian searched for employment strictly in "Christian" spheres—the church, educational institutions with a religious affiliation, and so forth—the world would be in real trouble for lack of evangelism! Your job is crucial for the kingdom, whether your workplace is a formal, paid setting, your home where you care for your family, or a charity organization where you volunteer. In God's economy, all jobs are treasured and needed.

Then how to clarify your call and choose a vocation? In conversation with the Spirit, examine your gifts and skills. How has God wired you? What are you passionate about? Where is God asking you to go, and what are you to do there? Some of us are made to be groundbreakers; some are gifted at establishing and developing for long-term impact. Ask the Lord how He wants to co-create with you and to show you the stepping-stones needed to progress. Seek the first stone and let the others appear in process.

With fresh revelation from God, we break the enemy's ploy to freeze us with his twin weapons of defeat and lack of direction. From this position of strength and a sense of purpose, we are fortified to handle challenges and fend off discouragement. Intel changes everything; it is the antidote to being *"destroyed for lack of knowledge"* (Hosea 4:6). God is raising up game-changers for this hour who are tough in battle and undeterred in their objective. Their faith-fueled forward motion will carve out space for others to follow.

RECLAIMING SOCIETY THROUGH CHRISTIAN LEADERSHIP

For believers to be the head and not the tail, we need divine wisdom, a key quality of every leader within the tabernacle pattern. Moses has been asked to lead the newly emancipated Israelites to the promised land—an estimated two to four million people whose long legacy of enslavement in Egypt had swallowed up much of their Hebrew culture. They were in dire need of good leadership.

GOOD LEADERS LISTEN TO GOD

God instructed Moses to meet Him in a very specific place to receive strategy for this gargantuan task. They needed a governmental plan, a new social structure, and practical guidelines for millions on the move. This was not a people flowing in holy harmony, or they wouldn't have needed a bunch of commandments including one forbidding murder. Where was God's chosen nerve center for imparting such crucial intel? He chose the tabernacle, deep in mystery and artistry.

And there I will meet with you, and I will speak with you from above the mercy seat, from between the two cherubim which are on the ark of the Testimony, about everything which I will give you in commandment to the children of Israel.

(Exodus 25:22; see also Numbers 7:89)

Scriptures imply that only the high priest was allowed to enter the Holy of Holies once a year. Some theologians suggest Moses stood at the veil, listening; others think he may have had a pass to enter. Either way, He was enveloped within the artistry and beauty of the inner chambers. In this sumptuous setting, God would converse from the angelic forms of the mercy seat, representing His throne of government and justice. Scripture paints a picture of heartfelt relationship, God and Moses talking face-to-face like close friends.

Where are we looking for solutions today? Are we seeking out the Spirit's wisdom, or do we tend to draw strictly from our education, skills, and experience? It isn't uncommon to concoct a sort of "smoothie" of mixed fruits from the Tree of Knowledge of Good and Evil and the Tree of Life, all whizzed up together. The product lacks the strength of spiritual wisdom required to succeed.

GOOD LEADERS TRAIN UP THE NEXT GENERATION

From the time when Moses's eventual successor, Joshua, was a young age, Moses modeled for him how to seek God, expect revelation, and then partner with Him in action. Joshua saw firsthand that tabernacle time was the clincher for successful leadership. After the death

of Moses, he became a formidable leader of Israel, his feats including taking the next generation into the promised land, conquering mighty forces, and seizing fortified cities.

The instructions he received from God for carrying out these achievements were creative and even downright weird—just consider the set of seemingly illogical directions regarding how to demolish Jericho. (See Joshua 6:1–21.) Yet Joshua listened closely, completed every step, and found himself lauded for conquering such a mighty stronghold.

David was yet another leader who found success in governing by listening to the Lord and then passed that practice on to his successor. He knew he could only find the revelation to lead from deep communion with God in the tabernacle. Faced with challenges on a national scale, he did not hover in the outer courts, fretting and nibbling his nails as he agonized over the possibility of God's desiring to do something new. His greatest desire was to foster an enquiring heart of honest and all-consuming friendship with God. (See, for example, Psalm 51:10–11.)

His successor, Solomon, wrote a great deal about the secrets of successful leadership and influence, citing God's wisdom and the ability to understand His metaphorical language as key. (See, for example, Proverbs 1:5–7, 20.)

All these leaders embraced the wisdom of God and, above all, His presence. The tabernacle invitation is the place where God and humanity collide, enveloped in the creative atmosphere of mystery, artistry, and exploration. In this holy space, our shortsighted spiritual spectacles feel like a poor fit. We need to fling them aside, jump up to our celestial seat, and see the vista of co-creative possibilities before us.

FUNCTIONAL EVANGELISM

Believers function in a cornucopia of workplaces and people groups, some Christian and faith-friendly, others not so much. One thing is sure: workplaces of every kind are having to keep up with recent demands for the acceptance of diversity, whether ethnic, gender, or another type. If Christians approach their coworkers with a narrow-minded method of

evangelism, they will hit a wall of frustration—and possibly even get fired. Good thing God's character gives us flexibility for any situation! Our witness is not just one of words but also demonstrations. If we co-create with God to develop a new engineering technique, fashion line, or justice policy, then we are changing the world with the kingdom.

Wherever our workplace or sphere of influence may be, it is holy ground, ripe for co-creation and evangelism. Most people come to God through a journey of stepping-stones rather than by a single cataclysmic event. They need time to pause, pose questions, and ponder along the way. The Holy Spirit is highly skilled at walking them through this journey. We are simply to respond to God by releasing His life into the atmosphere of Earth, and the people He puts in our path, as He directs us. Imagine God's full range of creative elements at work through the church, gathering a great harvest. We are invited into the forward motion of this exciting plan.

SPHERES OF FAVOR AND INFLUENCE

The quest to find who we are and what we were born to do is an ongoing conversation. One thing we can know with certainty is that we were born for relationship and wired with purpose. Our design is intensely individual, and as we discover its details, we find fire for living. As we progress down the long road of life, we will come upon pit stops that provide an opportunity to upgrade our vision and further clarify our purpose. We do well to take advantage of them, or we are likely to grow weary and disorientated.

To live on the outskirts of God's presence is to dwell in the blurry edges of our vision, a place where dreams die and hearts grow cold. But as we faithfully pursue our call, we will grow in favor with people and God. Doors of opportunity will open, inviting us inward with little effort on our part. There is no corporate ladder to climb into heaven; we can enjoy a blissful release from such worldly strains when we live according to God's perfect timing. If a door opens, it opens; if it doesn't, we can ask God the reason. Perhaps some further character development is required for us to access what lies on the other side. Perhaps everything

that glitters is not the gold we assume it is going to be. Or maybe it is actual gold that God plans for someone else to find. It could also be that the enemy has raised an obstacle we need to overcome. Whatever the reason, we can trust Him to guide us through the answer.

FAITHFULLY FULFILLING OUR COMMISSION

Following the favor trail will frequently lead us to the unexpected and into the cloud of co-creation. This is where heaven opens its storehouse of provision, supplying its supernatural all-sufficiency for our deficiencies of character and skill. I have learned to leave presumptions aside and meet every challenge with a blank page that is God's to fill. His ideas are always brilliant. Instead of a head-scratching process, it becomes a time of brainstorming full of exciting ideas as the Spirit speaks and a plan emerges.

Many times, God has assigned me a project that requires much time and effort, yet I have only a vague sense of its purpose at its inception. In these cases, it has been a conviction to complete the commission that has carried me to the end. What we do not fully understand in the moment has an eternal purpose that will one day be illuminated to us. I believe we will be blown away by the beauty of God's plans and our place within them. Do we honestly want to miss that moment because we decided our God-given commission was too "weird" or "illogical"? If God is the One giving directions, we can be sure that our obedience to carry them out will have significant impact, both now and for all eternity.

CAUTION WITH CLOUT

In different seasons of life, we are granted varying levels of favor and varying spheres of influence. We need to be aware of these moving parameters and their scope. How much clout do we have with our colleagues, neighbors, family members, and so on? Is our scope of influence mainly local, national, or international? In what spheres of society can we make a difference? It's a mistake to think that having a strong influence in one area means we can stroll into another area and wield our power to the same degree. A mogul in the oil industry who dazzles

others in his field with brilliant insights will find that his opinions hold little weight in the Disney boardroom.

It is no different for us as Christians, not only within world culture but also church culture. The Internet has opened a platform for anyone to spout their opinion, contributing to the rise of a virtual pulpit full of moralistic, religious-minded voices who have mistaken their permission to use the Internet for favor, with distressing results. We need to know the territory we have been called to, and we should respect and strive to learn from believers whose influence lies in other arenas.

BEWARE THE SPIRITS OF COMPARISON AND COMPETITION

Competition can be a killer. Some healthy competition may spur us on, but we live in a culture propelled by individualism and performance. The media fuels the game of comparison, a drip-feed of impossible standards that seduces us to compare and contrast, concealing the fact that we can never meet the mark. In the photoshopped world of physical perfection, we despair of the wobbles and marks of our real-life bodies. Comparing our creative works to those of others leaves us flattened; there is always someone more skilled or successful.

Performance pressure will kill us if we let it. Success can lead to an expectation of the next cool thing we can produce to sustain our reputation. This is world-system stuff, and falling victim to this lie has broken many. We need to learn how to live in the rhythm of each divine commission, free from the potentially deadly pressures of popularity and performance. One way to do this is to ask ourselves if we are willing to lay down what we have been part of building to follow the cloud into change. Such tests reveal how much of our identity is based on our works versus on our security in God. If we follow the cloud, it will keep leading us to the promised land of our destiny and help us seek less security in our works. It is the partnering process of co-creation with the Creator of all the universe that is the greater prize than any product we might make.

This truth was grasped by the master craftsman Bezalel. Once he and his team had completed the resplendent tabernacle, their names

would have been known throughout Israel, their skills and righteous deeds acclaimed. Perhaps the people looked to them for a follow-up, another dazzling artwork to perpetuate their newfound fame. But they were free from such pressure, for they had completed their commission and given it their best shot.

God's kingdom is not to be packed with competitors; it is a body of interconnected parts, all working together and cheering one another on. (See, for example, 1 Corinthians 12:12–26.) There are so many areas of culture to reach and so many people within them who are on God's heart. We need a multiplicity of believers to harvest the cultural landscape.

PURIFIED IN OUR PURSUITS

When seeking divine ideas, we need to check our motivation. What will we do with a "eureka moment"? Are we secretly looking for fame and fortune—hoping to record a hit worship song that will make our place in music history, or seeking knowledge that will earn us prestige from our peers? We may indeed prosper and find a following, but while God's blessings will pursue us (see Deuteronomy 28:2), the skeletons we keep in our closets are dangerous roommates. The more God entrusts to us, the more hazardous our hidden issues become. If we seek more, we also need to open the dark closet and let God flip on the light switch. If our weakness causes us to crave the approval of people, it will take us down.

Skill is not enough; good ideas or long lists of qualifications are not enough. If we are going to be initiators of heavenly transformation on earth, our lives must be holy and pure, first and foremost. *"Lord, who may abide in Your tabernacle? Who may dwell in Your holy hill? He who walks uprightly, and works righteousness, and speaks the truth in his heart..."* (Psalm 15:1–2). Holiness is not an unrealistic call to sterile religious behavior. God is well aware of our fragile frame, and His salvation encompasses all that we are. It offers us His strength to walk through life as real people with track records of brilliant successes and abysmal failures.

As obedient children, let yourselves be pulled into a way of life shaped by God's life, a life energetic and blazing with holiness. God said, "I am holy; you be holy." (1 Peter 1:15–16 MSG)

We are made holy through the salvation door, with our scarlet sins being exchanged for purity through Christ's blood—scarlet for scarlet. (See Isaiah 1:18.) This exchange initiates a transformative journey of heart and lifestyle. It is all about maintaining an open-handed posture before the Lord, who does not strike our open hands with the rod of perfectionism but rather holds them in the grace of His own.

ROOT OUT THE DESIRE FOR RECOGNITION

Everyone desires a sense of legitimacy—the satisfaction of believing that what we are doing matters and is appreciated. When God gives us light-bulb ideas, we want them to be recognized and embraced by others. But there will come a day when we find ourselves standing on the ledge that overlooks the abyss of prideful thinking. Only the harness of holiness will keep us from falling and failing.

A keen sense of our size in the universe will ultimately lead us to our true source of legitimacy. In a life of Christian pilgrimage, this is rarely a onetime test as we ascend the mountain of sacred connection. We will meet it round many a trail bend. The more acclaim comes our way for co-created works, the more this test becomes our friend, not our foe—like the hand that grasps ours, preventing us from slipping from the narrowing paths of great heights. Increasing exposure in the blustery mountaintops will require the stabilizing force of ever-maturing Christian character.

When we co-create with God, it's not all about us. We didn't spark the ideas by ourselves. We may get to be substantial players in the process, but it should be a process inextricably intertwined with God—a process that stretches and changes us more into His likeness. A holy fear of our Maker should prevent us from trying to steal His patents and pass them off as our own.

It isn't that God expects us to be silent partners, nameless ghost-writers; He is proud to partner with us, His sons and daughters, generating testimonies of a creative union that carry a powerful message of God's love for humanity.

The two greatest commandments will clear the way for pure motives and selfless pursuits: love God with all our heart, and love others as we love ourselves. (See Matthew 22:35–39.) Herein lies the antidote to self-seeking. Our greatest healing is to be found in God's unconditional love, celebrated as His personal artworks. No two humans are created the same; no two lions or even leaves on a tree. The Master Craftsman has no desire for dull mass production. This truth can disentangle us from deathly World standards, galvanizing us to stand guard against the enemy's schemes and put-downs.

DON'T DESPISE SMALL BEGINNINGS

When God grants us the eureka blueprint, the inspiring idea, and we start to pursue it by the process of co-creation, the enemy will oppose us at this point because it is easier to stop something at its inception than when it is fully formed. Our determination will be tested, as will our foundations.

When God unexpectedly asked me to write my first book with a prophetic message of creative restoration, its message was not commonplace, and it felt like a pushing against the popular current. The volume of work required was intense, and I had to wrestle to develop skills that had never been my forte. Conviction and obedience pulled me through these battles. The enemy rarely let up with his disparaging critique or his whispers that what I was doing was pointless. But I finally realized that even if all my efforts culminated in a book that would be read by Jesus and no one else, the multitude of hours and investment of hard work was worth it. It was this heart posture of mine that enabled God to use the finished product for His kingdom purposes. I won the long battle the moment the enemy's lie was exposed, and the burden of aspiration slid to the ground.

Like most people, I was raised in the world that teaches us the highest reward for our efforts is found in the accolades of humanity, in manmade rewards of recognition. On my first journey of writing a book, God continually encouraged me not to despise the day of small beginnings. (See Zechariah 4:10 NLT.) This verse refers to rebuilding Solomon's temple after its destruction by the Babylonians, a huge task tackled by the remnant of Israelite exiles who emerged from captivity. God assured them they would succeed *"not by might nor by power, but by My Spirit"* (Zechariah 4:6). Yet, the workers still had a significant part to play, chiseling stones and stacking them in place in a process of co-creation.

In the day of "small beginnings," as we pursue a revelation, we see clearly what our motives are and what it is we are relying on. Would we undertake the project for God alone? Are we willing to lavish time, skill, effort, and finances to see something come to life with no promise of endorsement from others? We have to learn how to live with the tension of having big dreams yet being satisfied with making small steps to achieve them. When God's approval is all we need, we are truly free to create.

CONCLUSION: A ROYAL PROCESSION

While praying one day, I entered into an encounter with God. I found myself on a beach of ethereal perfection. Pearls of white sand spun beneath my feet while the ocean's blue waters lapped across the shore. The Lord appeared as a great lion. As we strolled and talked together, I embraced His lavish mane of golden hair at His invitation, basking in the friendship of such a Father. Suddenly, the entrance to the temple of Solomon emerged through the air. The monumental pillars of Boaz and Jachin framed the doorway, yet instead of being made of brass, they were golden. The door led directly into the Holy Place. Light streamed from its internal chamber, incandescent with gold particles. It reached out and encircled us, drawing us inside.

Entering, I saw immense cherubim angels lining the walls at intervals, powerful guardians of this most sacred place. The room was radiant, every element drenched in the purity of mirror-glass gold. High walls dazzled with decoration and contrasting flush panels. The swirling light was alive, smokey, and surrounding, gently moving us through the room. I felt as if it was a part of my being, and I was somehow part of its luminosity. The ten golden lampstands flickered to form a corridor

of amber flames, and I knew there was something essential I was there to understand. Suddenly, my clothing transformed into a white dress, elegant yet simply cut in linen and long enough to spill across the floor. The hem was dip-dyed blood-red, the color seeping through the threads and fading into spotless white, as the sound of a Scripture filled the air: *"Though your sins are like scarlet, they shall be as white as snow"* (Isaiah 1:18).

Jesus appeared before us at the entrance to the Holy of Holies. Behind Him, a magnificent throne framed His royal apparel. He extended an invitation for me to sit by His side, yet no visible seat was present. As I wondered what I would dare sit on beside such a throne, my perception formed a thought that became a manifest object. It was a small stool, low to the ground and basic in form. Sitting down beside Him, I felt humbled by such immense honor—trivial me, seated alongside the great King of the Universe—and yet, in a strange paradox, I also felt like the blood of royalty. I was reminded of an orb and scepter of authority God had placed in my hands during two recent visions, the full implications of which I did not yet understand. Then something imprinted on my spirit. God wanted to give me a new revelation of my royal status, the view from His eternal kingdom, and the authority granted to me for this world. Yet, I still had much to learn about how to use it.

KINGS AND PRIESTS UNTO GOD

First Peter 2:9 says, *"But you are a chosen generation, a royal priest-hood, a holy nation, His own special people, that you may proclaim the praises of Him who called you out of darkness into His marvelous light."* As we seek to touch our culture with God's kingdom, we need to realize our royal status. Royalty carries authority; it's a catalyst for change. It takes time to grow into a royal office and learn its dynamics. We need the Spirit to teach us the implications of our royal designation on our individual calling.

The creation is waiting for us to grasp the royal authority we carry and its components, including the creative power of God. (See Romans

8:19.) Lack of identity leads to vulnerability and disillusionment. The world lives in an identity war zone, exiling God from its moral code and then suffering the consequences. As Christians, we are asked to answer its SOS, helping people to find their value and purpose as determined by their Creator. We will be all the more effective in this commission when we recognize our own royal identity—kings and priests, living tabernacles of the Lord. (See Revelation 5:9–10.)

USHERING IN A NEW ERA

I believe we are reaching the end of an era. It has taught us much, and its riches are to be treasured always; but something new has been set in motion that will catalyze the restoration of dynamic creativity to the church. As we prepare for the dawn of a new epoch, we are called to courageously fine-tune our valuable craft, surging past mainstream monotony and into the Spirit's slipstream for the time shift upon us. Investigation and innovation will lead us into ever-broadening options when we shake loose the "safe," faithless formulas and unleash a new age of creative movement. As we allow an expanse of God's character to emerge through His church, we will see an army on its feet in the mountains of culture, mobilized and diversely gifted, marching the glory of God throughout the earth.

The tabernacle pattern contains the cache of tools and weapons needed for this contemporary commission. Its pieces are like the mechanisms of a clock; they will activate power in perfect timing, in synchrony with one another and with the Master Clockmaker, counting our footsteps along the path to the nerve center of God's heart. We can find Him standing in the dusty desert, waiting for us to see His form, or in the outer courts, watching as we grasp the sanctity of atonement. We can find Him in the Holy Place, brooding over us, brightening our path deeper in with the light of menorah wisdom. He awaits us in the Holy of Holies, its entrance framed with the tatters of a torn veil hanging scarlet with sacrifice. It is here we will find a face-to-face friendship that will reveal the mysteries of our future.

Then the cloud covered the tabernacle of meeting, and the glory of the LORD *filled the tabernacle. And Moses was not able to enter the tabernacle of meeting, because the cloud rested above it, and the glory of the* LORD *filled the tabernacle.* (Exodus 40:34–35)

ABOUT THE AUTHOR

Charity Bowman Webb is passionate about the prophetic and creativity. Her goal is to equip people to discover the creative DNA that God has planted in His children so that they can change culture and live out their full design.

Charity works to ignite creative and pioneering ways of releasing God's Spirit in the church and on the mission field. As the director of Streams Creative House, a mission of Streams Ministries International, Charity's heart and calling are to help believers explore God though a depth of relationship, develop maturity through their revelatory gifts, and see restoration and understanding of the creativity of God released to transform society. She is passionate about helping Christians deepen their relationship with God by exploring their spiritual gifts and God-given creativity for worship, intercession, and mission.

In her native Scotland, she led the national creative team for CLAN (Christians Linked Across the Nation) for six years, helping to form a new pioneering community. She is also the cofounder of Blue Flame Ministry and helped to pioneer an evangelistic movement in prophetic and creative mission, training, and leading teams into secular settings.

Charity is also the author of *Limitless: God's Creative Mandate for His Church*. She speaks regularly at ministries and churches for conferences,

courses, and special events throughout the United States, the United Kingdom, Sweden, Germany, South Africa, and Singapore.

Charity and her husband, Alan, have two daughters and make their home in Inverness in the Scottish Highlands.